the best of FISHER

the best of FISHER

28 years of Editorial Cartoons
from Faubus to Clinton

George Fisher

Introduction by
Ernest Dumas

The University of Arkansas Press
Fayetteville 1993

George Fisher's editorial cartoons appeared in the *Arkansas Gazette* and are reprinted through the courtesy of the *Arkansas Democrat-Gazette*.

Originals to the cartoons in this book courtesy of The Arkansas Arts Center Collection.

The paper used in this publication meets the minimum requirements of the American National Standard for Permanence of Paper for Printed Library Materials Z39.48-1984. ☺

LIBRARY OF CONGRESS CATALOGING-IN-PUBLICATION DATA

Fisher, George, 1923 —
 The best of Fisher: 28 years of editorial cartoons from Faubus to Clinton.
 p. cm.
 ISBN 1-55728-268-4 (c). — ISBN 1-55728-269-2 (p)
 1. United States—Politics and government—1945-1989—Caricatures and cartoons. 2. United States—Politics and government—1989- —Caricatures and cartoons. 3. American wit and humor, Pictorial.
I. Title.
E839.5.F56 1993 92-23222
973.92--dc20 CIP

Acknowledgments

Special thanks to
Betty Lane
Dorothy W. Harwell
Mary Ann Woods
Judi Woods
Carl Slaughter
Ernest Dumas

2.00

Contents

Introduction

This is the most comprehensive collection of George Fisher's cartoons yet, covering a period of nearly thirty years, from the time his cartoons began appearing weekly in the *Arkansas Gazette* until the *Gazette*'s lamentable death on October 18, 1991. Fisher was already in his forties when he undertook, almost as a diversion, the work that would make him the most influential social and political satirist in the state's history and put him in the first rank of American cartoonists. He was running a commercial art service at Little Rock at the time, when an old friend urged him to grasp again the pen that he had wielded so trenchantly for his regimental newspaper in Europe during World War II, where he served as an infantry soldier. After the war, he worked for a snorting little newspaper in the Mississippi Delta, the *West Memphis News*. The *News* was run by a couple of brothers, who proved to be as reckless as they were fearless in fighting the local political machine that eventually put the newspaper out of business. After the paper shut down, Fisher moved to Little Rock and opened his commercial art service. A decade later, he began drawing cartoons for the *North Little Rock Times*. The *Gazette* picked them up and in 1972 contracted with him to draw two cartoons a week. He became the newspaper's chief editorial cartoonist in 1976.

Although this Fisher omnibus is not arranged in strictly chronological order, aficionados will not escape the impulse to trace the artist's growth and the metamorphosis of his ideas just as thousands of readers could not resist the daily search in Fisher's cartoons for the hidden "Snooky," the nickname of his late wife, Rosemary. There is some technical progression, to be sure, but what the reader is apt to find is a remarkable consistency of principle and thought. The instincts that stirred his

return to political cartooning in the early sixties were the same ones that inspired his pen at the noisy little delta paper: to oppose the tyranny of bigotry, ignorance, and greed. His first cartoons in the *Gazette* and those that made his reputation were about the political machine that rode racism to control of the state in the 1950s and 1960s. Readers will find some of his most poignant art in the chapters on human rights and the creation-science folly. It is the constant devotion to principle that sets him apart from the aimless gag artists that are popular on newspaper editorial and op-ed pages.

What has robbed Fisher of greater national celebration is the perception of him as a provincial cartoonist. It is not without premise. He has continued to draw as much about local and state subjects as national and international ones. And alongside his arsenal of classical metaphors, from Shakespeare to Norse mythology, are all those bucolic images, so familiar to Arkansawyers, so foreign to those outside the rural South: the tiny schoolhouses, front porches, and country stores around his boyhood home of Beebe, the decrepit quarters of the beloved Old Guard Rest Home, which was modeled after the Ozark shack at Timbo where he and the fiddlers and folklorists of the Rackensack Folklore Society sometimes gather. Nothing is provincial, however, about the lessons or the humor of the art. They are universal.

Ernest Dumas

All Around the Farkleberry Bush

Orval Eugene Faubus was governor of Arkansas for twelve years, far longer than anyone else before Bill Clinton. A brief defiance of the federal courts, which had ordered Little Rock Central High School to educate black children, made Faubus unbeatable for a time. So complete was his power that he left his image on every aspect of government. His dominion included the Highway Department and the countryside. In one celebrated episode, Faubus identified a roadside bush as a farkleberry and ordered its preservation. The farkleberry bush became his signature. After retiring in 1967, Faubus made three comebacks, in 1970, 1974, and 1986, and lost by a landslide each time.

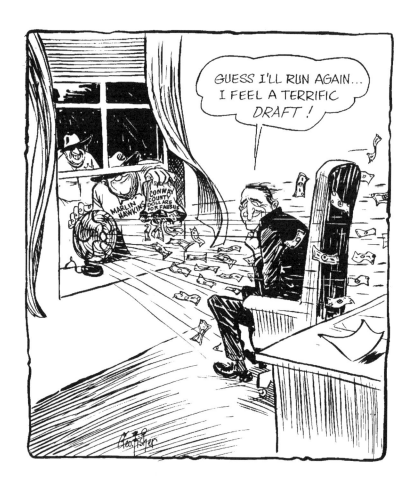

Governor Faubus put on a show of vacillation about running again until cronies in Conway County fetched the filing fee.

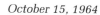

October 15, 1964

With the election approaching and Winthrop Rockefeller, Faubus' Republican opponent, running against gambling, Faubus sent the Arkansas State Police on a gambling raid in Hot Springs.

January 7, 1965

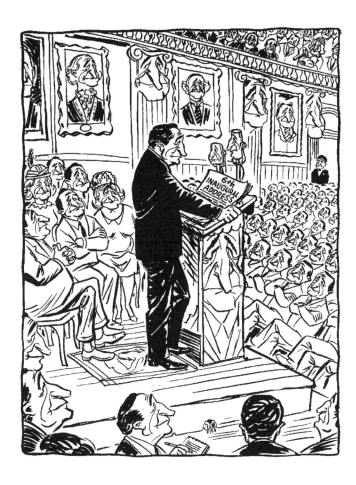

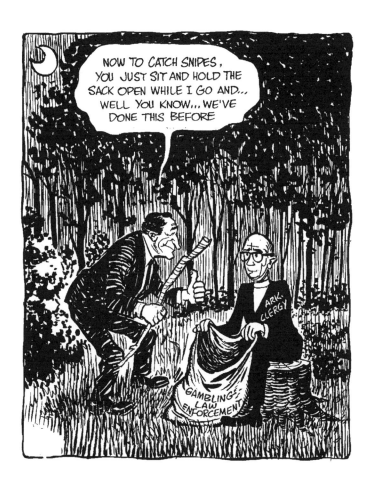

May 6, 1965

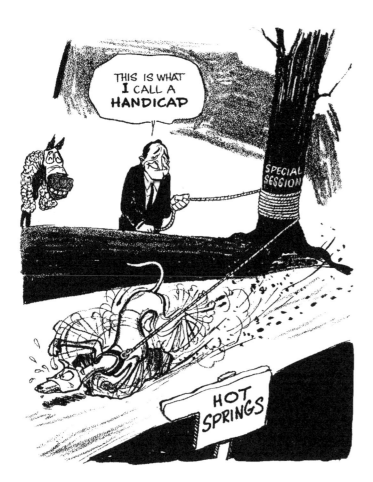

November 4, 1965

A group wanted to build a dog-racing track at Hot Springs, but Faubus called a special legislative session to stop it.

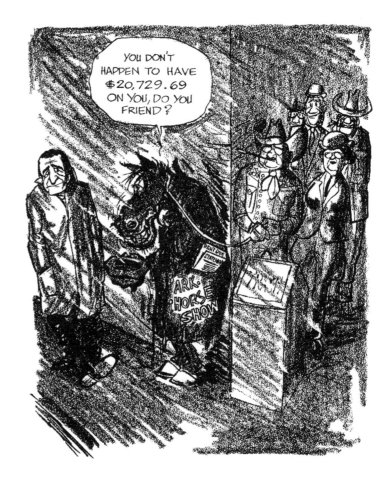

February 3, 1966

Equestrian fanciers among the governor's rich supporters needed cash to support their hobby, and Faubus obliged with his emergency fund.

April 21, 1966

The Faubus administration was groaning
under the weight of scandals: the horse-
show gift, midnight pay raises at the
Highway Department, the discovery of
special pensions for his pals on regulatory
commissions.

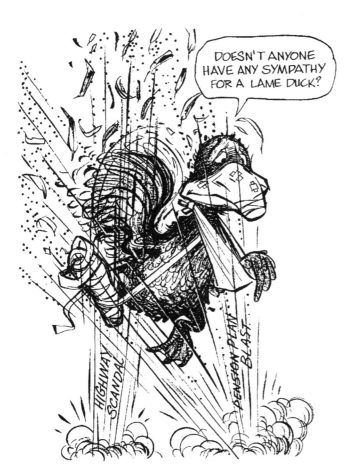

May 26, 1966

July 28, 1966

Arkansawyers went to vote without Faubus
on the ballot for the first time since 1952.

January 12, 1967

Developer Jess P. Odom, a Faubus supporter, opened a Dogpatch theme park near Harrison and advertised for a director. Faubus got the job.

October 10, 1968

Faubus turned up running a boiler-room operation at Little Rock for George Wallace in the presidential campaign.

In the Spring a young man's fancy lightly turns...

March 27, 1969

Faubus divorced his wife, Alta, and married Elizabeth Westmoreland, who had come to Arkansas to work for the Democratic Party.

June 25, 1970

Faubus ran again, promising a fresh reform administration.

August 16, 1970

Faubus promised that a new administration would be filled with youth, not the old regime.

Faubus said Dale Bumpers, his runoff opponent, was backed by the *Arkansas Gazette*, proof that he was "a flaming liberal."

September 13, 1970

Faubus hammered Bumpers for having once said that he doubted that God had physically parted the Red Sea. Bumpers won in a landslide.

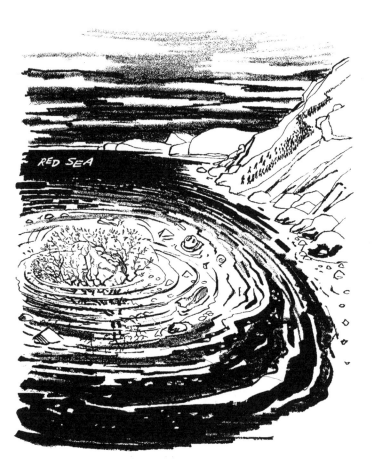

April 7, 1974

He tried another comeback in 1974, this time
against David Pryor, a former Congressman.

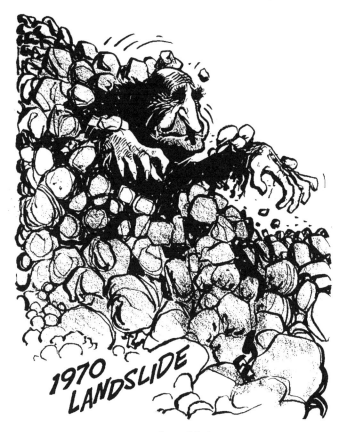

Return of Farkleberry

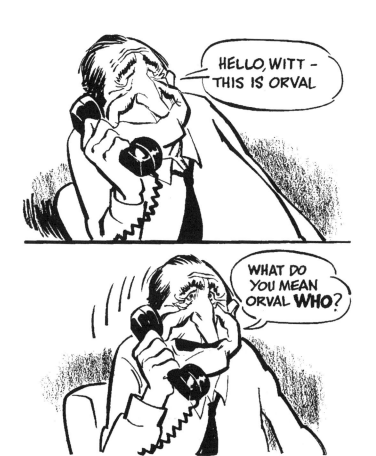

April 18, 1974

Faubus learned that his old bankroller, W. R.
"Witt" Stephens, was supporting Pryor.

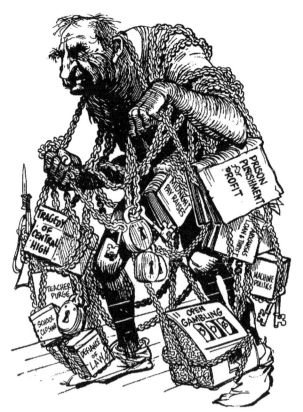

May 12, 1974

Faubus found himself defending the scandals of his six terms.

"I wear the chains I forged in life," said the Ghost of Faubus' Past.

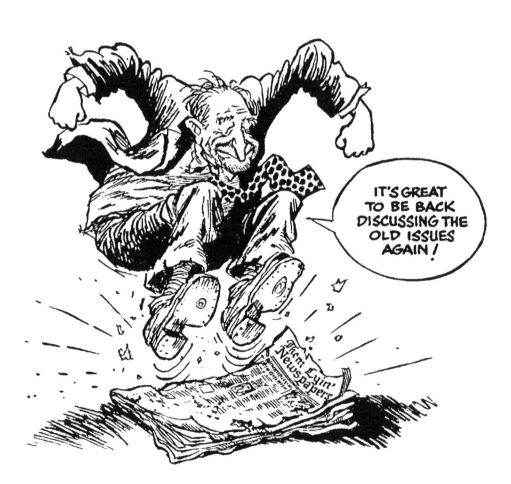

May 18, 1974

Newspapers weren't telling the truth about his record, Faubus said.

May 21, 1974

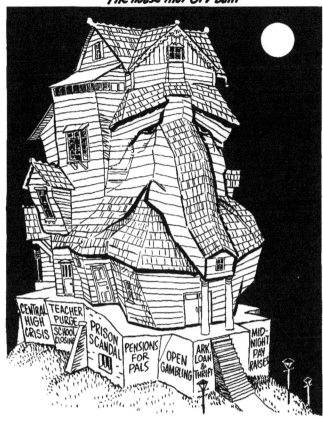

March 7, 1978

There was talk of Faubus running again, but he turned up in the camp of young Bill Clinton.

Rabbit Hole No. 2

FORGET, HELL!

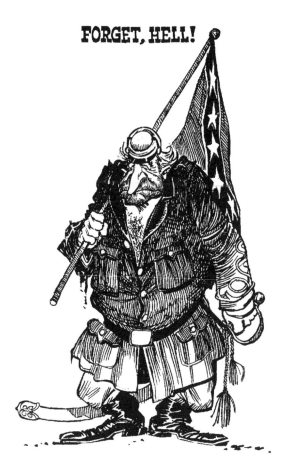

May 20, 1979

Faubus went on ABC's "Good Morning America" program and was unrepentant about his stand in 1957.

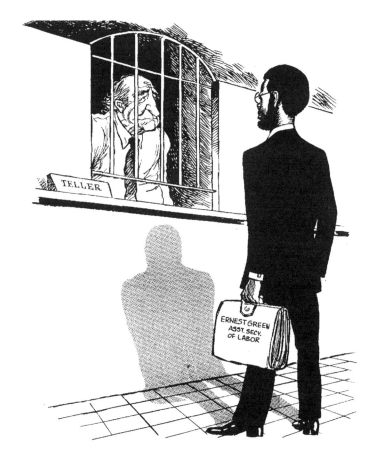

August 2, 1979

Faubus got a job as a teller at a one-room branch of the First National Bank of Huntsville just as Ernest Green, one of the Little Rock Central Nine, became assistant secretary of labor in the Carter administration.

Twenty years since 'Central High'

Let Freedom Ring!

 The United States never goes wrong when it makes freedom the premise of its policies, whether it is expanding liberty and opportunity for its people or pursuing policies to encourage foreign governments to expand the freedoms of their people. But, to our shame, it has not always been the impulse of our government—not even in the 1980s and 1990s.

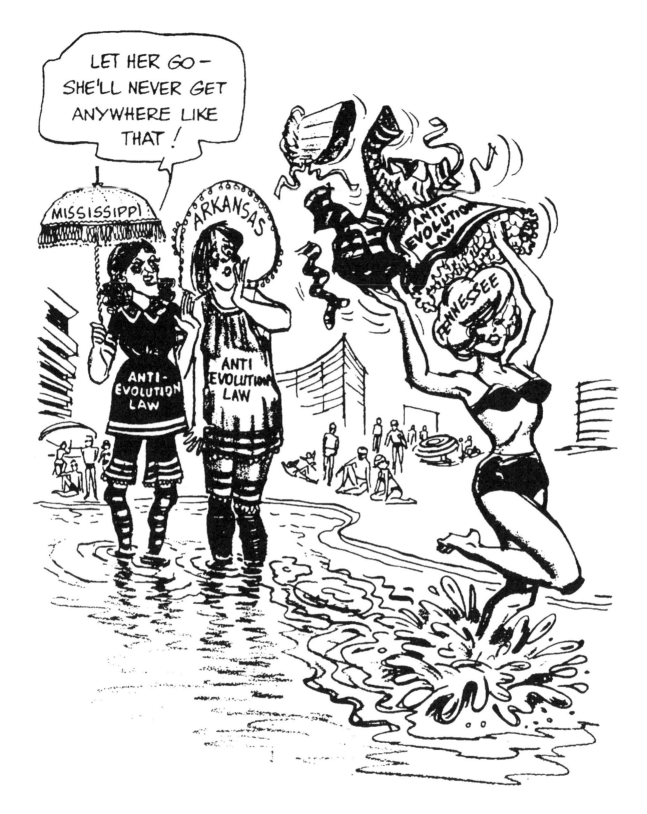

May 25, 1967

Tennessee repealed its anti-evolution law, leaving Arkansas and Mississippi as the only states forbidding the teaching of Darwin's theory of evolution in the schools.

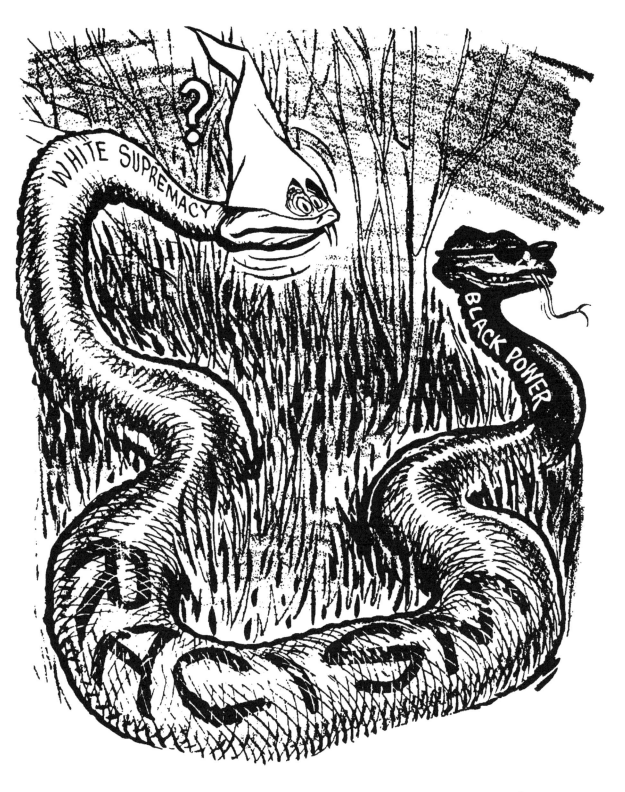

July 25, 1967

A few voices in the black-power movement sounded familiar themes.

17

August 1, 1968

The government was a passive collaborator of the racists.

August 27, 1978

Rip Van Winkle of the '70's

October 31, 1979

The struggle for the Equal Rights
Amendment for women was dying.

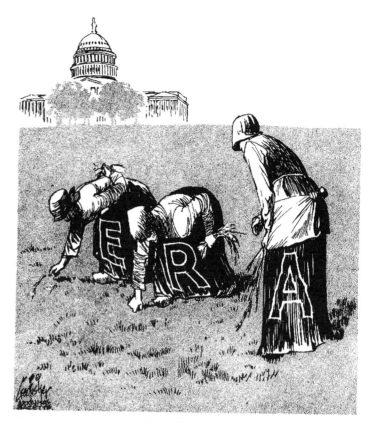

The Gleaners

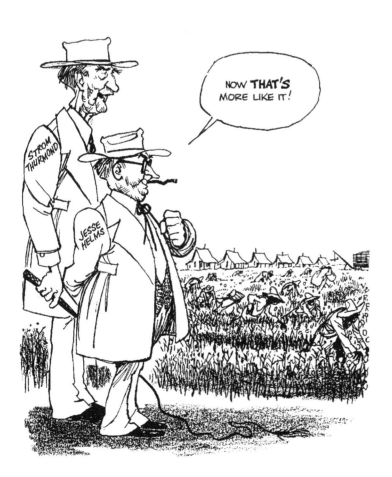

November 20, 1980

How You Gonna Keep 'Em Down on the Farm?

 After years of testimony in penitentiary appeals, a federal judge called the Arkansas prison "a dark and evil place" where men and women were brutalized and stripped of every shred of human dignity. That has been hard for Arkansawyers to reconcile with the popular notion that the prisons were country clubs for criminals. It has been harder still to reconcile their fear of crime and the fearful cost of "getting tough" on it. The legislature ordered up tough sentencing and rigid parole laws in 1977, and the cost of building and operating prisons has grown exponentially, becoming the fastest-growing item in the state budget. It has seemed that some day the state itself might become a walled prison. And, just think, we once operated our prisons for fun and profit.

January 4, 1968

Governor Winthrop Rockefeller imported a penologist, the state's first, to run Arkansas's scandalous prisons. The zealous Tom Murton would become famous beyond the state's borders.

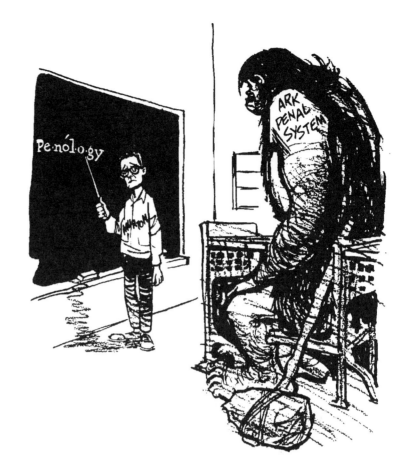

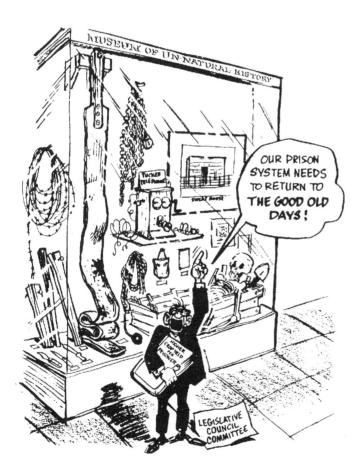

July 24, 1969

The fruits of prison reform dissatisfied legislators. Crop yields were down.

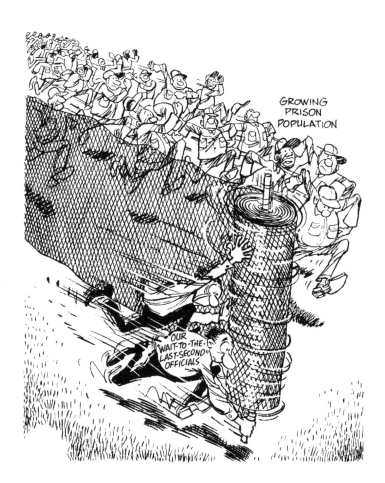

GROWING
PRISON
POPULATION

OUR
"WAIT-TO-THE-
LAST-SECOND"
OFFICIALS

May 12, 1977

The legislature enacted tougher sentencing laws, and the state couldn't keep up with the growth in inmates.

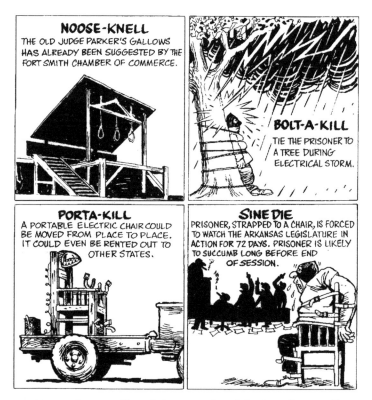

December 7, 1977

News Item: The Arkansas Legislative Council is concerned about the high cost of a new execution facility. (Here are some suggestions)

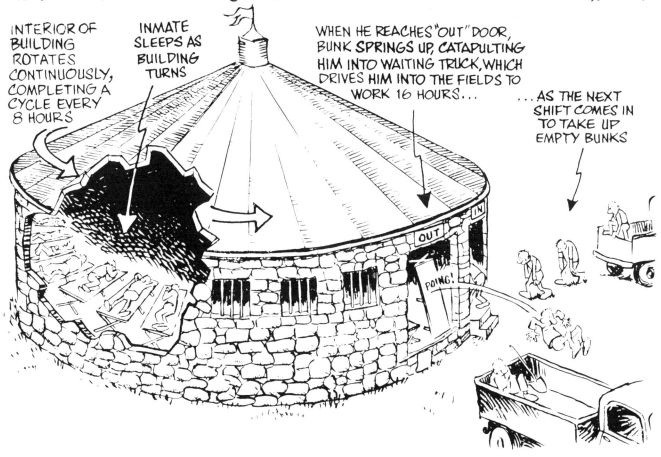

February 15, 1983

Everyone had ideas for scotching the phenomenal growth of the prisons, which was consuming a growing share of state taxes. This was mine.

23

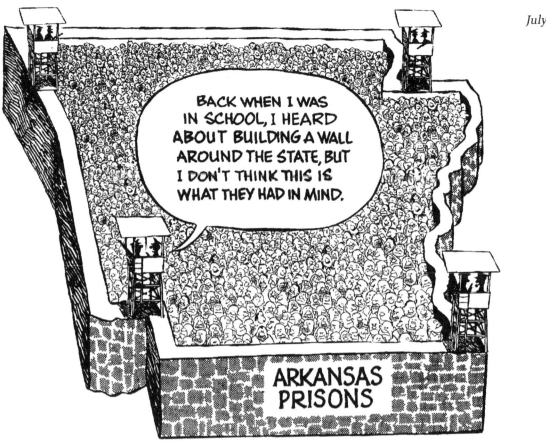

July 26, 1989

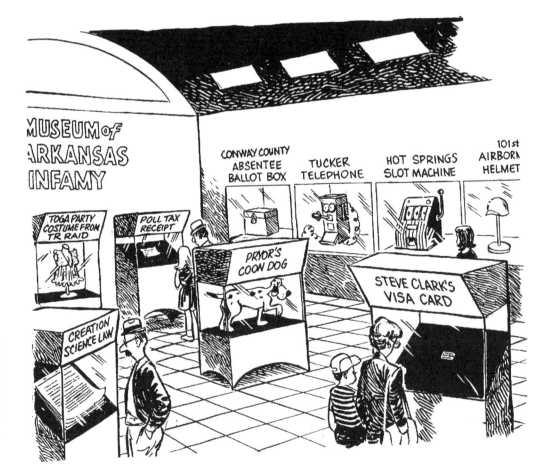

November 4, 1990

Attorney General
Steve Clark was
convicted of using
his VISA card for
lavish personal
entertainment.

The WR Legacy

Winthrop Rockefeller was the most improbable governor the people of any state ever elected, and he was chosen by the most improbable state. Arkansawyers trusted their politicians to live piously, flaunt their humble beginnings, carry themselves with rustic grace and keep their sights low but their rhetoric high. And they had to be Democrats. Rockefeller was a rich New York playboy, a resident of the state for only ten years when he first ran for governor, and a man so ungainly and shy that he could approach a microphone only after a few strong belts of vodka, and then what he had to say was unintelligible if he wasn't handed a text. Rockefeller became the first Republican governor since Reconstruction and laid out the most ambitious program—which required raising the state tax burden by half—ever proposed by an Arkansas governor. This unpolitician left little legislation but a state cleansed a little by his causes—social justice and education.

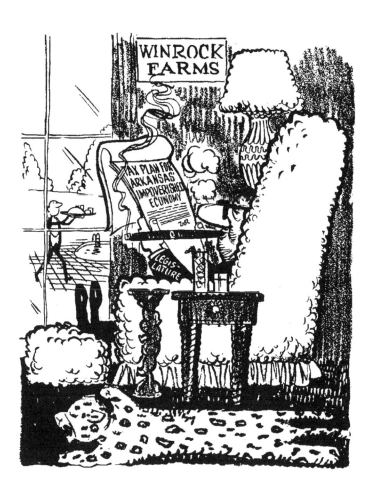

January 9, 1969

To win legislators over to his plan to raise the state's general taxes by 50 percent, Governor Winthrop Rockefeller invited them to his mountaintop mansion in small groups for food, drink, and instruction. It didn't work.

October 11, 1970

Rockefeller's brand of liberal Republicanism clashed with the national message espoused by Vice President Spiro Agnew, who was dispatched around the country to campaign for the Republicans.

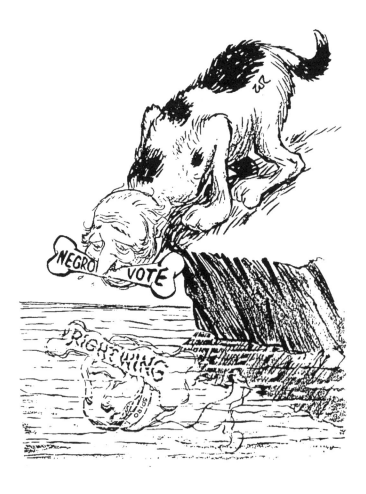

February 25, 1973

Two years after his defeat, Rockefeller died of cancer.

To The Least Of Us He Gave His Full Measure.

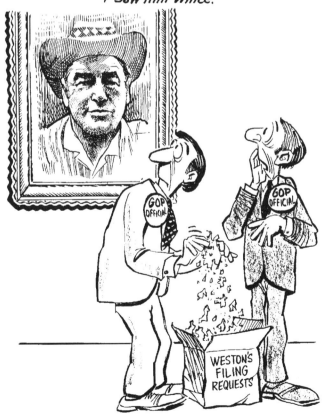

"I Know It Must Be My Imagination, But I Thought I Saw Him Wince."

April 16, 1974

The Republican party tried to keep an unorthodox country editor, Joseph Weston, from running for governor on its ticket.

David and Dale

The decade of the seventies was a high-water mark for Arkansas politics, but a low-water mark for political cartooning. A couple of sober reformers, Dale Bumpers and David Pryor, remade the Democratic party. Bumpers crushed the old political machine and the segregationists in the 1970 primaries and recaptured the governor's office from the Republicans. He whipped the legislature through a long agenda of education and bureaucratic and tax reforms and went to the U.S. Senate in 1975. Pryor, who followed him, made one serious misstep. To curry favor with local pols, he proposed the "Arkansas Plan," which was a nutty idea to cut state income taxes by 25 percent. He said it would allow people to vote higher taxes for local services. If they didn't want to spend their tax savings on local services, they could, he said in a memorable speech in Jonesboro, spend it on a new fishing rod or a new coon dog. The ill-fated scheme became the "Coon Dog Plan." The dog has never left Pryor's heels. The Coon Dog Plan went down in ignominious defeat, but Pryor rebounded and joined Bumpers in the Senate in 1979.

October 3, 1971

Lieutenant Governor Bob Riley chafed at the neglect of his office by Governor Bumpers. Bumpers sometimes neglected to notify Riley that he would be out of state, which made Riley the acting governor.

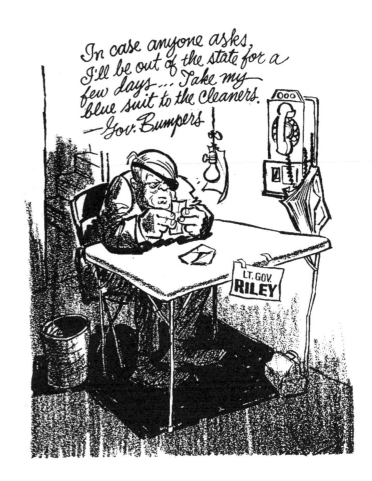

'Is It Rising or Setting?'

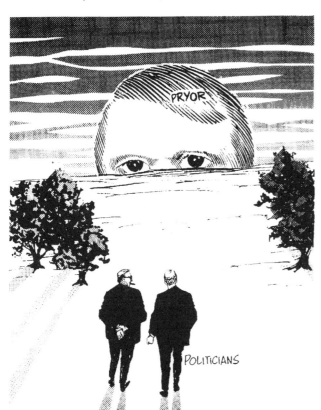

July 5, 1972

When Representative David Pryor lost a close race against Senator John L. McClellan in 1972, his career looked less than promising.

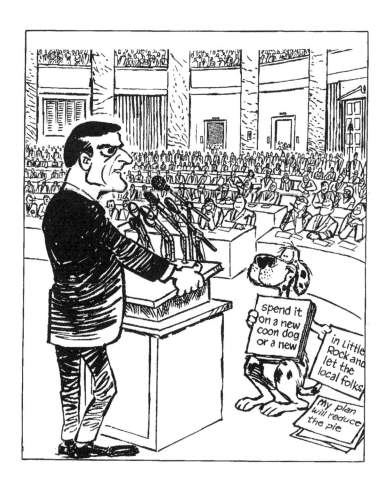

The Coon Dog Plan never caught on with the cities, schools, the public, or the legislature.

January 20, 1977

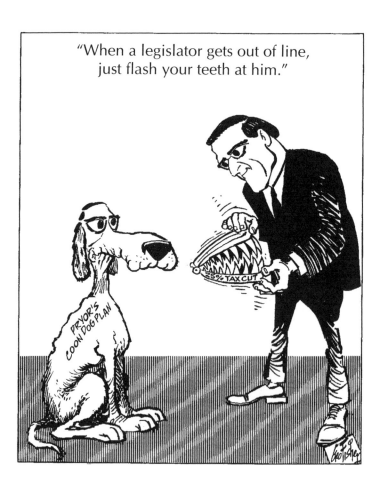

February 17, 1977

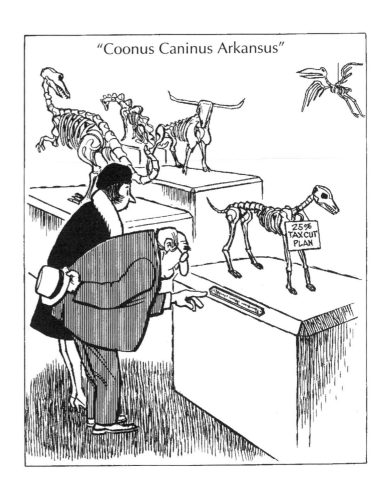

"Coonus Caninus Arkansus"

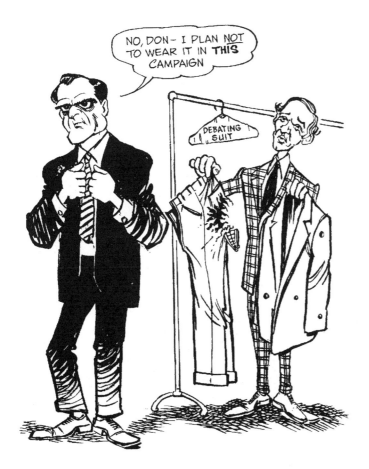

June 7, 1978

Remembering the disastrous debate with Senator McClellan in the 1972 Senate Democratic runoff primary, Pryor declined to debate Jim Guy Tucker and Ray Thornton, his chief opponents.

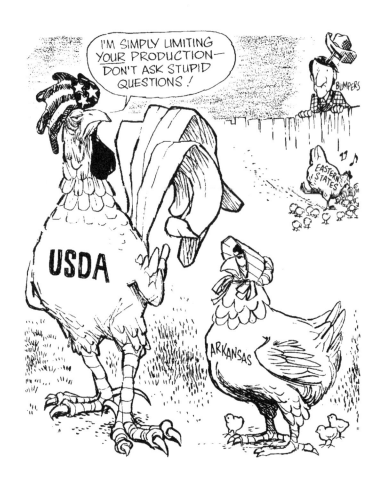

September 21, 1978

Bumpers went after the Agriculture Department when he found that federal regulations permitted faster processing of poultry in eastern plants than they did in Arkansas plants. It favored competitors to Arkansas poultry companies.

November 4, 1979

Without bidding, the Interior Department gave a Texas company drilling rights to thousands of acres of gas-rich land on Fort Chaffee near Senator Bumpers' home for one dollar an acre. Bumpers stopped the drilling, and the state eventually received millions of dollars from leases.

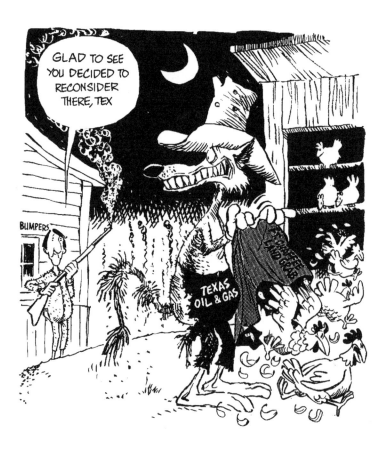

August 21, 1980

Bumpers and Pryor weren't overwarm in their support of the national ticket.

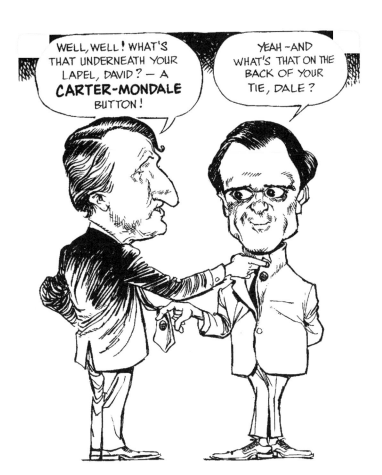

June 16, 1991

Bumpers fought for a dozen years to stop the no-bid leasing of federal lands for pennies to speculators and mining companies in western states. He never succeeded.

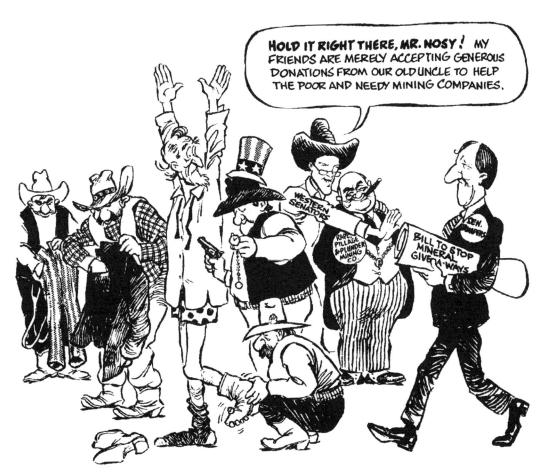

Rotten to the Corps

 Americans are enthralled by the idea of progress, but often it is only mindless material change. Whole federal agencies are its servants—the Army Corps of Engineers to the damming and dredging of free-flowing streams, the U.S. Forest Service to the turning of national forests into coniferous farms for the wood-products industry. Sometimes I've had suspicions about the Environmental Protection Agency, the Soil Conservation Service, and the National Park Service. State agencies are little better and sometimes much worse—the state Pollution Control and Ecology Commission leaps to mind.

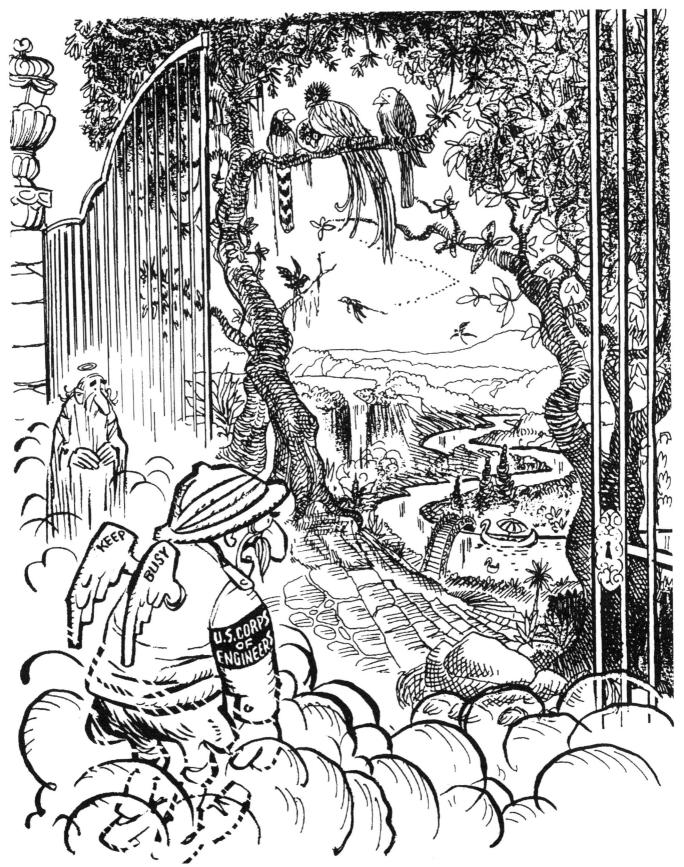

"Where's Your Drafting Department? This Place Is A Mess."

November 16, 1971

35

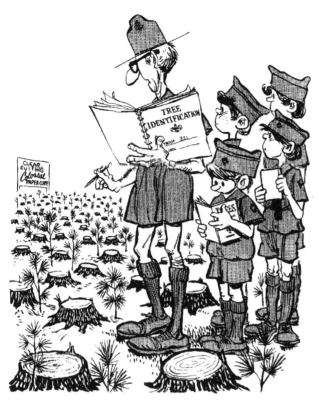

June 7, 1972

"That One Over There Was A White Oak—
This Was A Silver Leaf Maple—
That One Was A . . ."

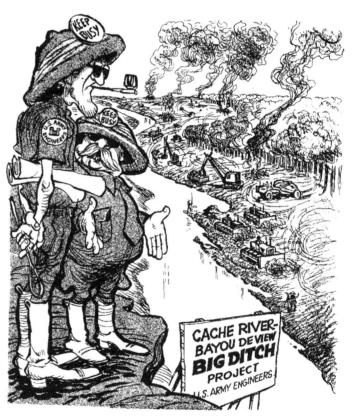

July 27, 1972

"God Would Have Done It In The
First Place If He'd Had The Money."

December 19, 1972

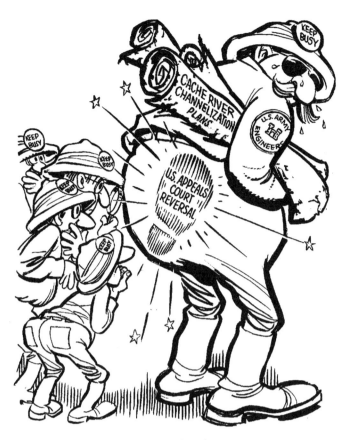

Impact Study

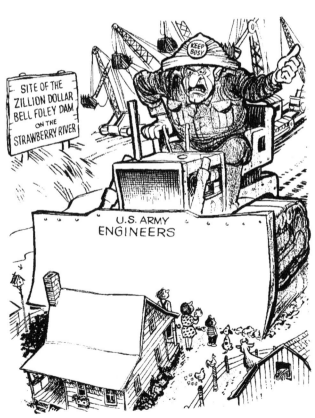

"You Heard Me—Clear Out! We're Flooding
This Land To Prevent Land Flooding!"

February 28, 1974

"Well, There Goes The Neighborhood."

July 7, 1974

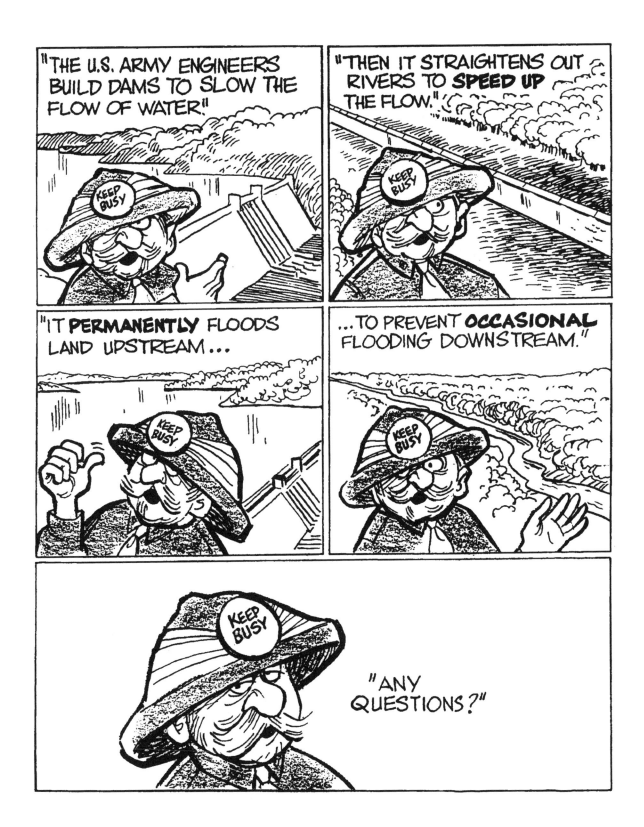

September 1, 1974

April 29, 1975

"But We Only Want To Pollute
This Small Area."

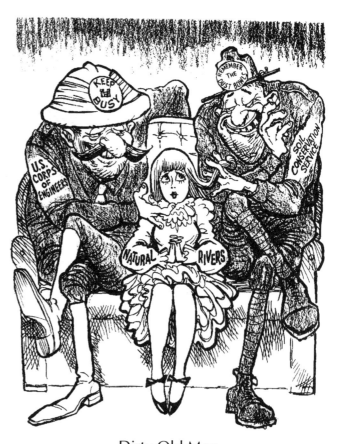

February 15, 1976

Dirty Old Men

August 31, 1976

"You're more apt to catch a dead chicken."

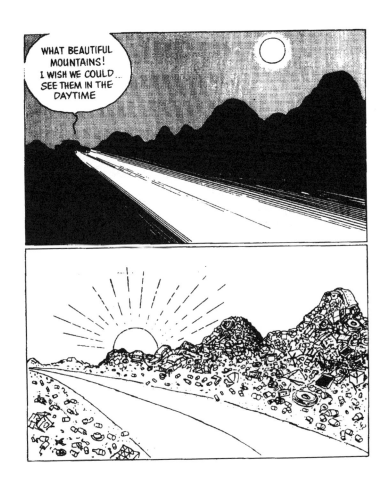

March 27, 1977

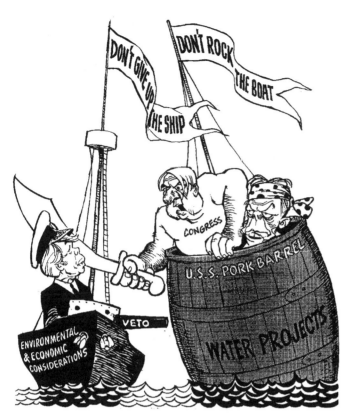

May 25, 1977

"You wanna go down in history as
a great president or not?"

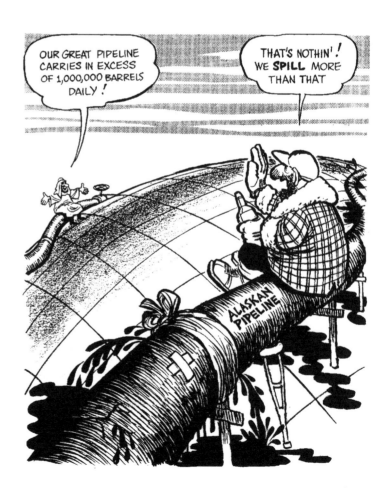

August 18, 1979

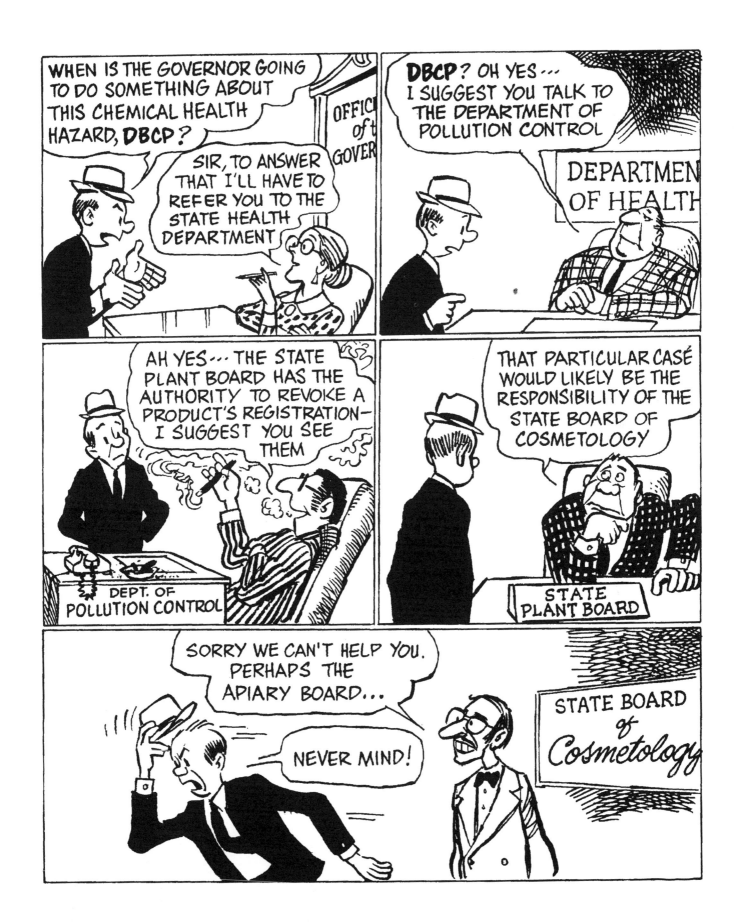

August 28, 1977

April 13, 1978

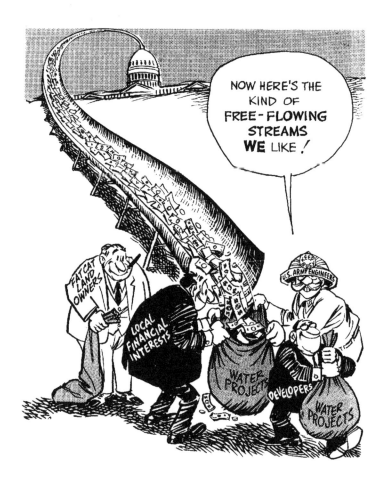

November 23, 1979

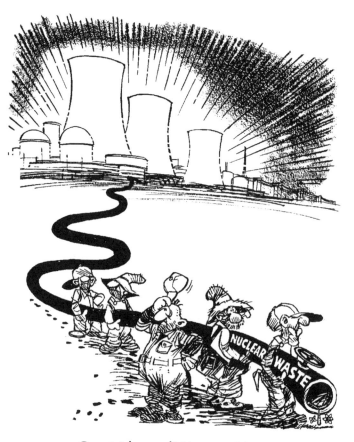

Great Ideas of Western Man

44

April 16, 1989

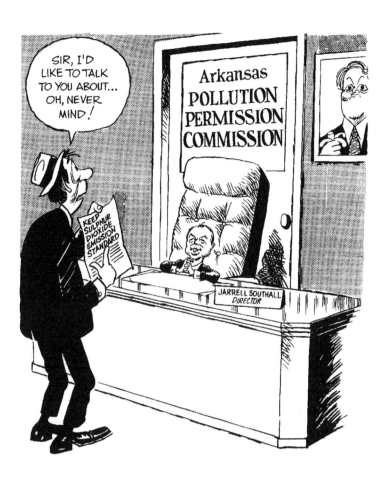

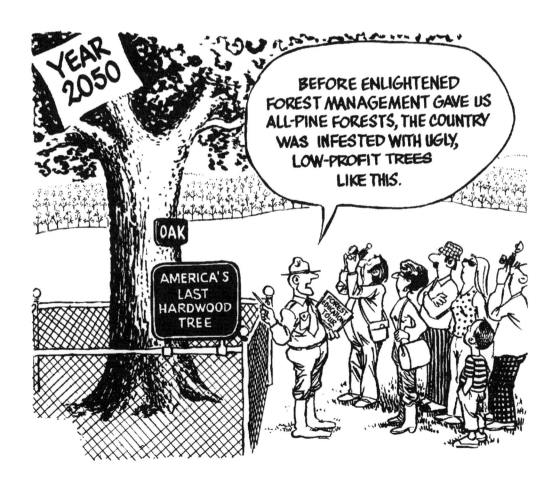

December 10, 1987

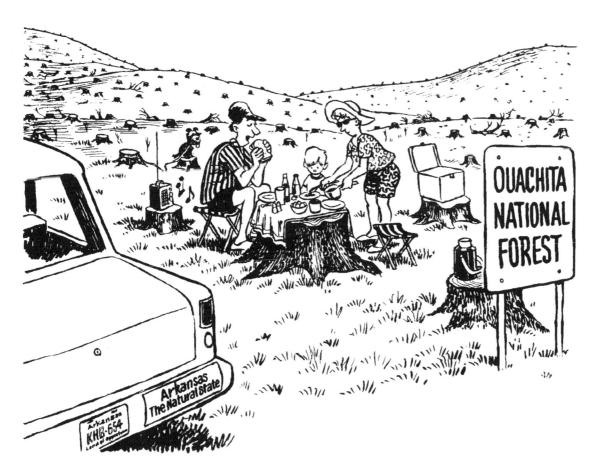

June 14, 1989

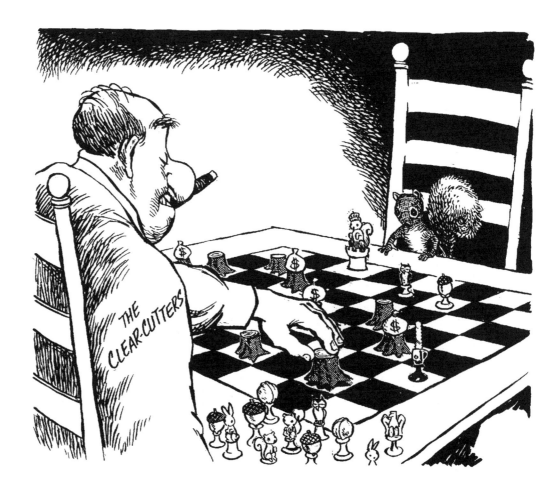

August 3, 1989

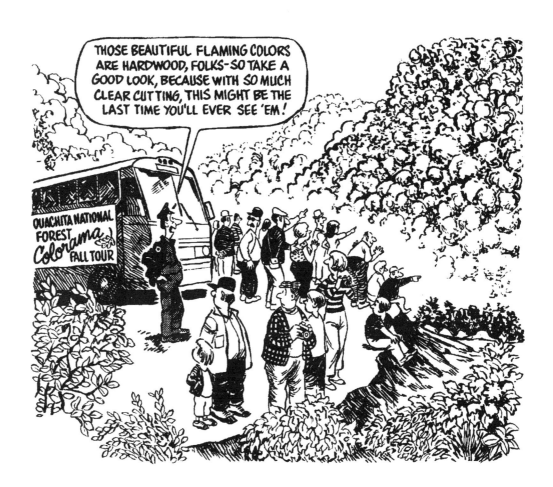

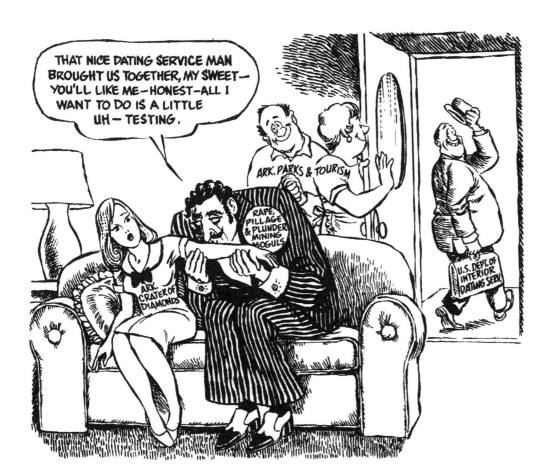

November 29, 1989

Say Uncle

 The bitter experience of Vietnam—the deceptions by U.S. leaders, the division over the worthiness of the cause, the horrors of the war itself, and, finally, defeat—changed Americans' view of their role in the world. But Ronald Reagan and George Bush rediscovered something about war. It could be an antidote to the political blues. Whenever Reagan and Bush slumped badly in the polls, they sent American troops into war zones or created war zones. The country will always rally around the boys (and the commander in chief), and the presidents zoomed in the polls after the invasions of Grenada, Panama, and Kuwait.

President Nixon talked about peace but
stepped up the bombing.

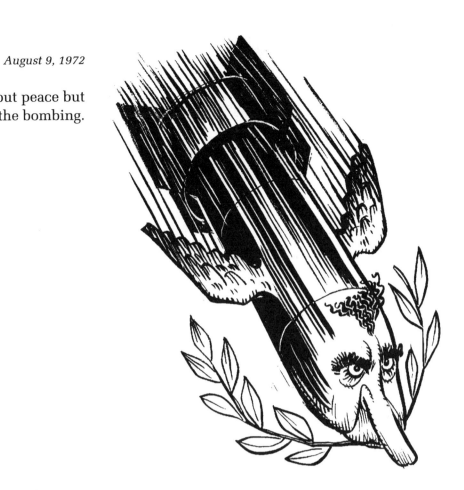

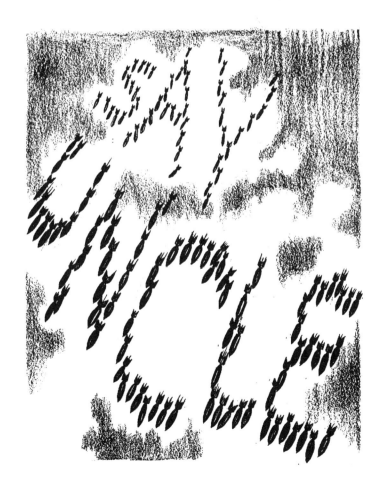

November 8, 1972

"Yeah—But What Have You
Done For Me Lately?"

January 21, 1975

President Thieu of South Vietnam complained
that the United States didn't do enough.

February 11, 1975

After U.S. forces pulled out and the
South Vietnamese regime was collapsing,
President Ford appealed for more aid to
save South Vietnam.

"Our Involvement Will Be Limited To . . ."

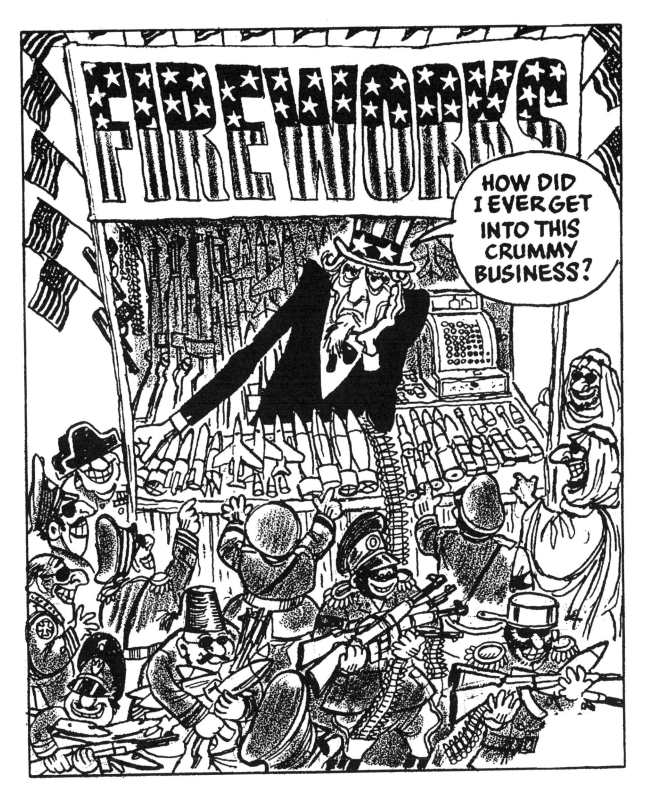

July 13, 1976

The United States was the chief supplier of
weaponry to military regimes around the world.

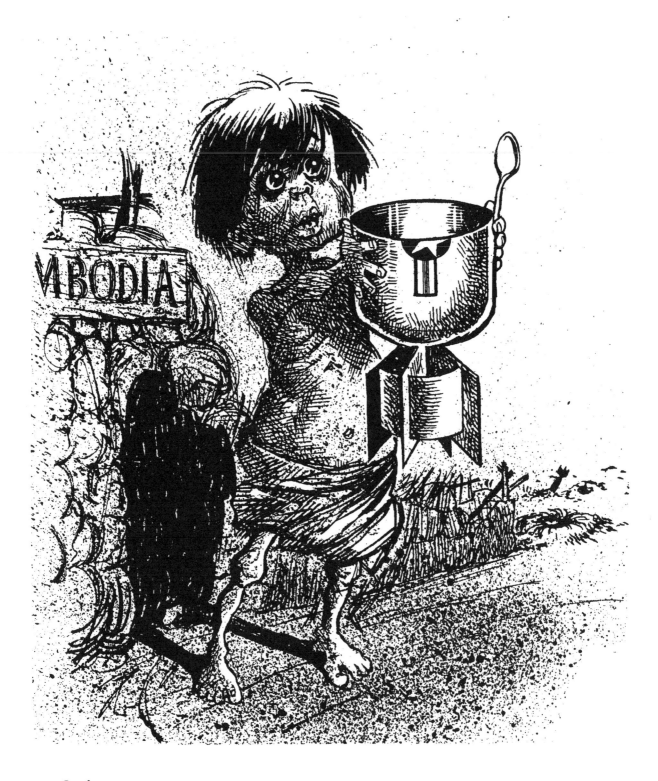

October 23, 1979

In poor Cambodia, the war was nothing compared with its aftermath.

September 25, 1980

Iran and Iraq began a bloody war that lasted for most of the decade.

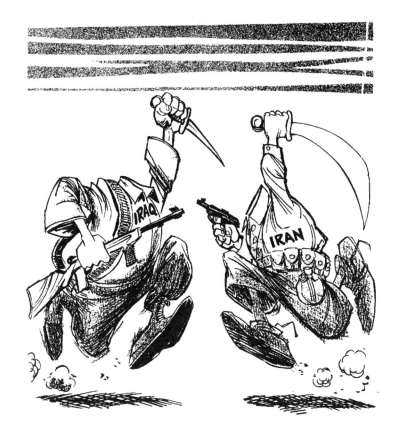

Underdeveloped Nations

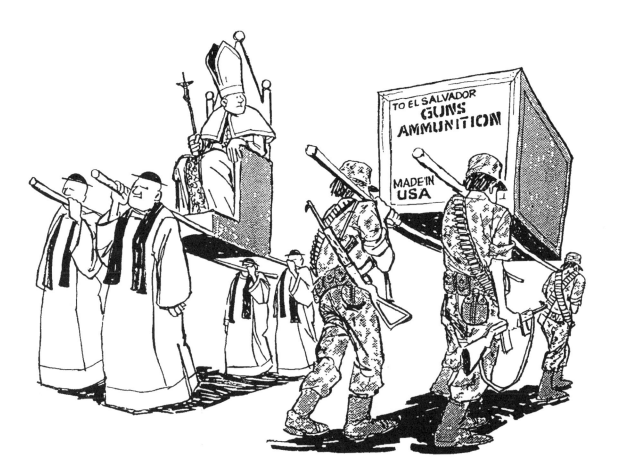

March 9, 1983

The Pope went to Central America to preach peace.

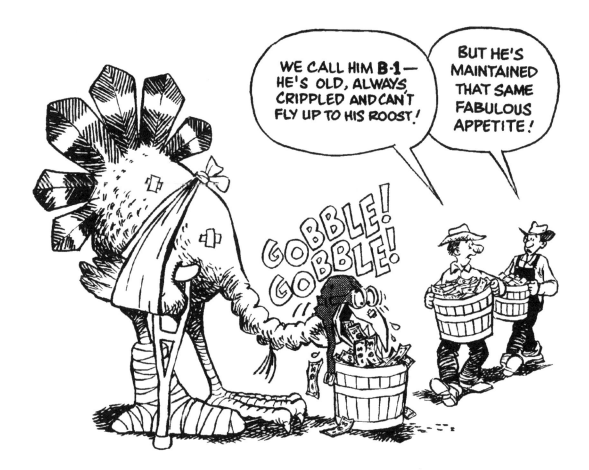

November 25, 1988

The B-1 bomber was obsolete before its production began, and it was a failure in maneuvers, but Congress and the president kept funding it.

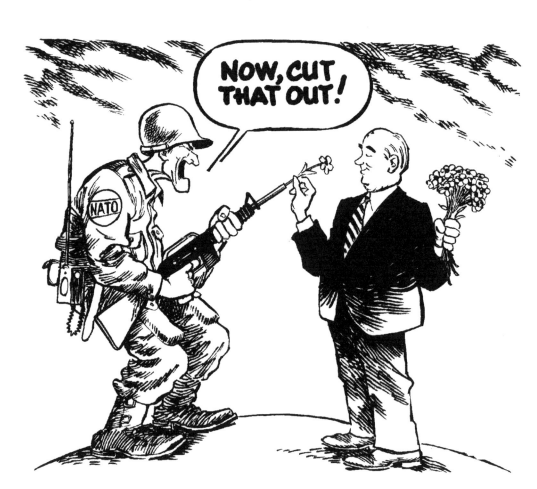

May 26, 1989

The West just couldn't believe Mikhail Gorbachev was serious about rapprochement and arms reduction.

July 18, 1990

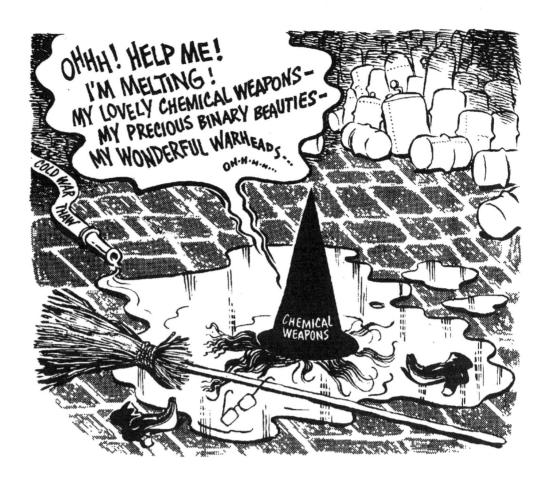

PRIVATE

COMPANY COMMANDER

REGIMENTAL COMMANDER

DIVISION COMMANDER

ARMY COMMANDER

COMMANDER-IN-CHIEF

August 28, 1990

While American forces deployed to the Middle East to liberate Kuwait from Saddam Hussein, the president vacationed in Kennebunkport.

Nearly the whole world embargoed commerce with Iraq while growing allied forces assembled in Saudi Arabia.

October 26, 1990

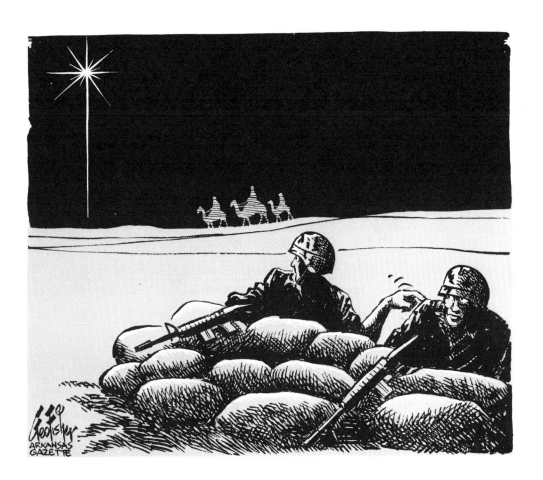

December 25, 1990

Christmas Day in
the Arabian desert.

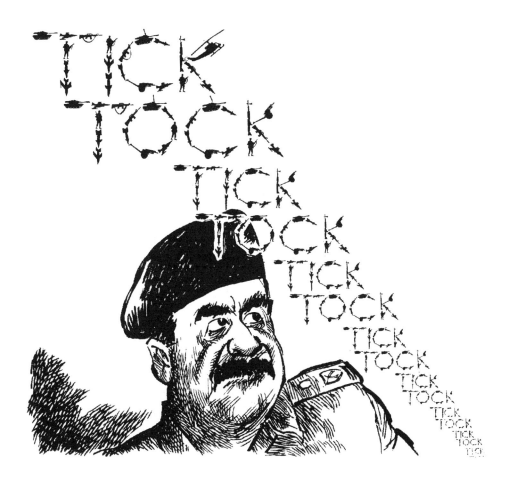

January 15, 1991

January 15 was the dead-
line for Saddam Hussein
to withdraw his forces
from Kuwait.

57

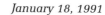

The allied forces
struck.

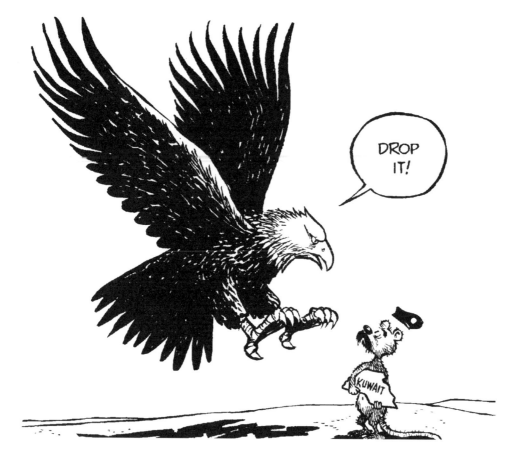

April 5, 1991

His nation
prostrate, Saddam
still survived.

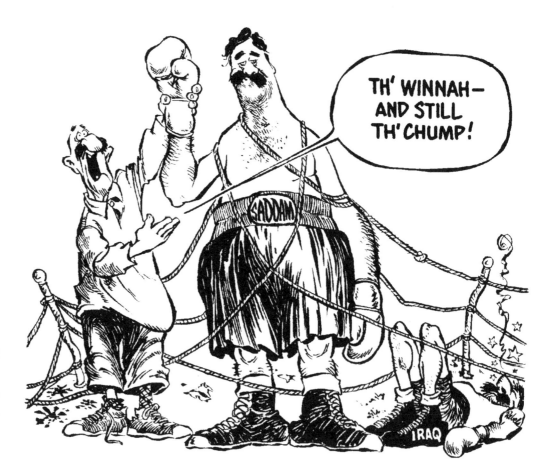

58

May 1, 1991

Reporters com-
plained about the
restrictions on
press coverage of
the war.

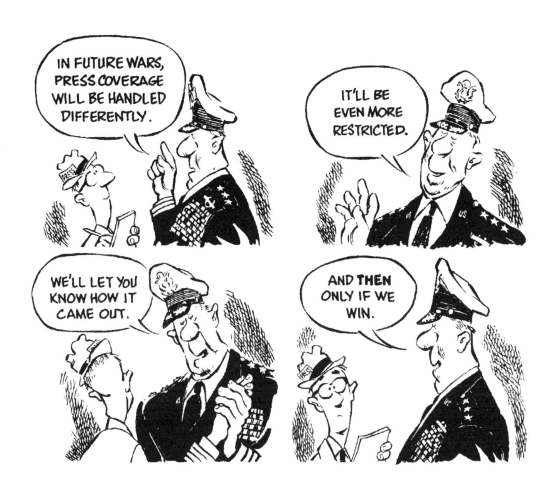

August 30, 1991

(R)EVOLUTION IN HAITI

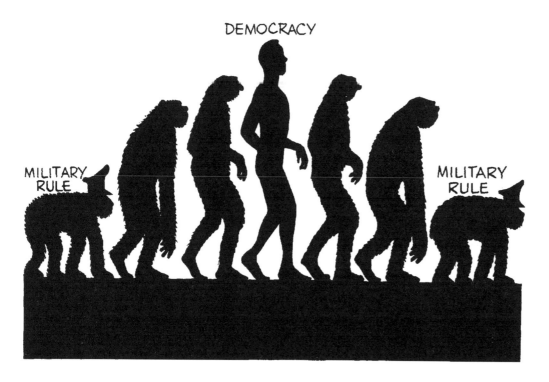

DEMOCRACY

MILITARY RULE

MILITARY RULE

October 8, 1991

We celebrated democracy in Haiti too soon.

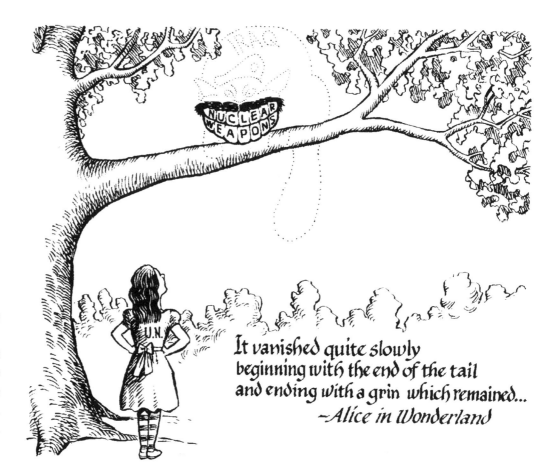

NUCLEAR WEAPONS

U.N.

It vanished quite slowly beginning with the end of the tail and ending with a grin which remained...
~Alice in Wonderland

October 10, 1991

United Nations inspectors were having trouble locating Iraqi nuclear works.

Mommy, They're Back!

The Arkansas Constitution requires the people to abide the state legislature for sixty days every two years—longer if it screws up the state's business too badly, which it regularly does. "Deliberative" does not describe a session of the legislature. In about fifty working days, the legislature disposes of about 2,000 bills, and it turns about 1,200 of them into laws that Arkansas must live by. Few other legislative bodies on earth match its quantitative production, but superlatives don't describe the quality.

"Us Gals Has Got To Stick Together."

December 31, 1972

State Representative Paul Van Dalsem of Perryville, who had enraged women in 1964 with his remark that they handled uppity women in his county by giving them a cow to milk and keeping them barefoot and pregnant, turned up as a cosponsor for the Equal Rights Amendment for women.

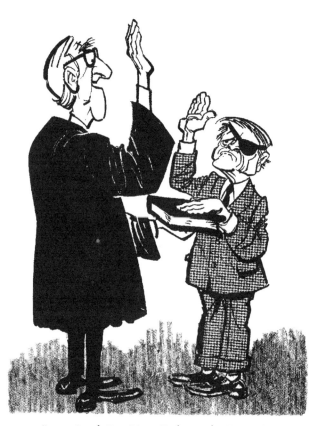

January 1, 1975

When Governor Dale Bumpers resigned to be sworn in early as a United States senator, Lieutenant Governor Bob Riley got to be governor for a few days.

". . . And Do You Solemnly Promise To Do Absolutely Nothing."

March 2, 1975

Legislators expressed alarm at the growing number of community colleges, which sapped the state's meager resources for education, but they couldn't resist voting for any particular legislator's college.

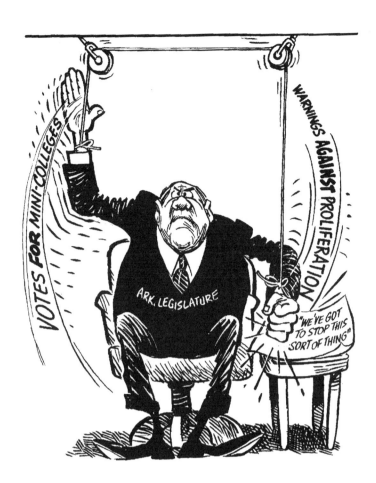

May 11, 1975

The legislature authorized a convention to rewrite the state's outmoded constitution, but the Arkansas Supreme Court found a technicality and struck down the act.

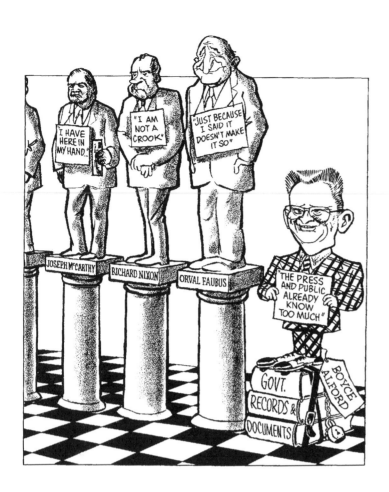

February 25, 1977

State Representative Boyce Alford of Pine Bluff had a penchant for inapt remarks. His classic was in a debate on freedom of information.

March 10, 1977

Legislators were always complaining that the most powerful members, those who made up the Joint Budget Committee, were too powerful because they wrote all the appropriations and frequently channeled the money to their own districts.

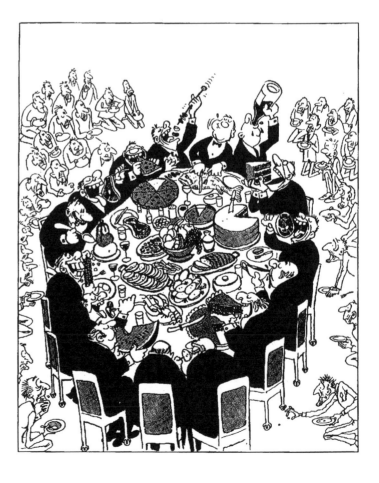

July 14, 1977

Under the state constitution, the Highway Commission is independent of the governor, the legislature, and the people.

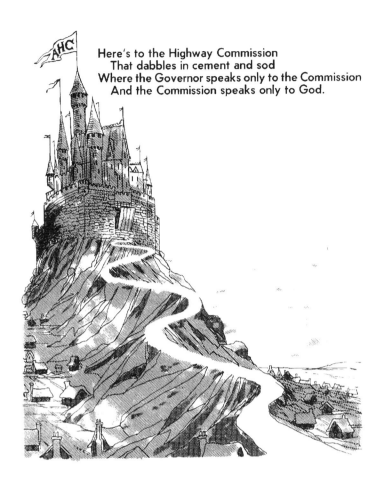

July 26, 1977

Governor Pryor persuaded the legislature to pass a tax to prevent highway litter, but it proved to be so unpopular that he had to call a hasty special session to repeal it.

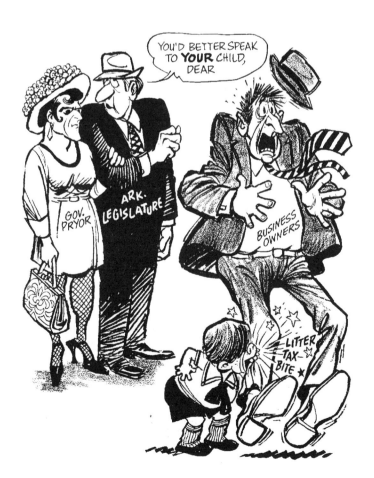

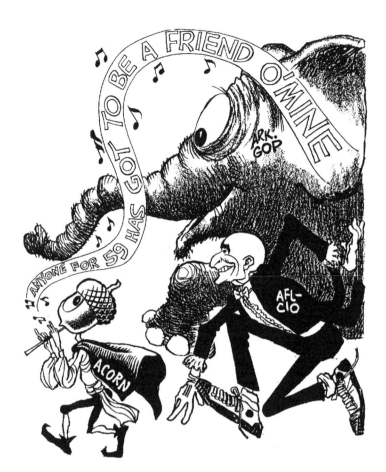

November 5, 1978

A constitutional amendment to exempt groceries from the sales tax attracted unusual allies: ACORN (Arkansas Community Organizations for Reform Now), an activist group for the poor; organized labor; and the state Republican party. Voters defeated it.

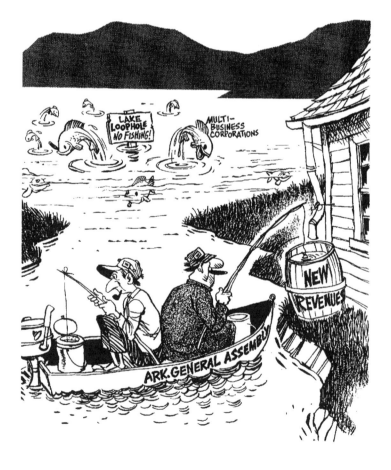

March 14, 1979

The legislature was looking for new tax sources, but it wouldn't touch an obvious one, tax loopholes for special interests, including a fat one enacted in 1977 that allowed multi-business corporations to avoid taxes on profitable operations by combining their tax reporting with losing ventures.

July 6, 1979

The Constitutional Convention debated whether it ought to recommend ending the constitutional autonomy of the Highway and Game and Fish commissions but chose not to.

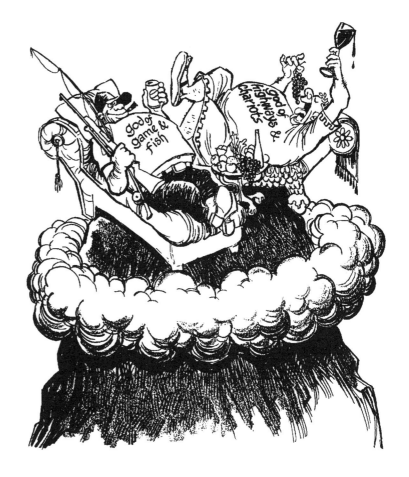

How to Build an Elephant House in Arkansas.

April 8, 1980

The Republicans had plenty of people who wanted the big offices but few who wanted to seek office on the local level.

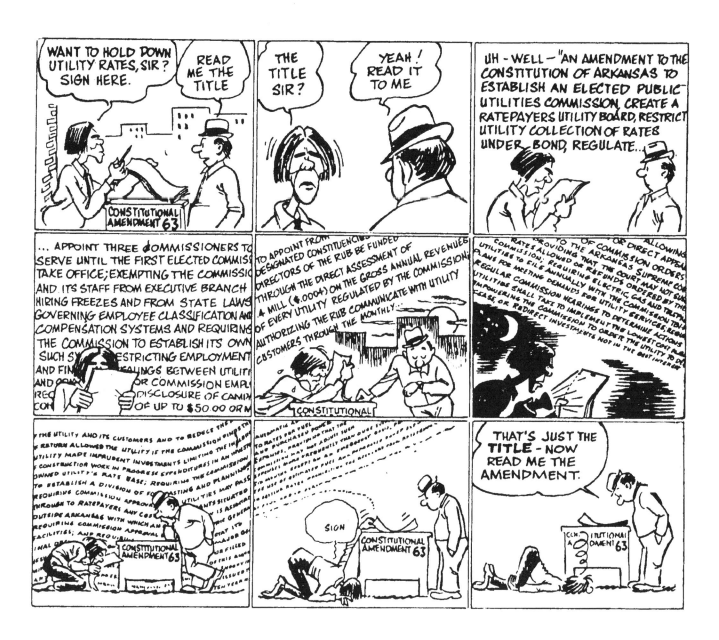

August 22, 1982

Groups seeking tougher utility regulation drafted a constitutional amendment that was nearly ten thousand words long. The Supreme court subsequently said it was too confusing and struck it from the ballot.

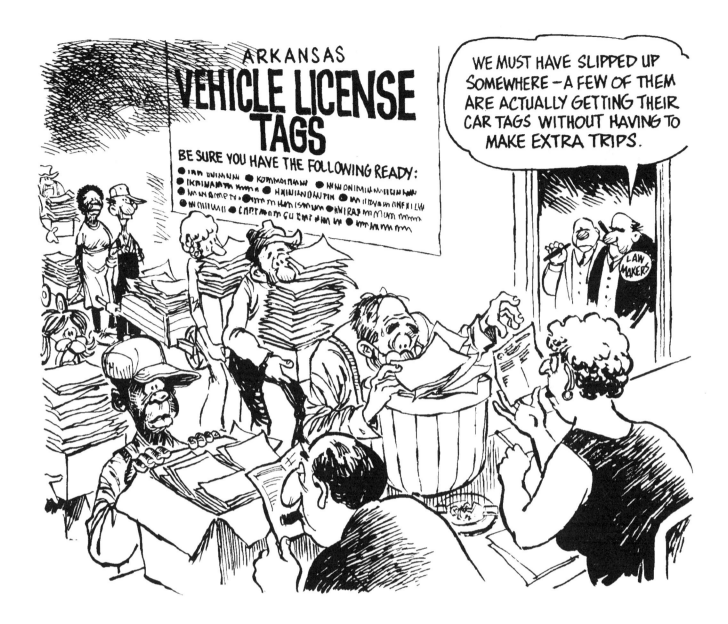

August 6, 1987

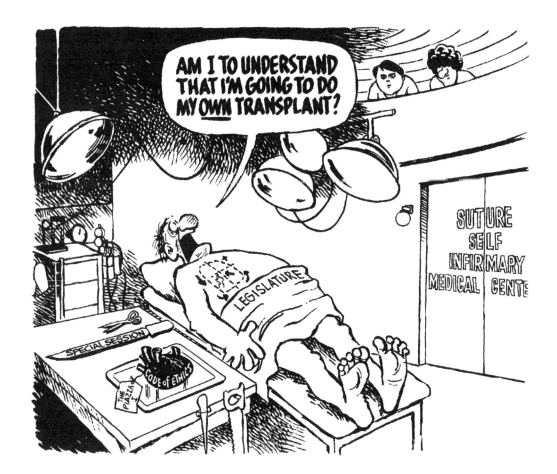

January 17, 1988

Governor Clinton called the legislature into session to pass an ethics bill to regulate the behavior of legislators and lobbyists. To no one's surprise, the legislature made a mess of it and the voters had to do it with an initiated act.

March 8, 1988

The Arkansas Constitution favors special interests by requiring a three-fourths vote to pass taxes that fall mostly on corporations and the rich but only a simple majority to raise the sales tax. Fair-tax groups started a petition drive to change it.

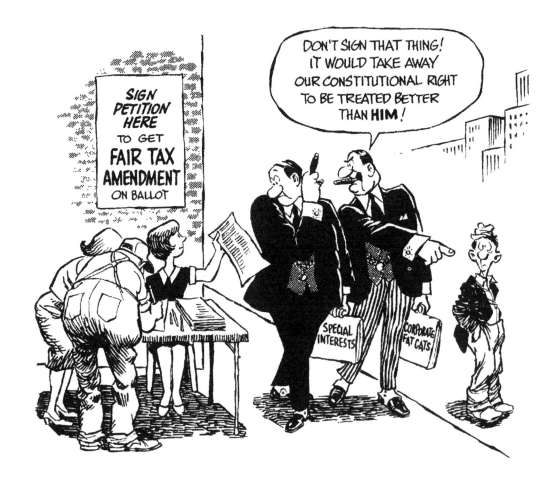

October 25, 1988

The state Board of Correction ended a policy of allowing high prison officials to get free groceries out of the prison food lockers. Senator Knox Nelson, a patron of the prison superintendent, Art Lockhart, later got the emoluments restored.

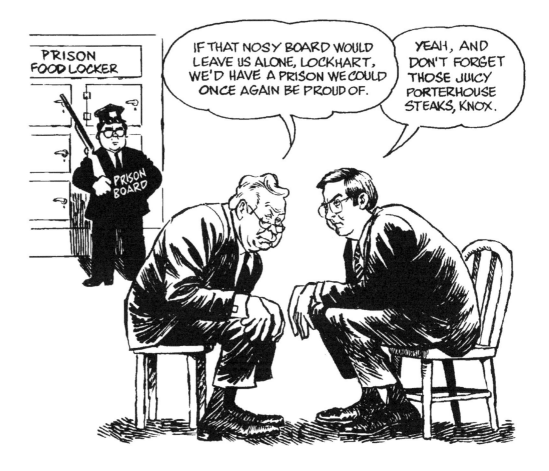

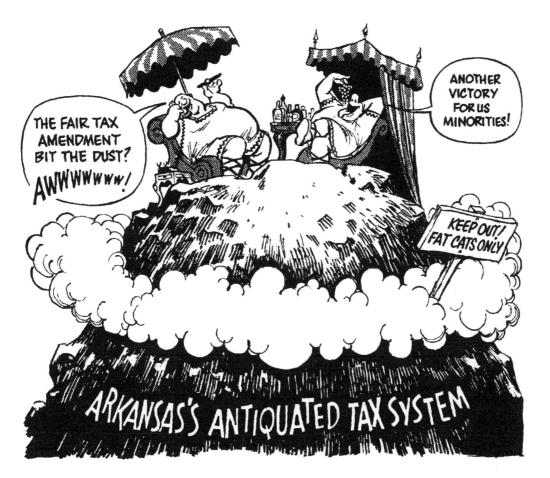

November 13, 1988

A 1934 constitutional amendment allows a tiny minority in the legislature to block tax increases, which lets special interests set the state's tax policies. Business interests defeated a proposed amendment that would have changed it.

71

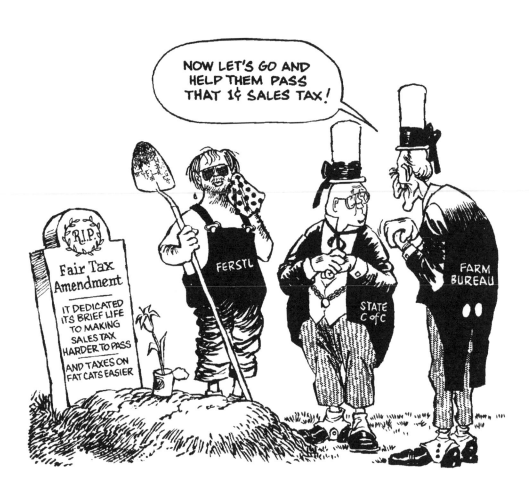

January 5, 1989

Monied interests defeated the fair-tax amendment, clearing the way for an increase in the sales tax.

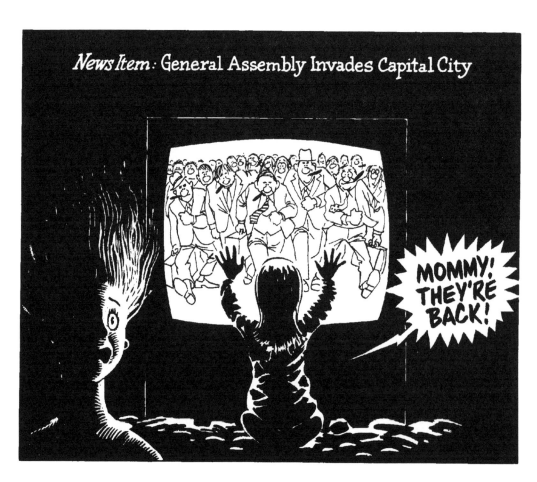

January 8, 1989

February 12, 1989

The legislature in quick order drastically slashed taxes on the horse-racing track, extended the racing season at the dog track, and fattened their own perquisites.

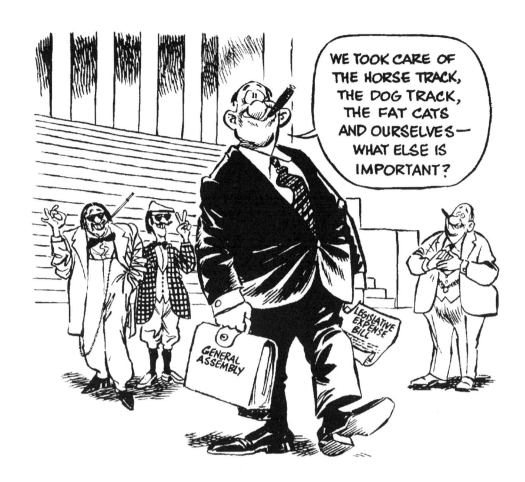

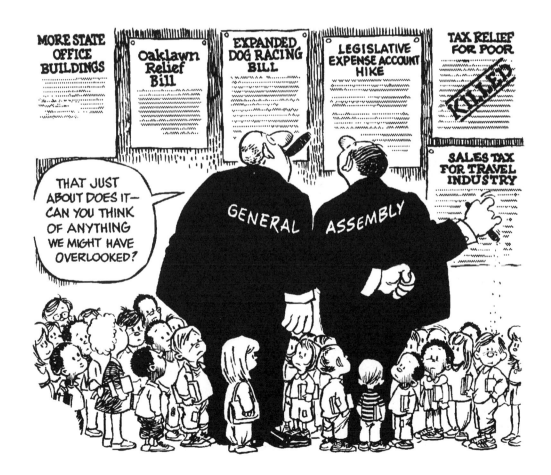

February 24, 1989

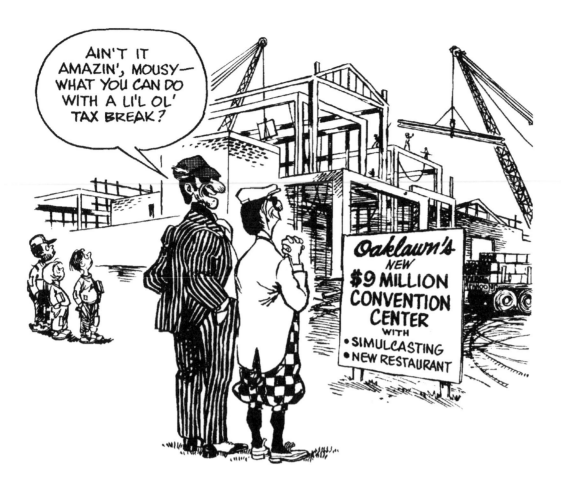

Changing of the Guard

April 18, 1989

The Arkansas Poultry Federation always keeps a senior legislator on its payroll to manage its interests in the Arkansas General Assembly. Senator Joe Yates of Bentonville took over the job from Representative L. L. "Doc" Bryan of Russellville.

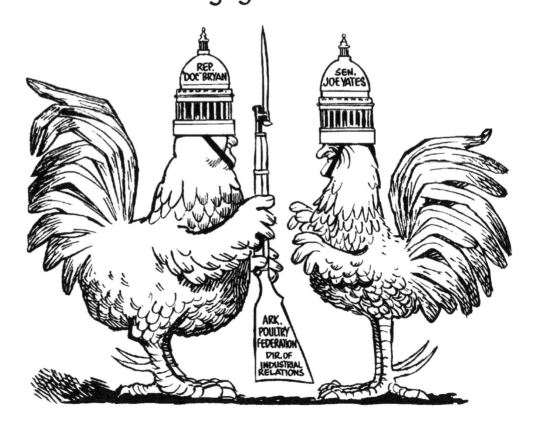

May 16, 1989

Lottery supporters prepared to put a lottery amendment on the ballot by promoting it as an antidote to taxes.

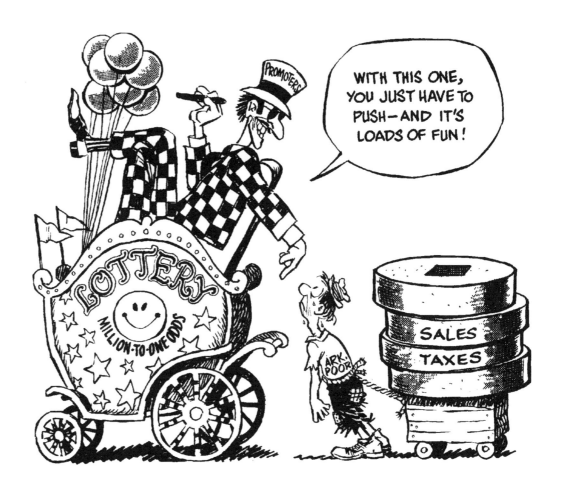

June 27, 1989

The legislature kept coming back into session to straighten out the messes it had created.

July 19, 1989

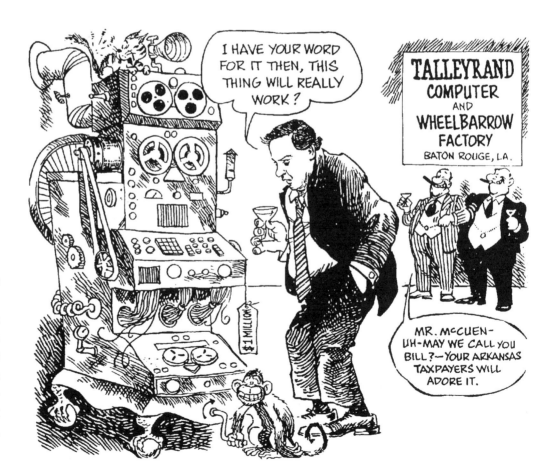

September 22, 1989

Some Louisiana
promoters sold
Secretary of State
W. J. McCuen a
$1 million com-
puter system that
never worked.

The Arkansas Industrial Development Commission didn't want to let anyone see its records on recruitment of an industrial prospect.

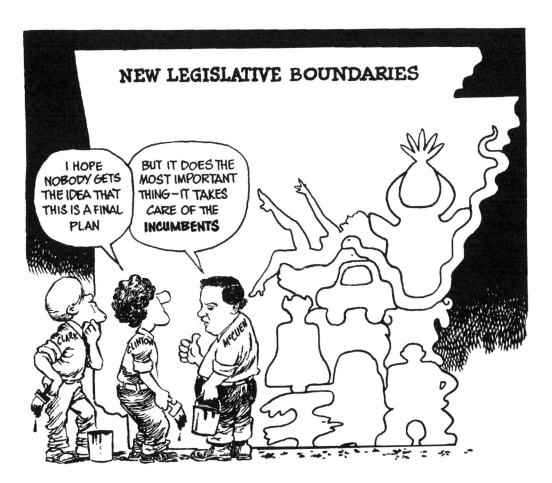

January 10, 1990

The Board of Apportionment began drawing the new boundaries for state legislative districts.

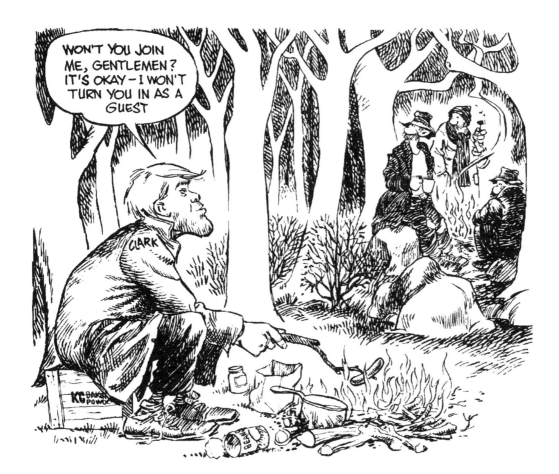

February 7, 1990

Attorney General Steve Clark got caught by the *Gazette* padding his expenses by charging the state for lavish meals and listing as business guests people who weren't there.

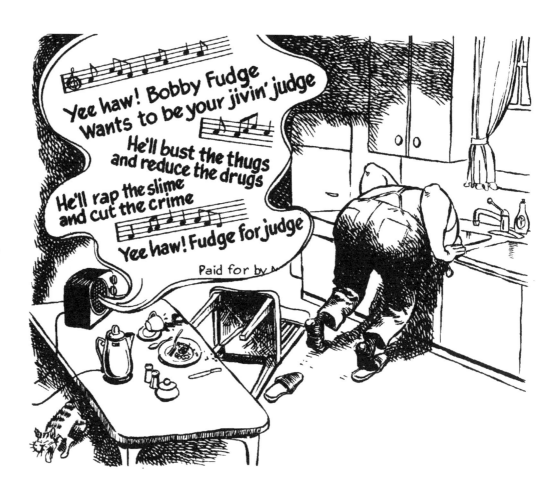

May 16, 1990

It became the political wisdom in Little Rock that no one could be elected to local office, particularly that of judge, without a discordant jingle.

September 9, 1990

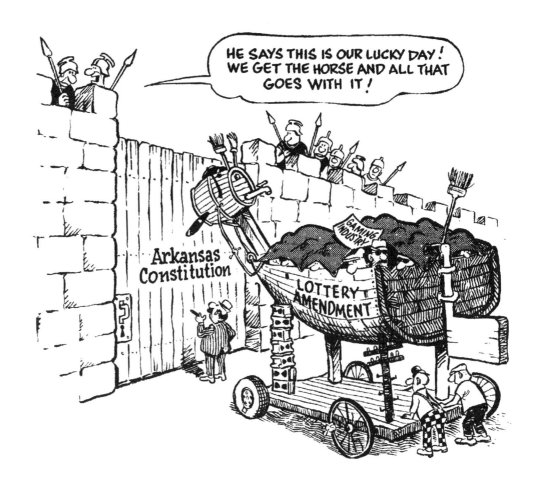

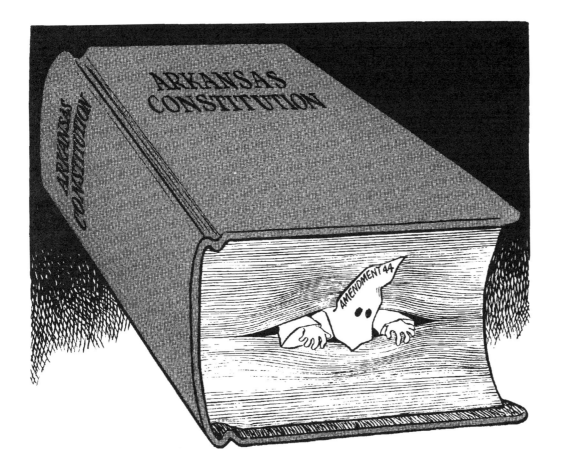

September 27, 1990

The state kept getting embarrassed, and sometimes financially hurt, by Amendment 44, a 1956 constitutional amendment that instructed state officials to resist federal court rulings requiring racial integration. The voters repealed it in 1990.

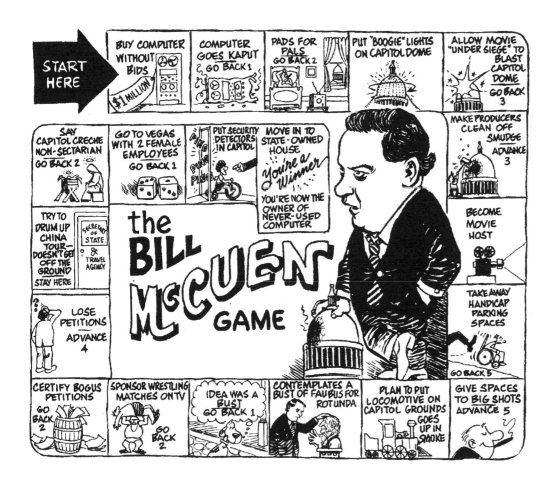

February 7, 1991

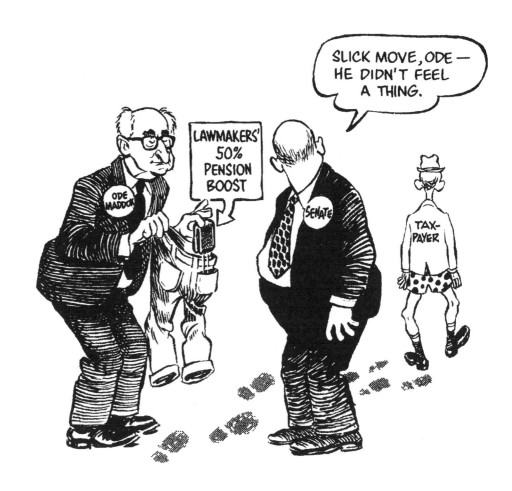

February 17, 1991

March 7, 1991

The legislature raised lots of taxes, but none of it was for aging services. The agencies on aging eventually banded together and passed their own little tax.

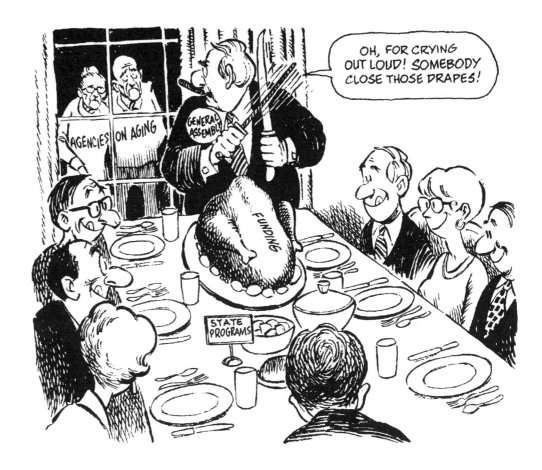

March 21, 1991

Arkansas was (and remains) about the only state without a civil rights law. Legislators saw a civil rights bill introduced by liberals and backed by Governor Clinton as an invasion of the rights of businessmen. They defeated it.

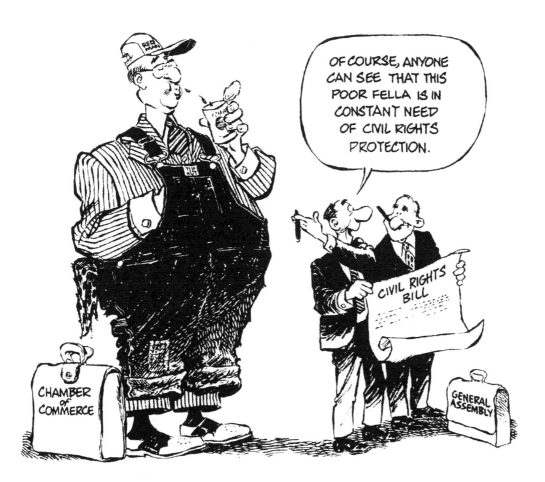

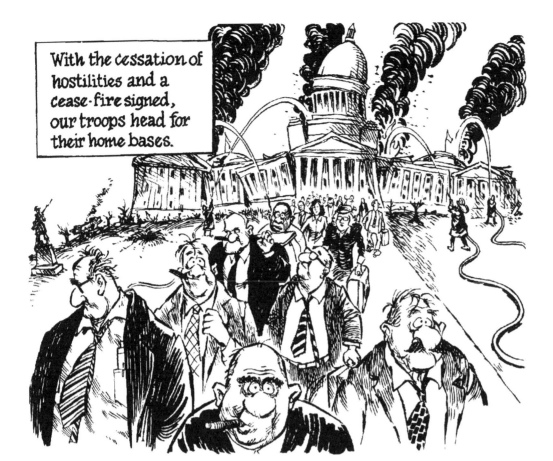

With the cessation of hostilities and a cease-fire signed, our troops head for their home bases.

The legislature adjourned about the time that the war in Iraq ended.

May 2, 1991

The secretary of state spent the spring gallivanting around the country with two female employees at public expense.

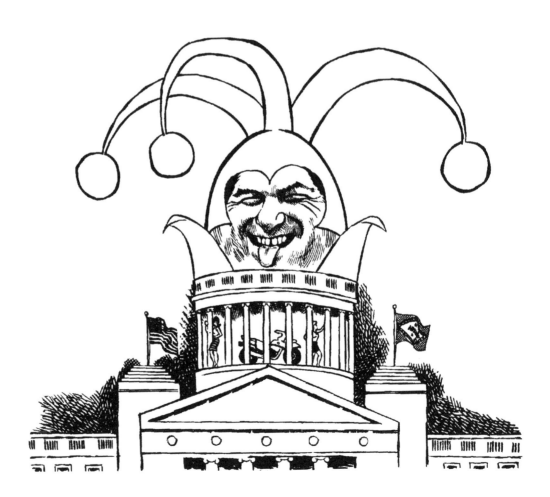

They Never Change Their Act

The people of North Little Rock take city government seriously, but a latent virus breeds on the plaster and marble at the old City Hall and foils all their impulses. The voters regularly turn out their mayors and aldermen and install progressive-sounding successors, but before long the new officials are back at the old stand, offending good taste, judgment, propriety, and sometimes the law.

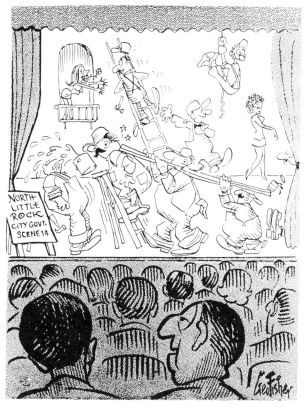

January 30, 1973

"Year in, year out—
They never change their act."

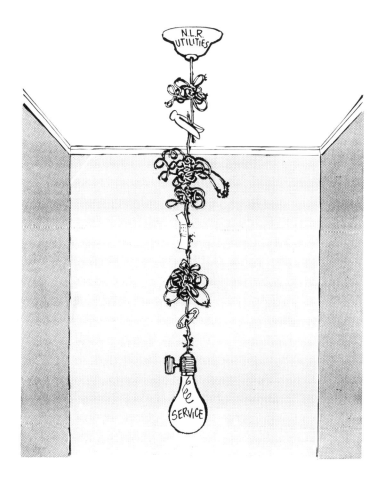

July 12, 1977

May 8, 1979

Burns Park began charging an exit fee to support the park. Could the idea not be used to support the city's anemic municipal services?

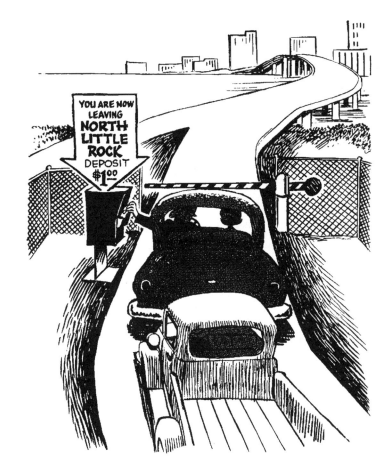

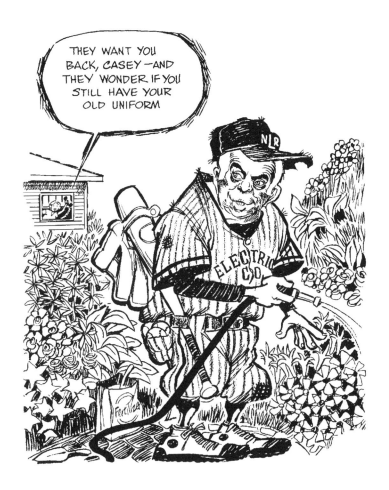

July 18, 1979

Former Mayor Casey Laman was called out of retirement to run the city when the troubled mayor had to resign.

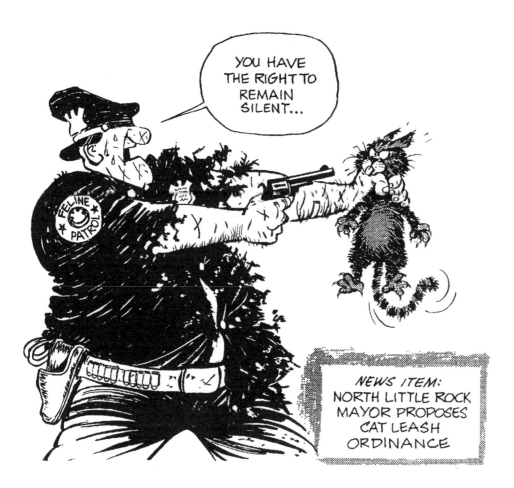

May 8, 1980

A proposed ordinance to leash cats ran into stiff resistance.

January 7, 1987

The city's popular mayor, Terry Hartwick, began to get into trouble. It worsened when the married mayor began to pay inordinate attention to a young woman.

Richard Millstone Nixon

You never can tell about upbringing. Richard Milhous Nixon, who was bred in the Quaker faith, seemed to have no core of values that would sustain him through the blandishments and perils and defeats of politics. He practiced a ruthless pragmatism of win-at-all-costs in politics, which led him to condone the Watergate burglary and to direct an unlawful coverup and to support friendly tyrants abroad. Nixon became the first president to resign his office and the most disgraced president in American history. But there were indications sometimes that his Quaker impulses could take over. After ratcheting up the Vietnam War to ruthless levels, he pulled Americans out of it and made peace with Communist China.

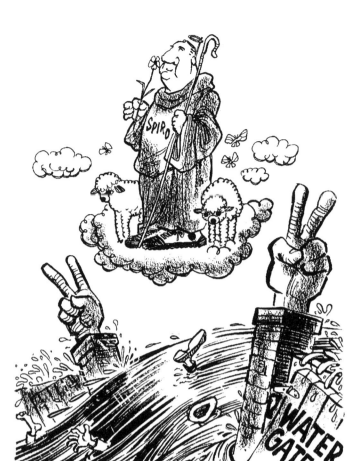

Nixon's vice president, Spiro Agnew, tried to separate himself from Watergate and his president. But Agnew had to resign in disgrace first.

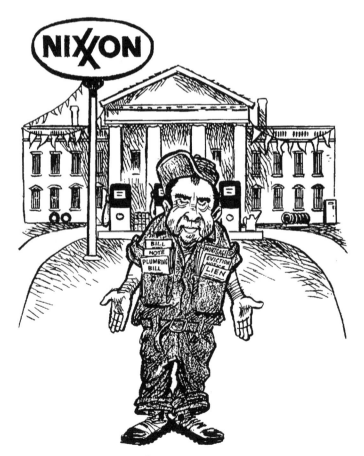

November 20, 1973

It turned out that the White House had been an unusually accommodating place, recalling the Exxon promotion, "I can be very friendly."

"I can be very friendly."

88

April 30, 1974

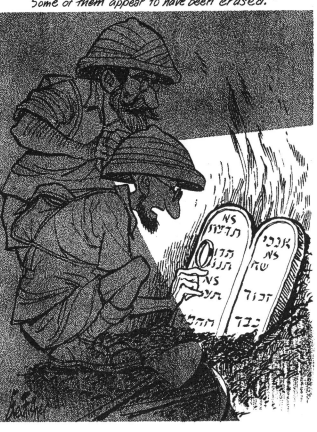

"*Some of them appear to have been erased.*"

" *There But For The Grace of Immunity...*"

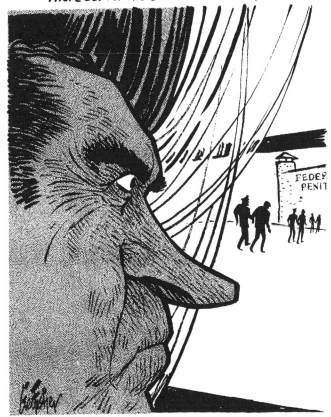

June 27, 1974

Another one from the Nixon White House trudged off to prison.

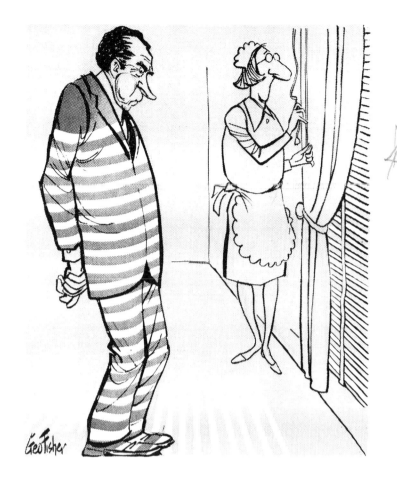

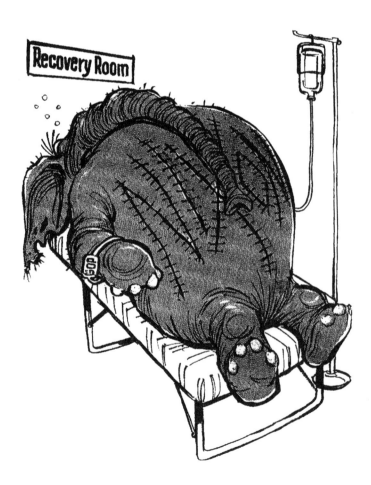

August 25, 1974

October 30, 1975

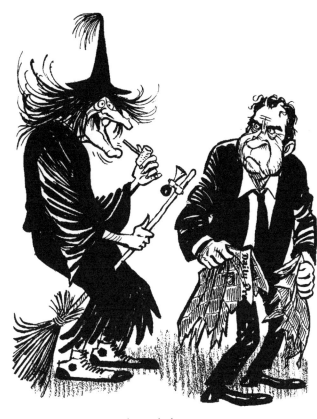

'Join the Club, Sweetie.
I'VE Had A Bad Press for Centuries.'

September 8, 1977

In a TV series in which he absolved himself
of blame for Watergate, Nixon blamed the
instability of the late Martha Mitchell of Pine
Bluff, whose antics, he said, so distressed her
husband, Attorney General John Mitchell,
the reelection chairman, that he dallied with
hoodlums and other unsavory types. The
cartoon recalls Martha's famous midnight
call to a *Gazette* reporter complaining about
Senator J. William Fulbright's vote against
a Nixon Supreme Court nominee.

Any Color You Want as Long as It's Bland

Gerald Ford was the accidental president, in every sense of the word. President Nixon made the staid but principled old jock from Michigan his vice president when the long arm of the law finally caught up with Spiro T. Agnew, and Ford become president when Nixon resigned to head off his impeachment and trial. Body and mind, Ford was prone to error, bouncing golf balls off the noggins of spectators, bumping his own head on aircraft doorjambs, pardoning the crimes of an ex-president. We like him better as an ex-president. Unlike Nixon, he doesn't pontificate; he just plays golf and knocks down good fees for appearing here and there.

December 5, 1973

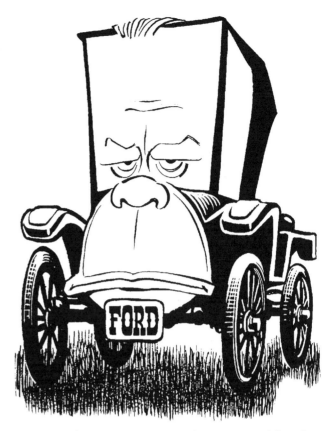

Any color you want—as long as it's bland.

September 11, 1974

On the same day that Evel Knievel tried to jump the Grand Canyon on a motorcycle, President Ford pardoned Nixon. Ford never recovered politically.

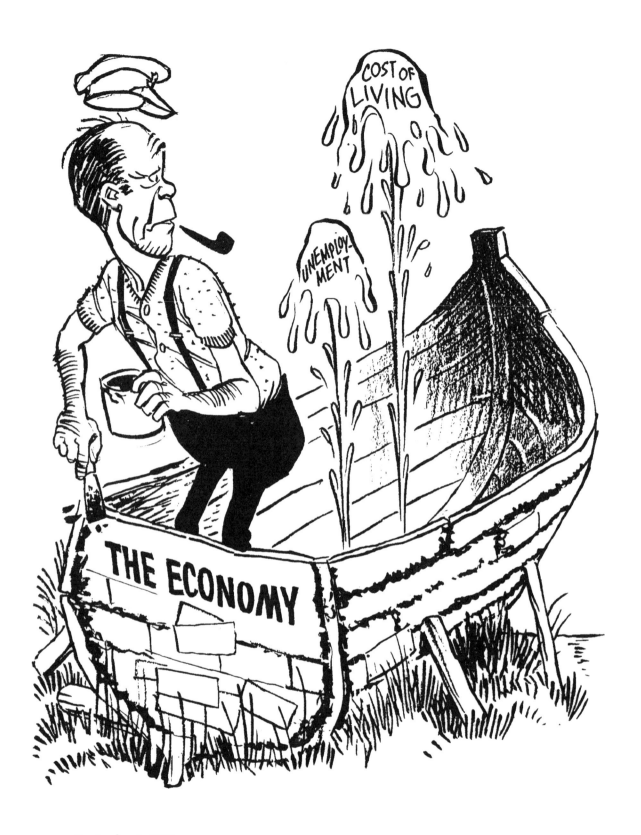

September 3, 1975

Ford never got a sputtering economy going.

Ford kept shuffling his cabinet to deal with persistent crises.

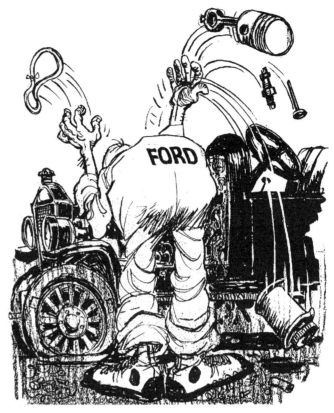

"I Shouldn't Have Bought A Used
Car From That Man."

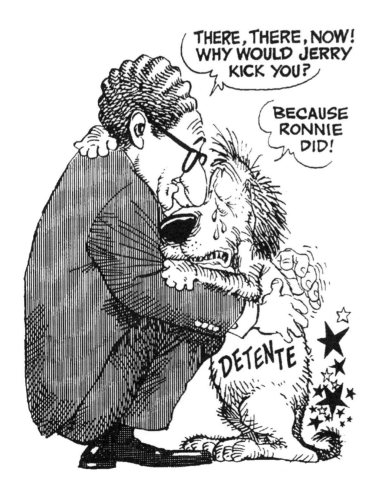

March 4, 1976

Henry Kissinger was proud of the effort to achieve detente with the Soviet Union, but the presidential campaign was spoiling it.

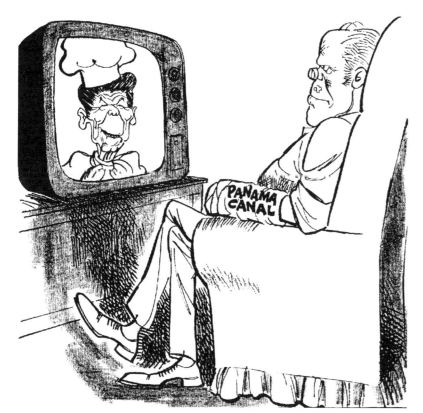

May 28, 1976

Ford burned himself every time he tried to respond to Reagan.

'Yesterday we learned how to make a flaming shish kebab. Today . . .'

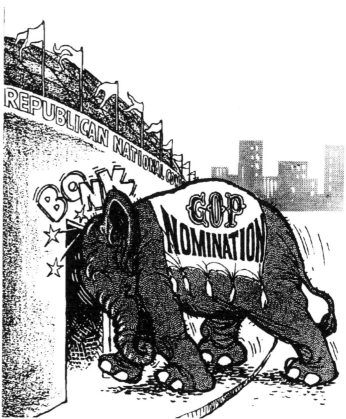

August 8, 1976

Ford was prone to accidents, like bumping his head on airplane doorjambs.

It's beginning to look a lot like Ford

Own Your Own Business

It has always been a mystery to me that Americans would weep over the slaughter of their youth and imprison themselves in their heavily locked houses but cry out in fury at any suggestion that would stem the flow of the cheap artillery that killed their children and kept them in thrall. No group is more daunting in Congress than the National Rifle Association, and few cartoons brought such storms of protest as those critical of the gun lobby.

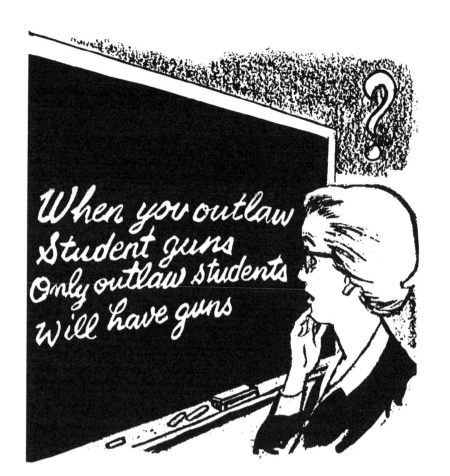

When you outlaw
Student guns
Only outlaw students
Will have guns

November 27, 1974

One Little Rock student was wounded by another, exposing the growing problem of student possession of guns at school. There were protests that the schools didn't have a right to crack down on gun possession.

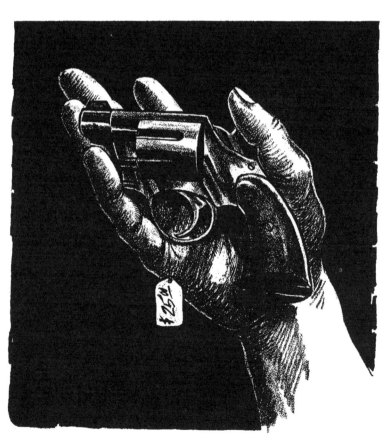

July 22, 1977

For about 25 bucks you, too, can own your own business.

April 7, 1981

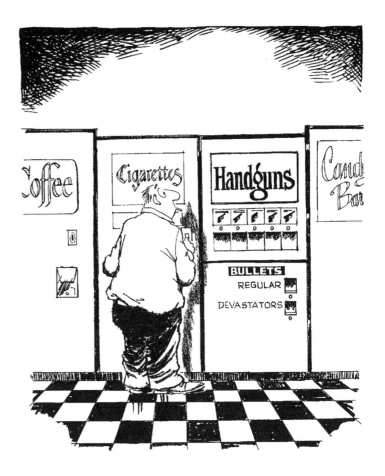

Main Street, U.S.A.

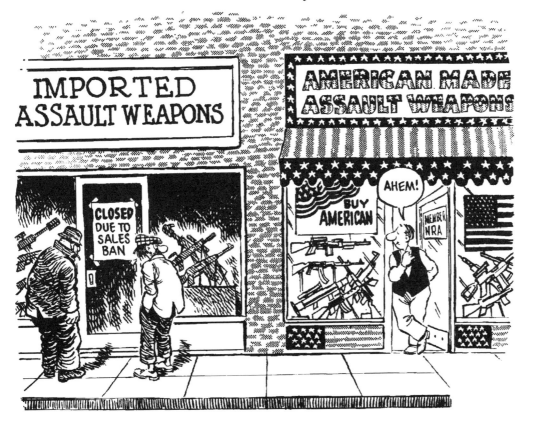

July 14, 1989

The Bush administration found the "solution" to the crime sprees involving military-style assault weapons: ban only those made abroad.

Of Mice and Men

Improving education has not been merely a task of finding money and sound educational strategies. Often it has been a pitched battle against ignorance and narrow-minded traditions, manifested by the impulse of school boards and administrators to ban reading material such as John Steinbeck's *Of Mice and Men,* the legislature's effort to impose religious instruction in biology classes, and the resistance to consolidation of tiny, inefficient school districts that soak up much of the state's meager resources for the schools.

January 5, 1975

A new law committing state tax money to community colleges caused a profusion of the little schools, gobbling up the state's limited higher-education money.

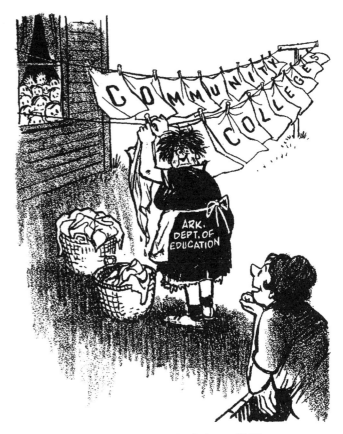

"Have you tried the pill?"

Frank of the Ozarks

December 31, 1975

Frank Broyles, the athletic director at the University of Arkansas, was out front pushing for construction of an airport to serve northwest Arkansas.

December 10, 1976

Broyles tapped professional football coach Lou Holtz as his successor as head coach of the Razorbacks.

May 20, 1977

Satellite

February 7, 1978

The anemic university found itself supporting nationally ranked athletic teams.

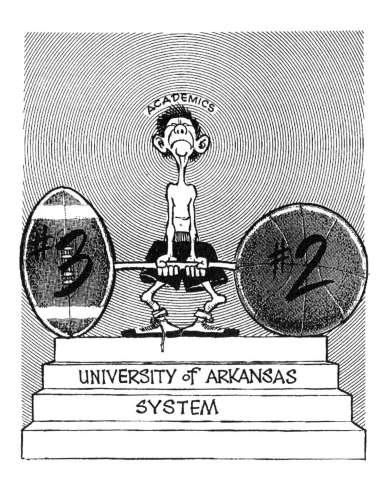

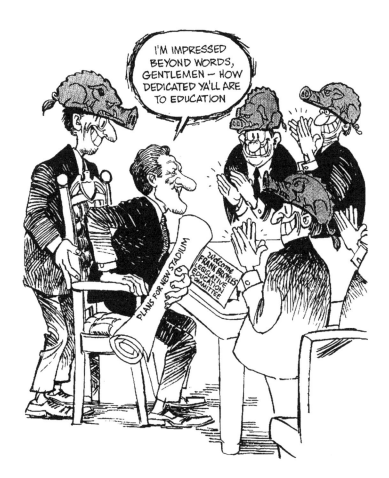

October 9, 1979

Tightfisted legislators always gave Broyles a hospitable hearing.

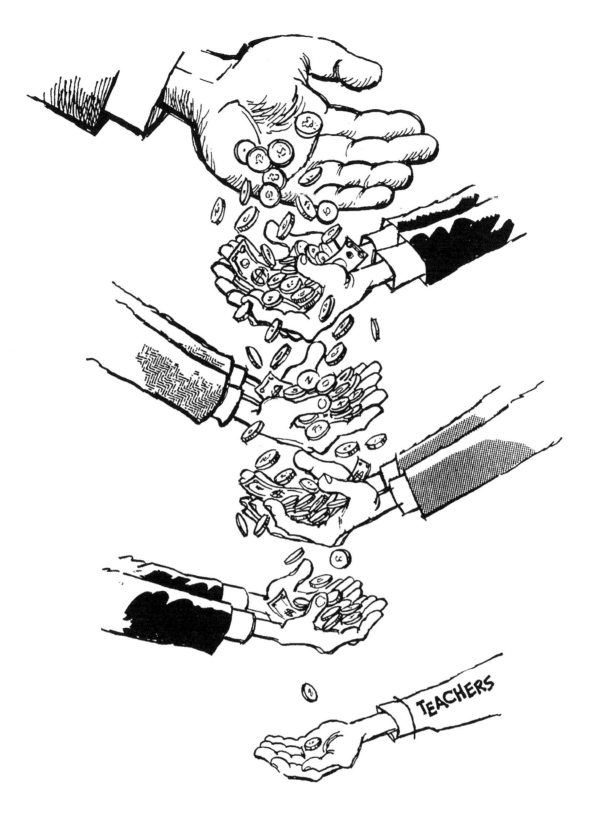

December 21, 1980

Teacher pay was always the legislature's budget priority,
but something always happened to the money.

December 11, 1985

Governor
Clinton's cele-
brated teacher-
testing program
was beset by
foul ups.

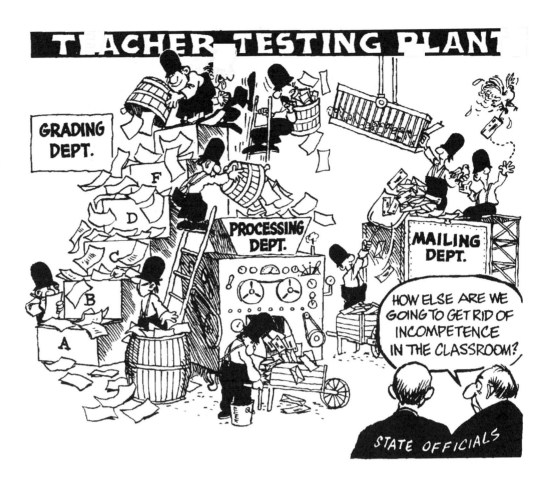

October 11, 1987

Rebuffed on
organized reli-
gious exercises
in the schools,
fundamentalist
groups were
seeking approval
of "moments of
silence" in the
schools.

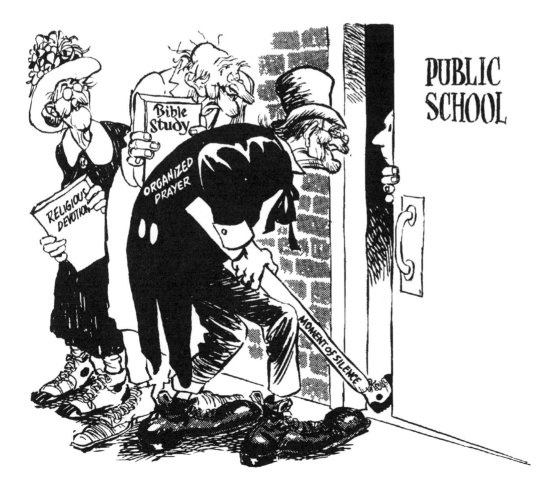

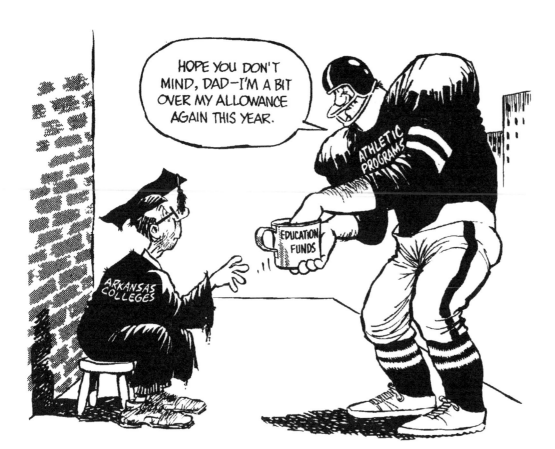

February 24, 1988

Every year, athletic programs at the state universities dipped into scarce academic funds for millions of dollars.

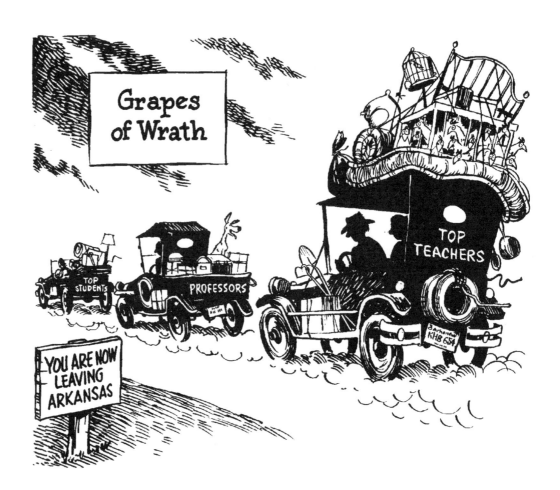

May 11, 1989

October 25, 1989

A few legislators talked about writing into law some academic requirements for participating in extracurricular sports. A common standard in schools was four Ds and an F.

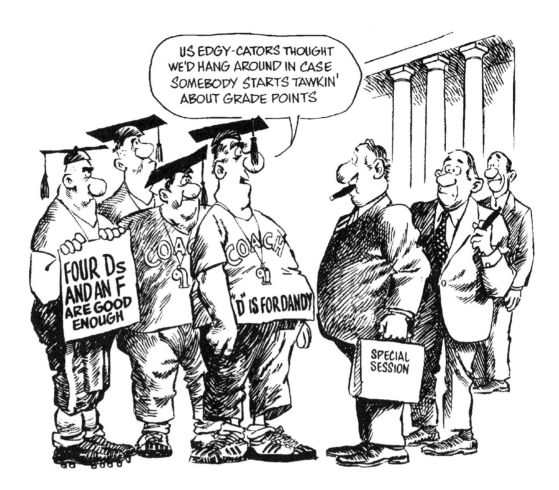

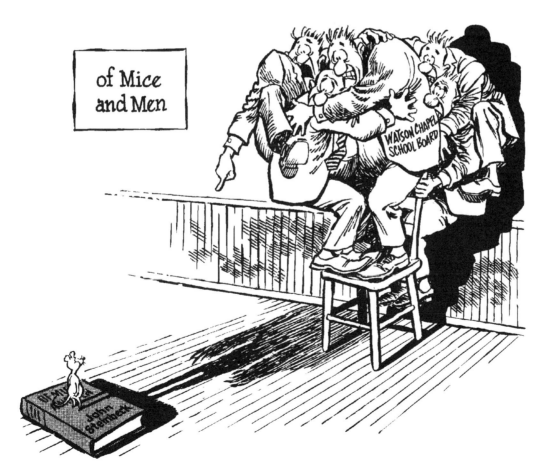

November 30, 1989

The Watson Chapel School Board voted to ban John Steinbeck's classic, *Of Mice and Men,* from the reading list of high school students.

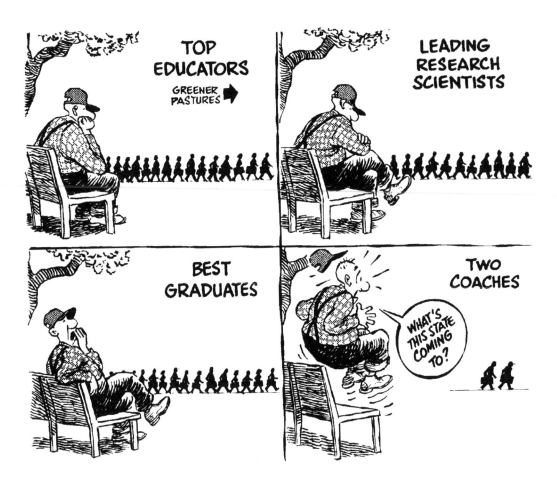

January 26, 1990

In short order, the football and basketball coaches at the University of Arkansas left.

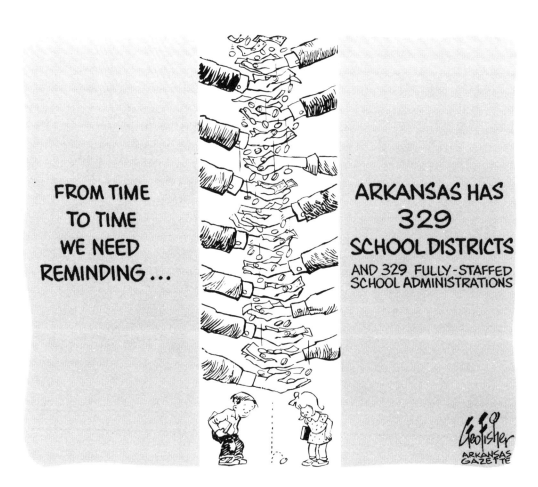

March 28, 1990

Arkansas still had more than twice as many school districts as any other state in the South.

Born Again

 It was never clear to me how Jimmy Carter got elected president. He flouted all the conventions of politics, with his quaint, understated manner, excessive candor, devotion to principle (or was it only naiveté?). Strangely, it got him elected but troubled his presidency. He immediately spoiled relations with Democrats and Republicans alike in Congress by fighting congressional deficit-raising water-development projects. He talked bluntly about the nation's obligations and perils (the national malaise and the moral equivalent of war) rather than spout the happy talk of Reagan. He conveyed the seriousness of national crises by personally managing them from the White House rather than golfing and fishing his way through them at his vacation home as Bush would do. He insisted on human rights as the cornerstone of American policy toward every nation. People laughed at his quaint statement that he was a born-again Christian, which he said provided the core of his principles. Sadly, no one scorned his successors for their fake piety.

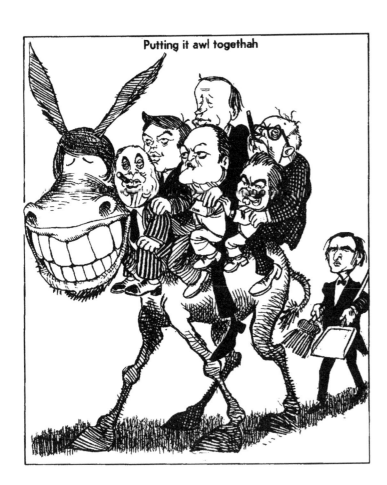

Putting it awl togethah

June 18, 1976

Jimmy Carter's primary critics, from
George Meany of the AFL-CIO to George
Wallace, came together after his victory.

July 18, 1976

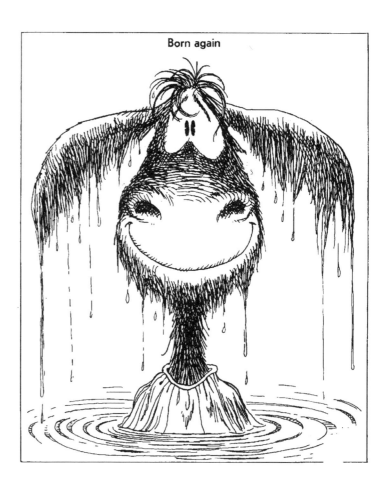

Born again

Arkansas returned to the Democratic fold, where it had been for all but two elections in its history.

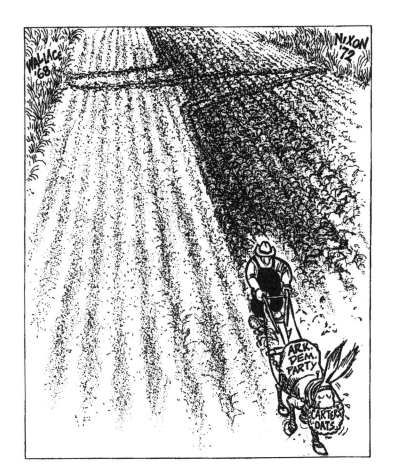

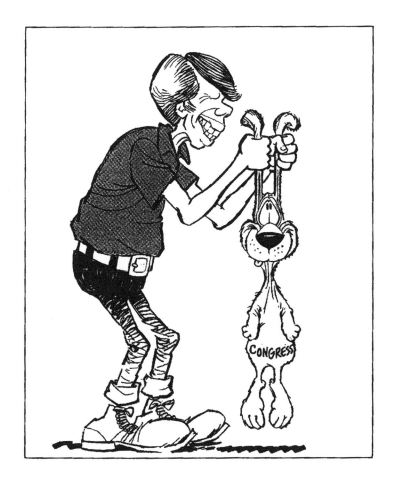

November 26, 1976

Carter told of repulsing an angry rabbit in his boat at Plains.

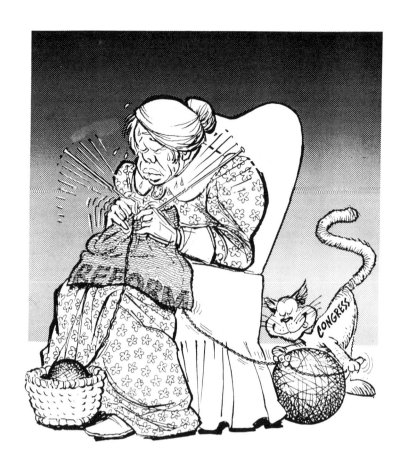

April 18, 1978

Carter and the Democratic Congress weren't exactly working closely.

February 20, 1979

Carter hoped Mexican oil could help with the Mideast oil embargo.

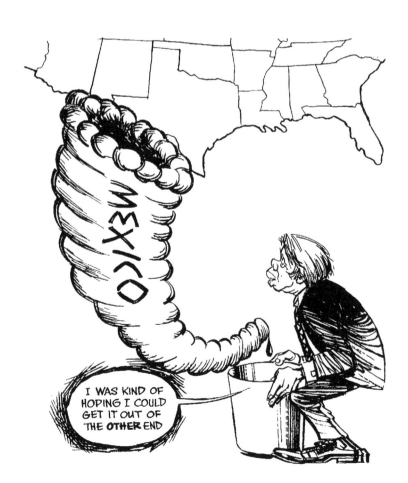

112

July 17, 1979

Carter's quarrels with Congress had both sinking in the polls.

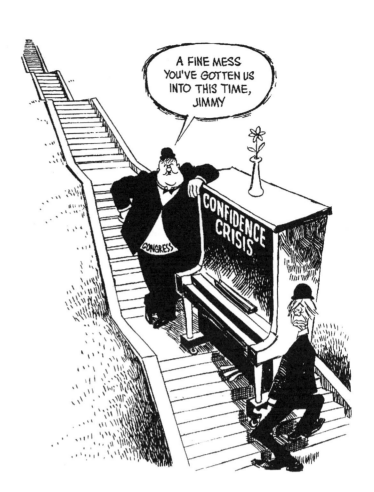

November 17, 1989

While ex-President Carter was getting publicity for his carpentry on low-income housing for Habitat for Humanity, ex-President Reagan was raking in millions for speaking to industrialists in Japan.

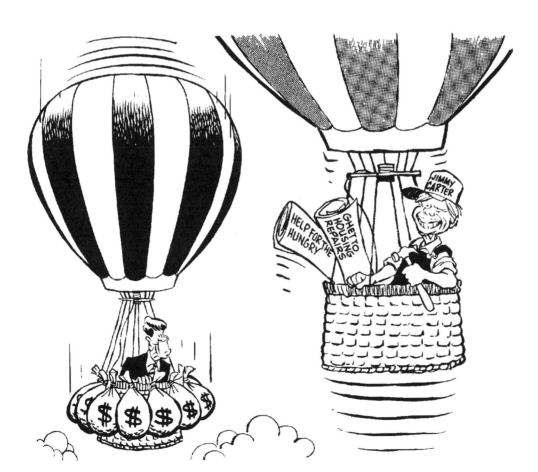

Over My Dead Body

Ronald Reagan was a second-rate film actor, at best, but he was great on the live stage. For eight years, he delivered his lines perfectly and enraptured the American people. We never minded that what he said made little sense or that it hurt the country or even that he didn't mean what he said. "If you can't balance the budget, Jimmy Carter, move over, I will," he said before plunging the country $2 trillion deeper in debt. He told a cheering audience at Little Rock's Convention Center in 1984 that taxes would be raised "over my dead body." He raised taxes every year of his presidency except the first. But he kept the people believing for eight years that the plot was going to have a happy ending. After he left, they found out it had been a Greek tragedy.

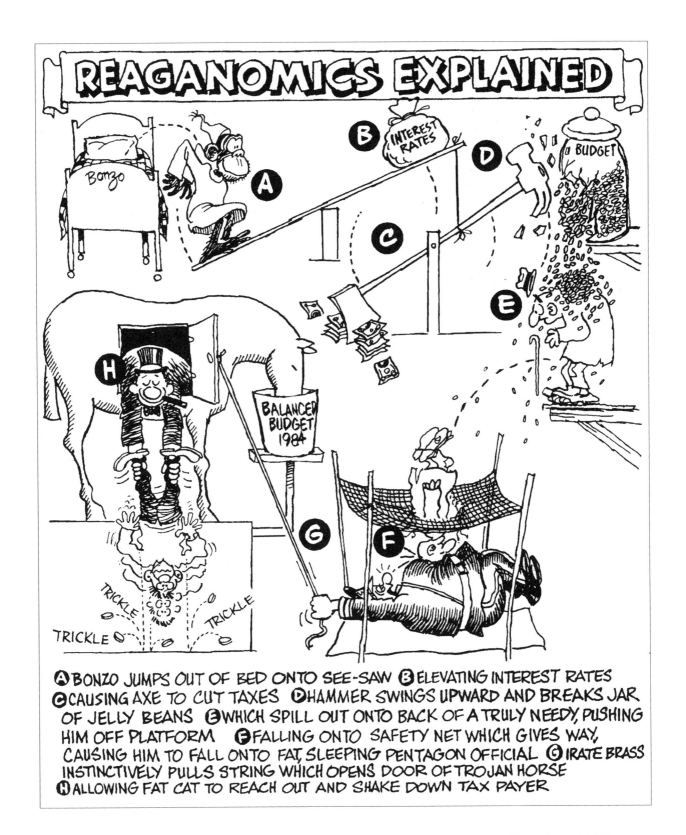

November 20, 1981

Congress knuckled under and enacted Reagan's tax and budget
cuts, but the economic indicators headed the wrong way.

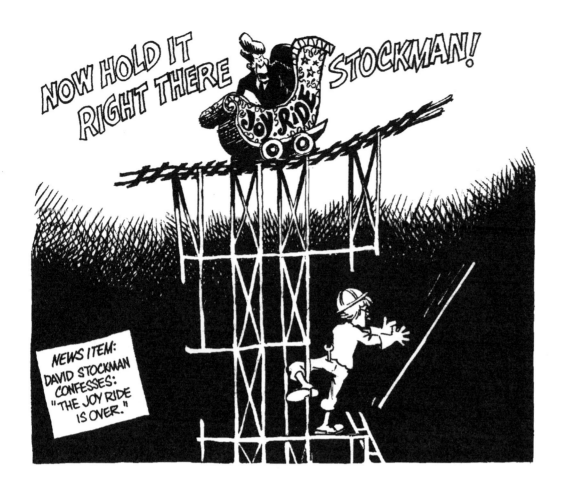

October 1, 1985

The confessions of Reagan's budget director were too candid for comfort.

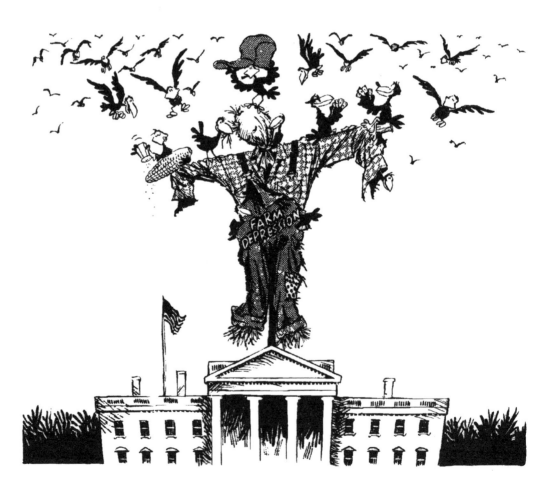

October 22, 1985

Despite the highest federal farm spending in history, the rate of farm foreclosures hit new records.

January 18, 1986

The White House did its best to stanch the disclosures about secret and illegal dealings with Iran and the Nicaraguan contras.

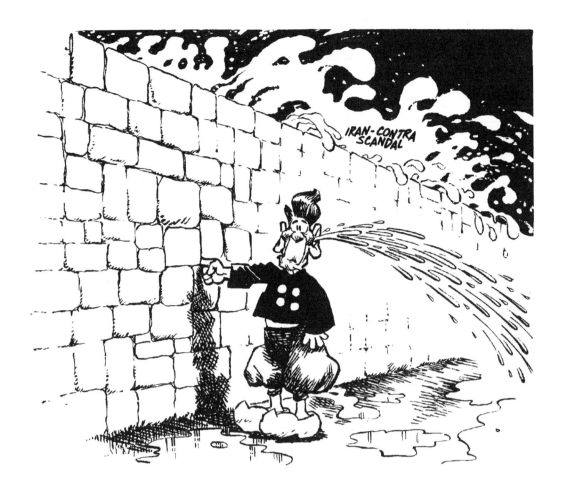

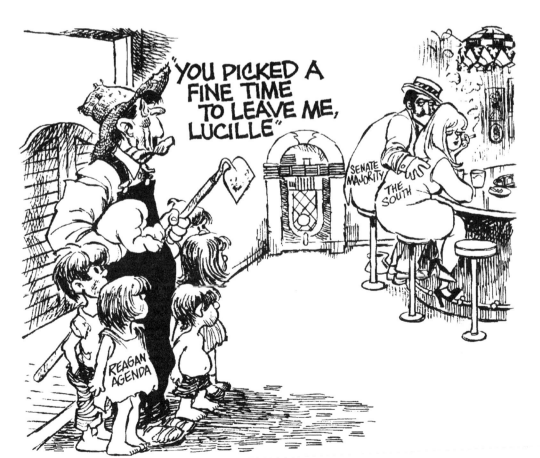

November 11, 1986

Voters turned out Republican senators in Georgia, Alabama, Florida, and North Carolina, giving Democrats a solid majority in the Senate.

119

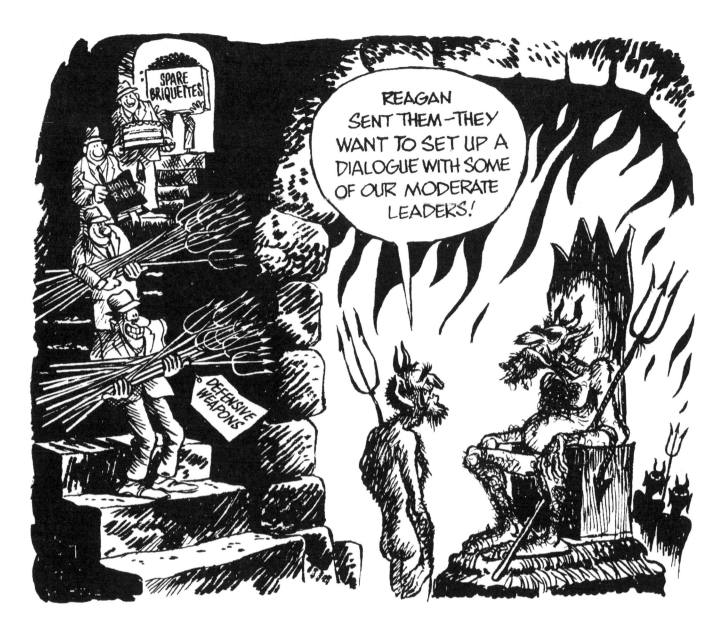

November 18, 1986

Reagan's explanation of arms deals with the Ayatollah Khomeini's Iran was
that the administration wanted to encourage "moderates" in the government.

December 9, 1986

Reagan finally made a small concession.

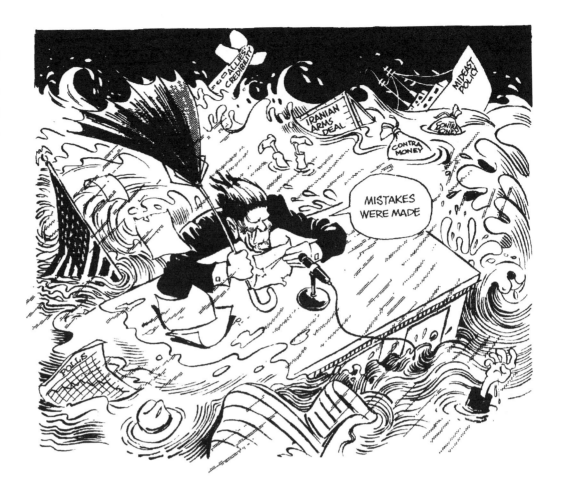

March 1, 1987

Reagan first insisted that he didn't know anything about the arms-for-hostages deal, then he said he didn't really consider it trading.

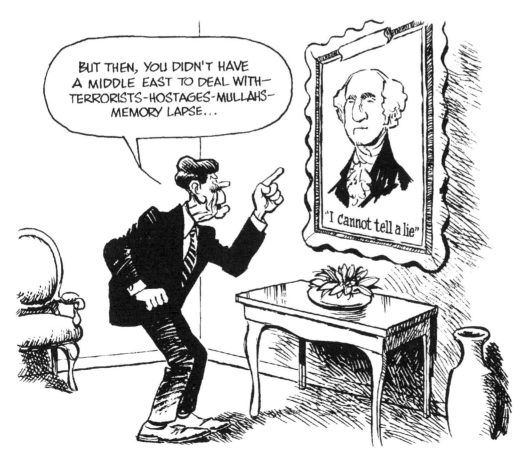

The Tower
Commission
found that the
president
hadn't been
very attentive.

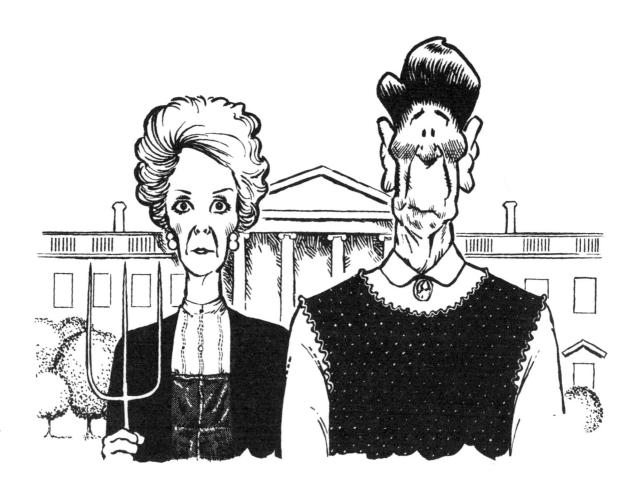

*March 8,
1987*

122

October 25, 1987

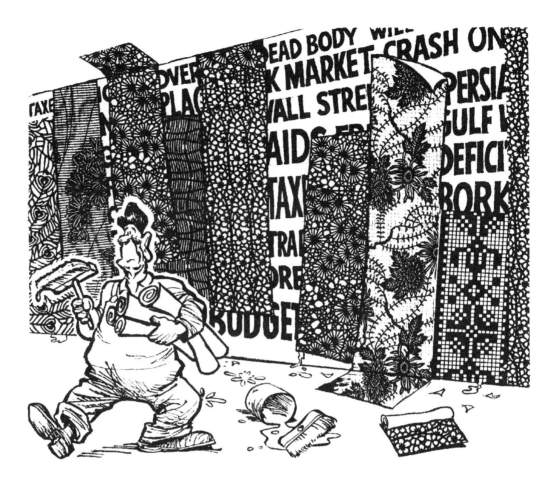

Another fine Meese

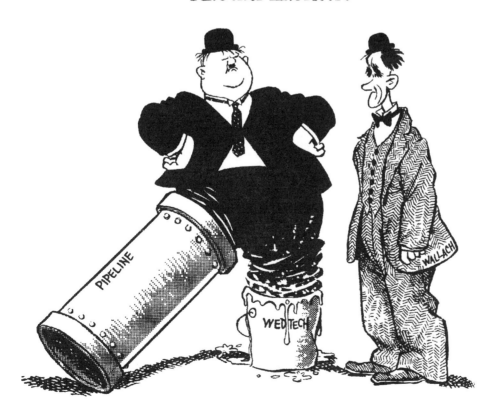

February 12, 1988

Reagan's attorney general, Ed Meese, got into one ethical mess after another.

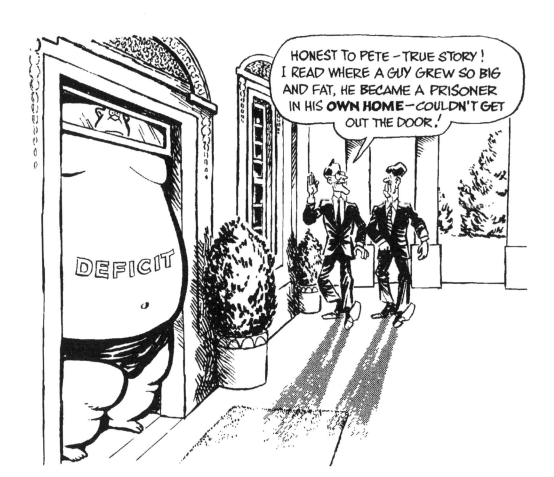

September 30, 1988

The newspapers reported on a man who had gotten so big that he could not be maneuvered through the door of his bedroom. Civil rights activist Dick Gregory tried to help him.

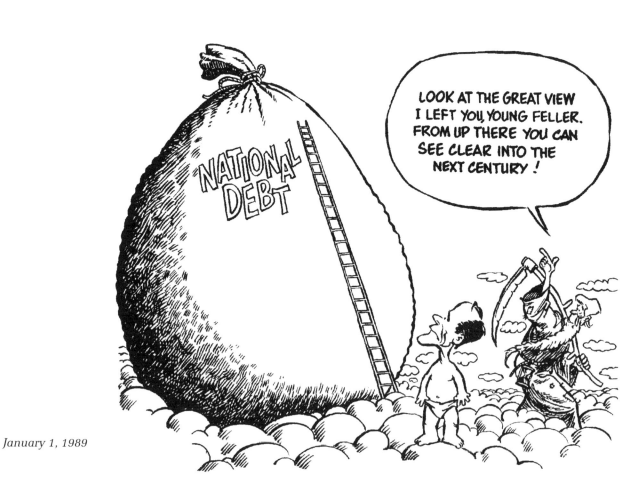

January 1, 1989

January 18, 1989

The Reagan
presidency
was coming
to an end.

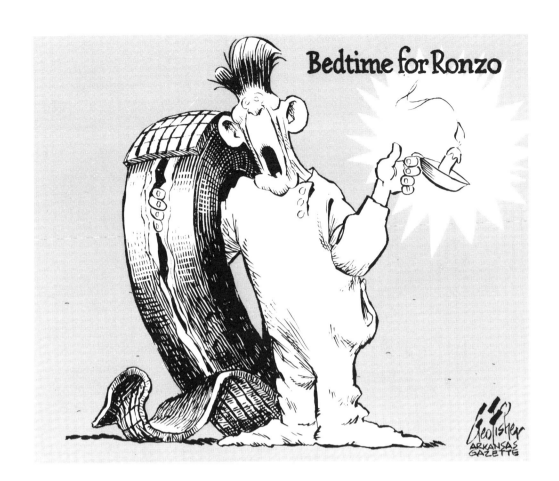

May 8, 1991

More disclosures
led to a congres-
sional investiga-
tion to determine
if Reagan opera-
tives meddled to
hold up the return
of American
hostages until
after the 1980
election.

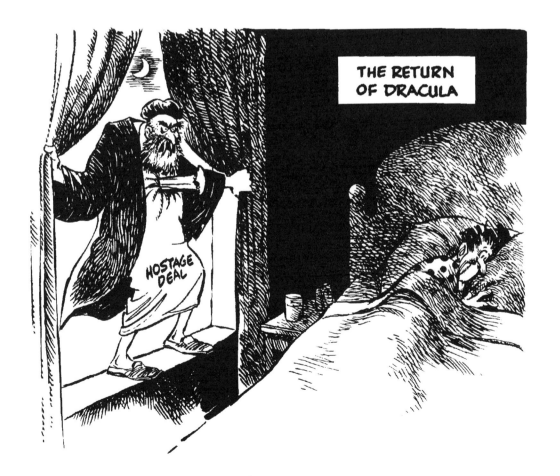

Bench Marks

 The courts provide a peculiar balance in our democracy. The founding fathers didn't intend that the members be elected or be subject to the whims of men and women who were. (A few states like Arkansas ignore the doctrine and elect their judges, but it is observed by the federal system and many states.) The founding fathers intended that courts not represent the interests of the entrenched, the powerful, or even the majority, and their fidelity was to be to the Constitution and the Bill of Rights. The other branches of government and their bureaucracies and the private institutions might seek to satisfy the majority, but the courts would always be there to protect the liberties of the minorities, the dispossessed, and those who held unpopular or even repulsive views. The courts never served the role to perfection or even very well, until the 1950s, 1960s, and 1970s, when there was an unpopular experiment with Madisonian and Jeffersonian principles. Ronald Reagan and George Bush have appointed most of the federal judiciary we have now, and even the pretense has been abandoned. The Bill of Rights is what the majority and the powerful want it to be.

April 14, 1977

An increasingly conservative
Supreme Court began to reinterpret
the civil rights laws.

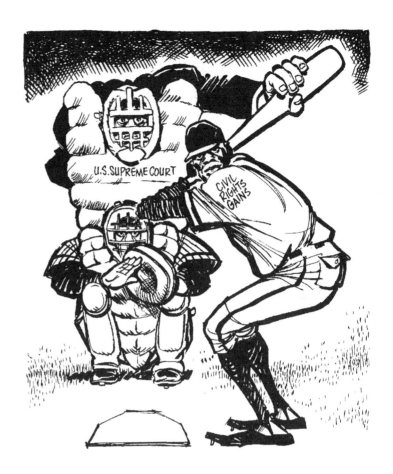

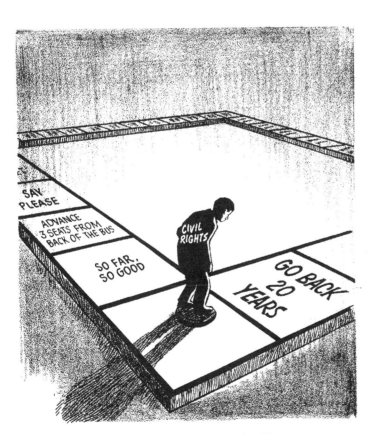

The Supreme Court Shuffle
(A new game where nobody wins)

August 26, 1977

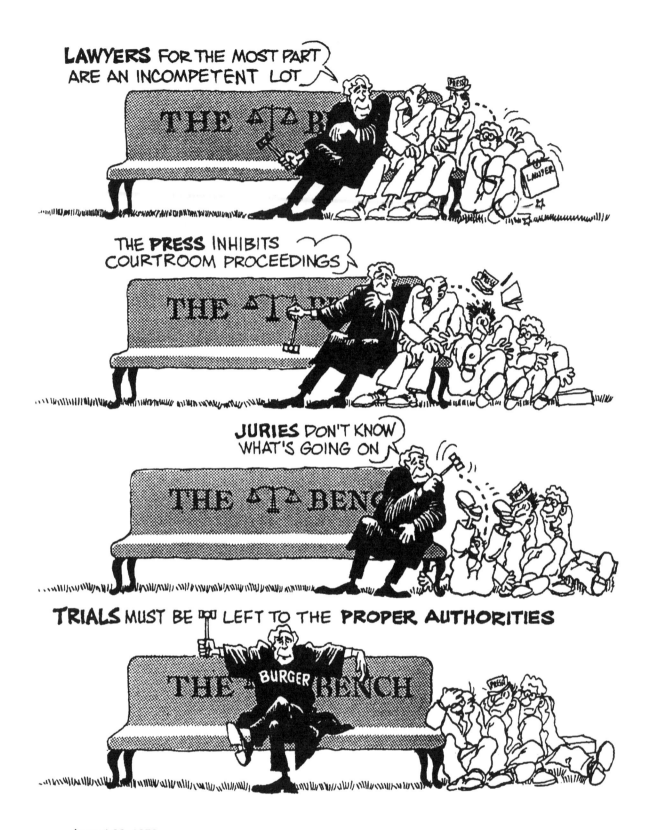

August 26, 1979

Justice is not being served in the United States, Chief Justice Warren
Burger said in a series of speeches, and he identified the reasons.

January 20, 1988

After the Senate refused to confirm Robert Bork, Reagan's right-wing nominee to the Supreme Court, Bork began a writing and speaking crusade to expose liberals and clear his name.

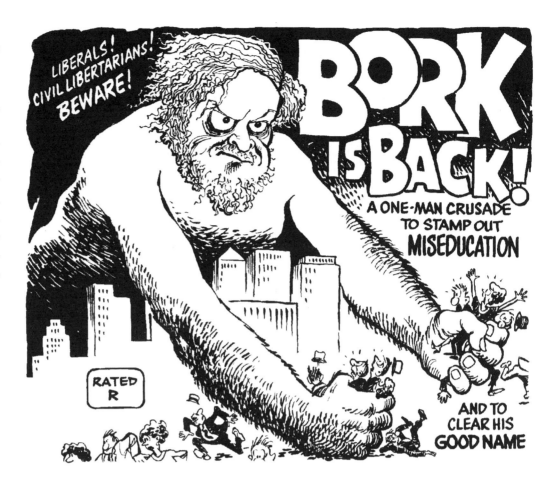

September 19, 1990

President Bush chose a Supreme Court justice, David Souter, with no record and virtually no utterance on the most divisive legal question.

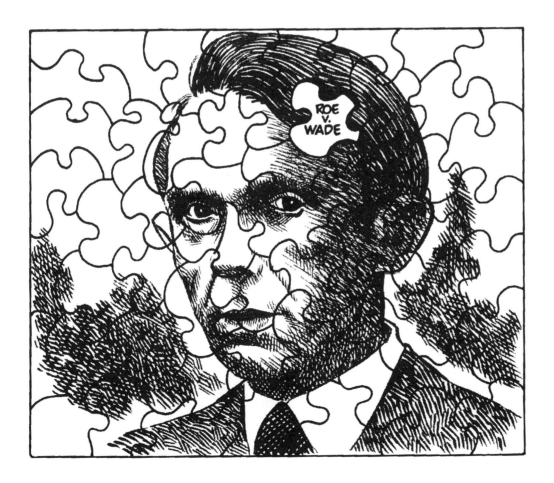

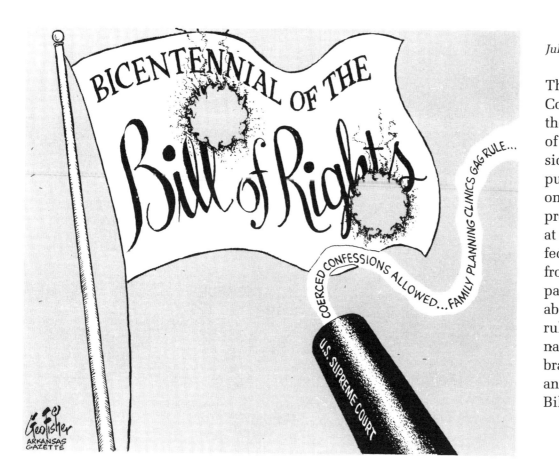

July 4, 1991

The Supreme Court permitted the introduction of coerced confessions in court and put its imprimatur on a federal rule prohibiting doctors at clinics receiving federal money from advising patients about abortions. The rulings came as the nation began celebrating the 200th anniversary of the Bill of Rights.

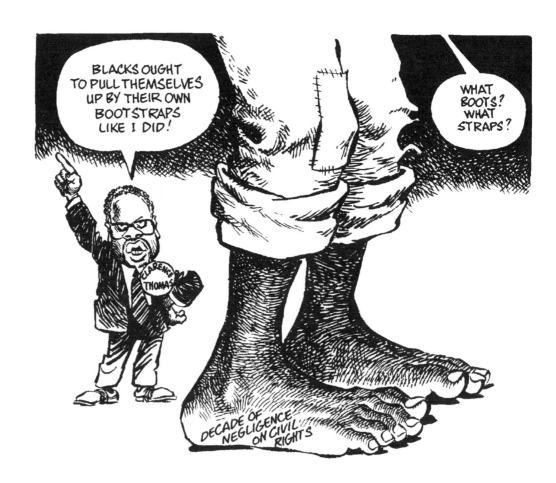

August 6, 1991

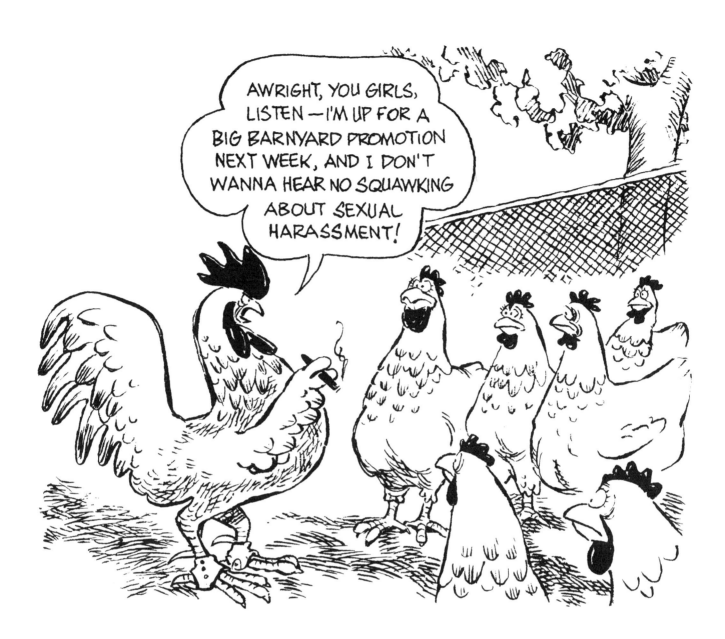

October 15, 1991

Clarence Thomas' confirmation to the Supreme Court after
accusations of sexual harassment sent a message across the land.

Grand Goof

 In late 1979, customers of Arkansas Power and Light Company learned an astonishing thing. Although they were already paying plenty for their electricity because AP & L had built too many big power plants, they were going to help pay for a big nuclear power plant that a sister company in the Middle South Utilities system had begun to build near the town of Port Gibson in southern Mississippi. Governor Clinton, the state Public Service Commission, the attorney general, and, finally, AP & L tried to extricate Arkansas from the draconian deal. In the end, the Reagan administration and the federal courts said that a deal was a deal and that Arkansas would have to pay the lion's share of the $3.5 billion cost, whether it needed the power or not. For ten years, the politicians, the regulators, the courts, and the utilities in three states exchanged blame for the mess. But Arkansas paid, and it will keep on paying until far into the twenty-first century. Grand Gulf was only emblematic of the country's heedless and wasteful policies on energy and the planet's vanishing resources.

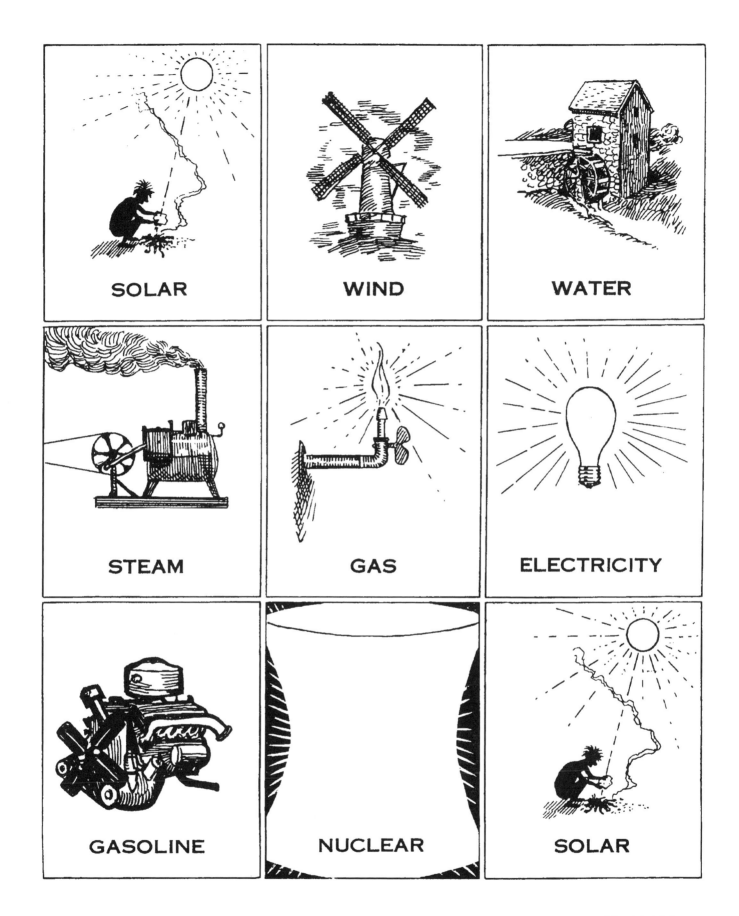

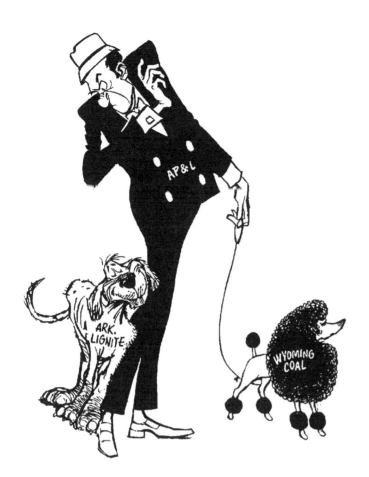

July 20, 1977

South Arkansas interests wanted the Arkansas Power and Light Company to burn Arkansas lignite in its generating plant to help the Arkansas economy, but low-sulphur Wyoming coal was cleaner and more efficient.

July 6, 1978

Despite the Middle East oil shocks and the rising dependence on foreign oil, Congress could not agree on a national energy strategy.

June 29, 1979

Year of the Child

November 16, 1979

It was the year of the child, but hunger stalked the world.

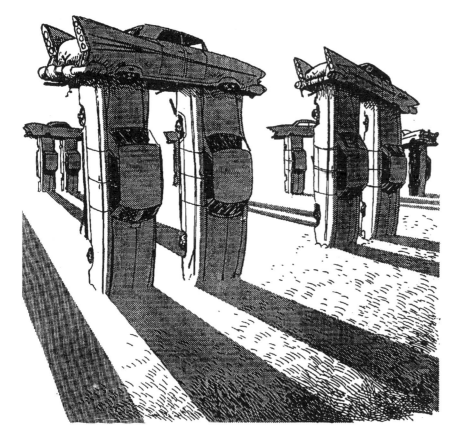

June 15, 1980

Stonehenge, U.S.A.

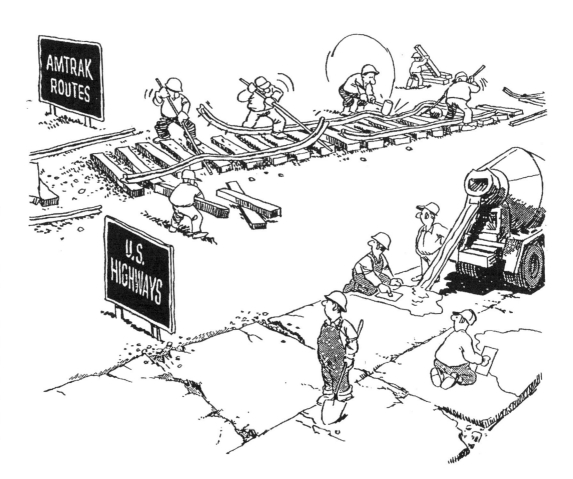

July 19, 1985

It seemed perverse that the national government was dismantling parts of the Amtrak rail system while it was letting its highways fall into disrepair.

September 18, 1985

Everyone was unhappy that Arkansas was having to pick up the costs of a giant nuclear power plant in Mississippi when Arkansas didn't need the power. The politicians couldn't agree on who was to blame.

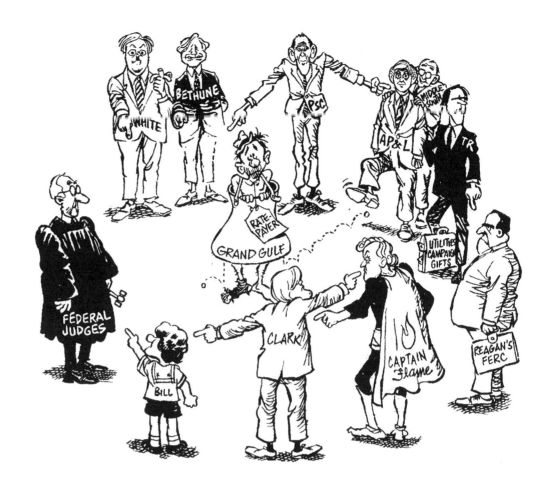

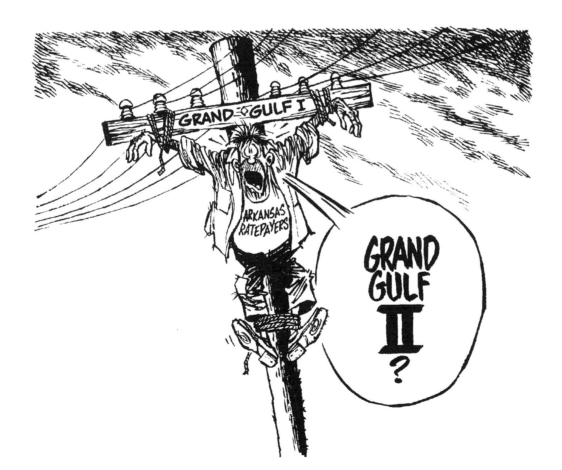

December 31, 1985

Arkansas was about to be liable also for a second unit of Grand Gulf, although construction was halted.

137

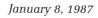

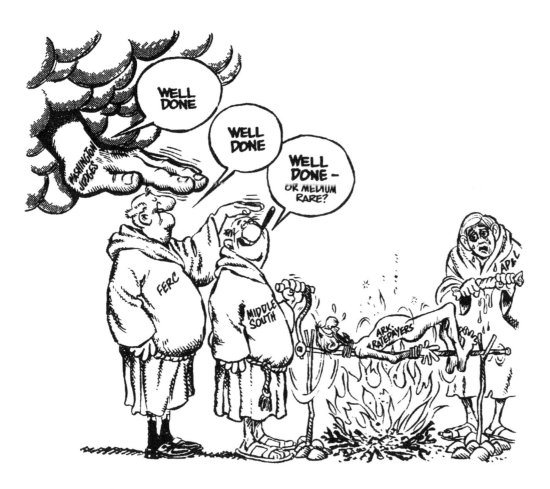

Arkansas got no reprieve from either the Federal Energy Regulatory Commission or the District of Columbia Court of Appeals, both of which said Arkansas indeed would have to pay for Grand Gulf.

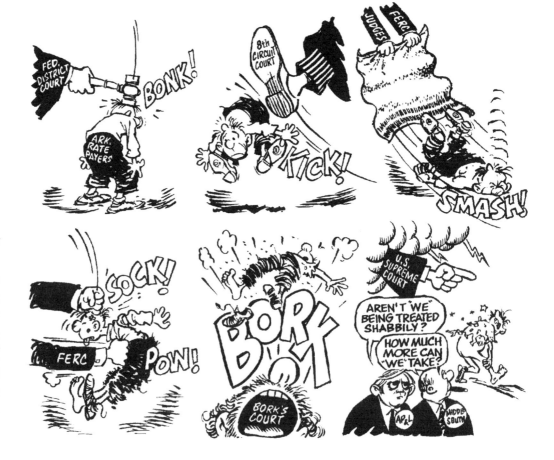

December 18, 1987

Arkansas Power and Light Company weakly complained about the Grand Gulf rulings, but it was the ratepayer who took the licks.

138

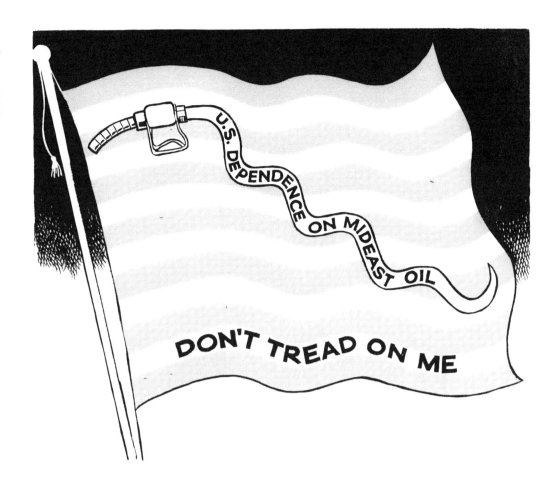

January 10, 1990

Reagan and Bush never developed an energy policy.

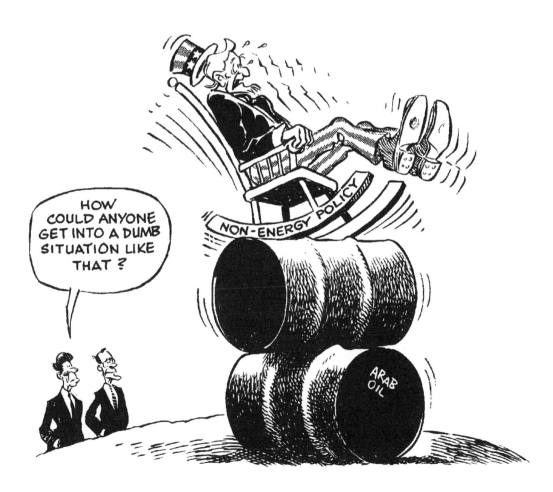

September 6, 1990

Charming Billy

 At thirty-two in 1978, Bill Clinton was the youngest person ever nominated for governor of Arkansas, and at thirty-three at his inauguration he was the youngest governor in the United States. But his remarkable political gifts didn't always protect him from his immaturity and impetuousness. Clinton remained the boy wonder of American politics in parts of three decades, and he navigated the fourteen years in a variety of conveyances that were appropriate to his political circumstances. I graduated him from a baby carriage to a tricycle when he was elected. In 1992, he was headed toward the White House in a backroad pickup.

March 9, 1978

Before the filing deadline, Attorney General Bill Clinton seemed to be on his way to being one of the youngest governors in American history.

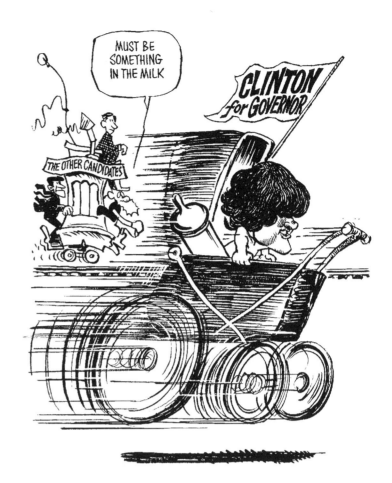

June 1, 1978

Could you dress a politician all in blue?

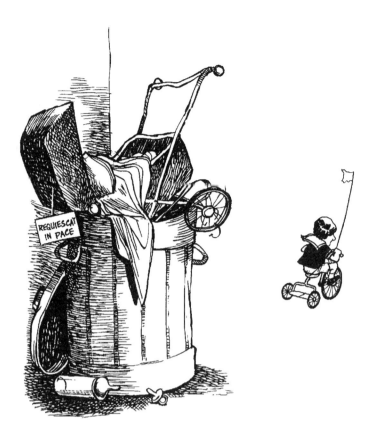

The governor expressed some resentment at being caricatured as a baby.

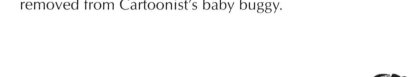

News Item: Governor Clinton wishes to be removed from Cartoonist's baby buggy.

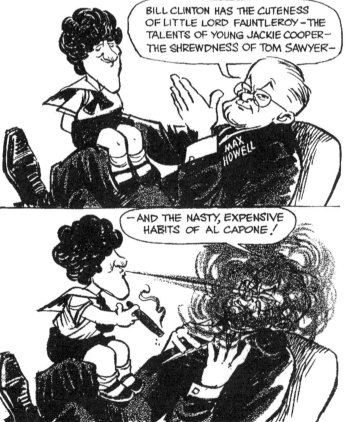

BILL CLINTON HAS THE CUTENESS OF LITTLE LORD FAUNTLEROY—THE TALENTS OF YOUNG JACKIE COOPER—THE SHREWDNESS OF TOM SAWYER—

—AND THE NASTY, EXPENSIVE HABITS OF AL CAPONE!

February 11, 1979

State Senator Max Howell, the dean of the legislature, praised the new governor but was soon rebuffed.

June 28, 1979

Clinton capitulated on a large increase in the license fee on heavy trucks, but the truckers and big shippers wanted more— the authority to haul much heavier loads on Arkansas's beat-up highways.

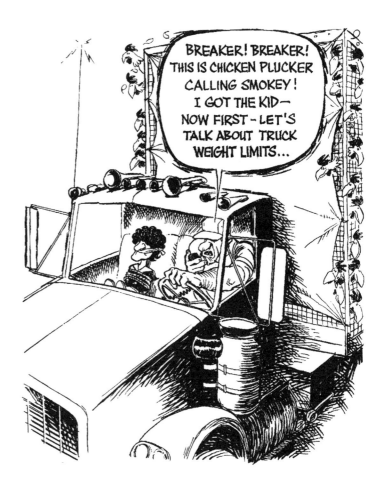

September 27, 1979

A *Gazette* writer reported that Clinton's official car traveled at high speeds between appointments.

April 22, 1980

The Senate scuttled a new formula for distributing the state's tax assistance to the schools which would have helped poor schools.

November 7, 1980

A political unknown named Frank White, a Democratic turncoat, defeated Clinton in the general election.

The Democratic gubernatorial primary shaped up as a race between a repentant Bill Clinton, a macho Jim Guy Tucker, and old Joe Purcell, an unreconstructed bore.

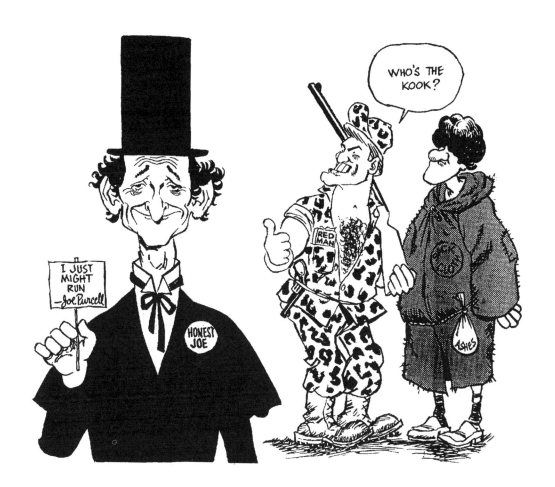

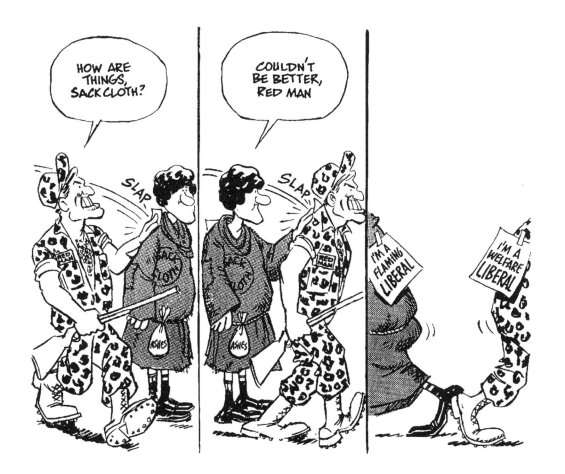

April 27, 1982

Neither Clinton nor Tucker would let the other forget his past.

June 10, 1982

Clinton won a decisive victory over Purcell in the runoff.

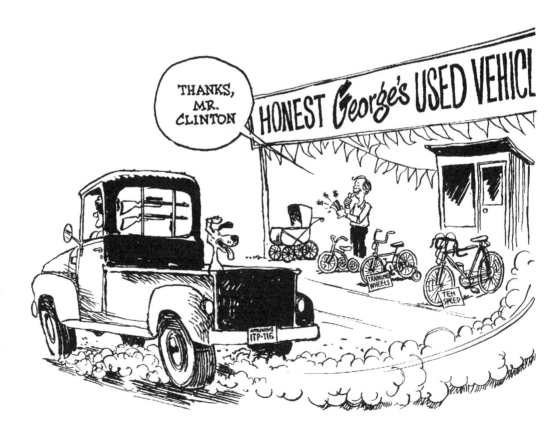

November 4, 1982

Then he beat
Frank White
easily in
November.

November 23, 1982

At Thanksgiving, Clinton began releasing recession-driven budgets.

March 2, 1983

Would the big trucks pay higher taxes for the heavier loads on Arkansas highways? It was hard to say.

May 24, 1983

Clinton was getting advice from everyone on whether
to call the legislature together to raise taxes.

June 28, 1983

August 21, 1983

Clinton got part
of his tax pro-
gram through the
legislature. It
defeated his pro-
posals for taxes
on corporations
and natural gas.

February 12, 1985

Clinton cast
himself as a
fiscal conserva-
tive and a friend
to business. He
supported big
tax breaks for
expanding
Arkansas
corporations.

150

March 22, 1985

Clinton vetoed a fuel-tax increase that he had seemed to support. He didn't fight the legislature's over-ride of the veto.

May 30, 1985

Clinton admitted dreaming about running for president.

151

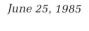

The regular session messed up a few programs and had to reassemble to correct the errors. The special session was messy, too.

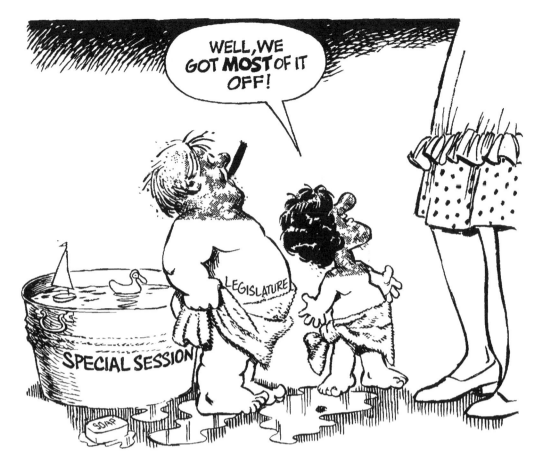

September 11, 1985

The governor decided his Public Service Commission ought to strike a deal on the Grand Gulf power plant case because the courts probably would favor the utility.

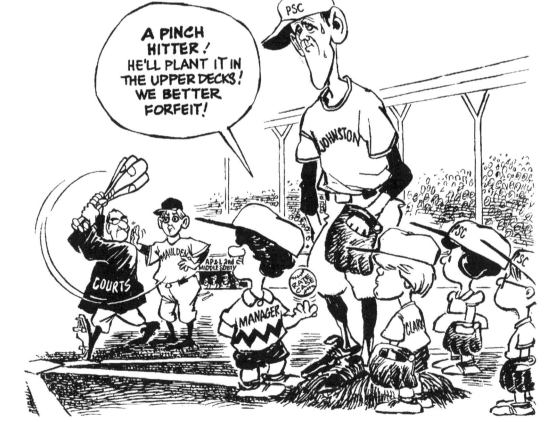

November 13, 1985

Legislators and Clinton finally acknowledged that they had made a mistake in 1979 when they had drafted a bewildering amendment to offset court-ordered property-tax reform, but they couldn't figure out how to undo the mess.

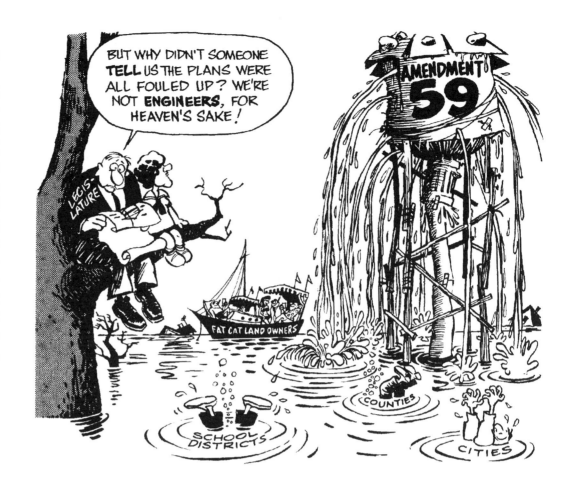

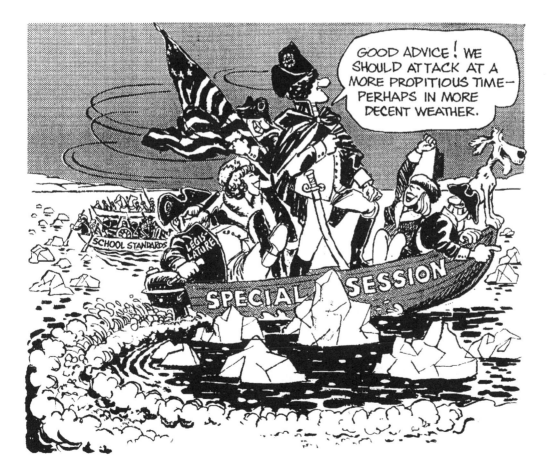

September 2, 1986

Election time didn't seem to be the right moment to address a school-funding crisis.

153

Front Runner

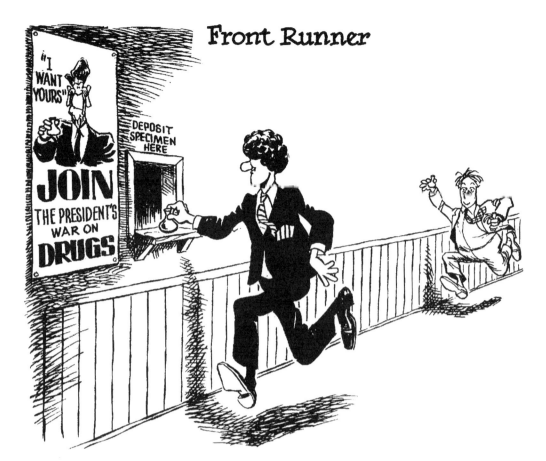

September 9, 1986

Clinton heard that Frank White, who was making a comeback, planned to have himself tested for drugs and then issue a challenge to Clinton and his aides. Clinton beat him to the punch.

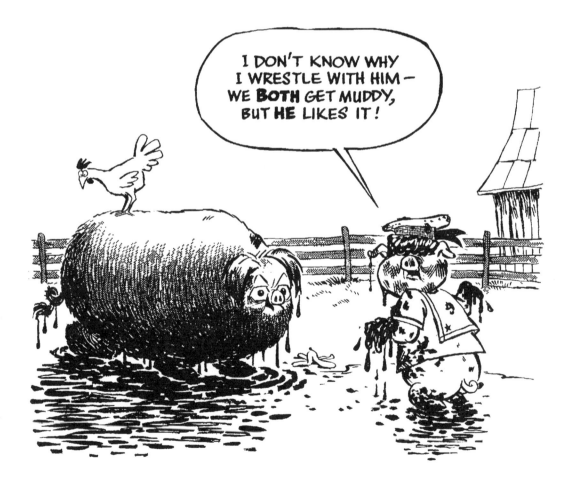

October 16, 1986

The Clinton-White campaign was one of the dirtiest in memory.

November 27, 1986

It was budgeting time again.

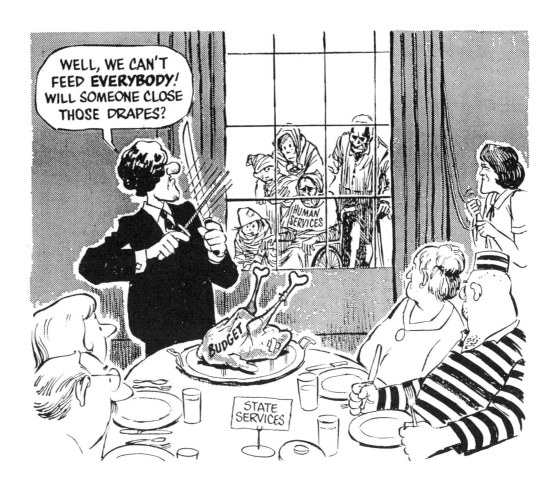

February 10, 1987

Senator Nick Wilson of Pocahontas, the president pro tempore of the Senate, got to be governor when Clinton was out of the state and made the most of it.

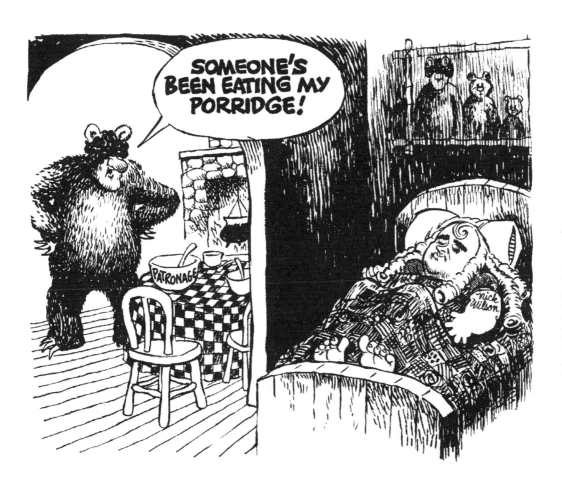

155

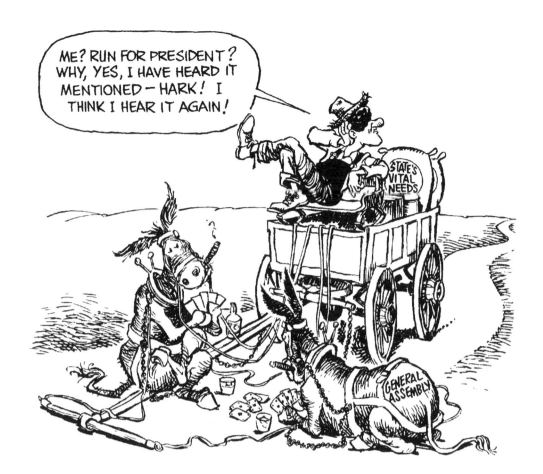

March 3, 1987

Clinton was pre-occupied with the approaching presidential race, and it showed in the legislative halls.

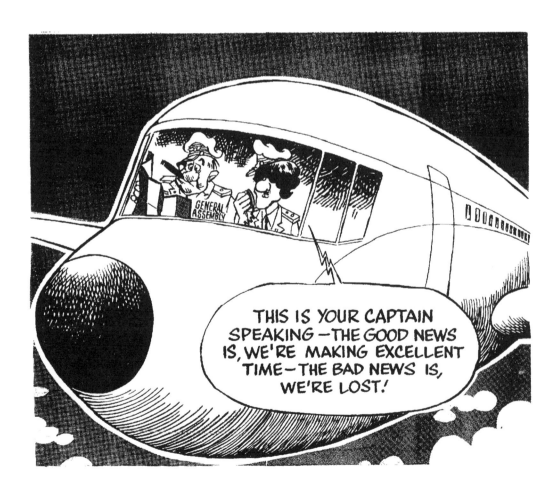

March 5, 1987

April 3, 1987

While the governor was partying in California with film celebrities looking at him as a presidential candidate, the legislature was deliberating on his program with its usual solemnity.

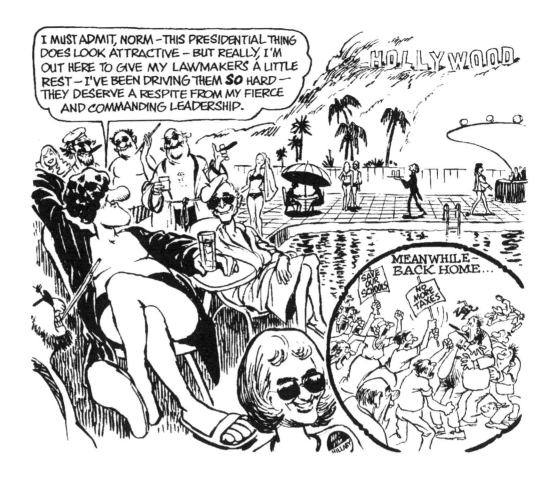

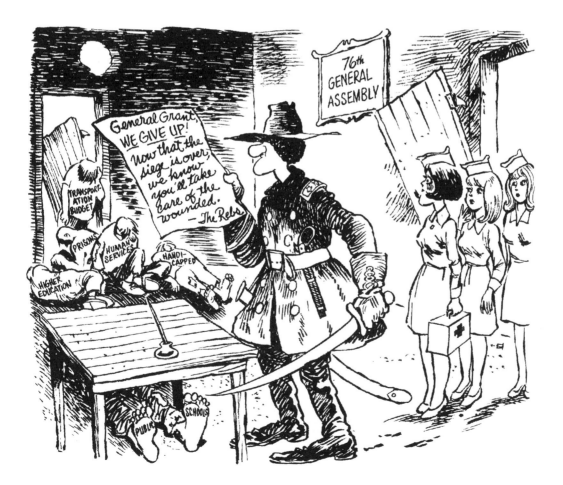

April 7, 1987

The governor compared himself to Grant at Vicksburg in his dealings with the recalcitrant legislature.

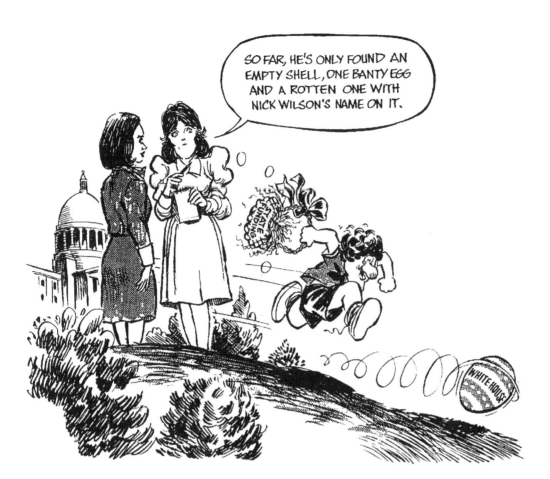

April 19, 1987

Easter at the statehouse.

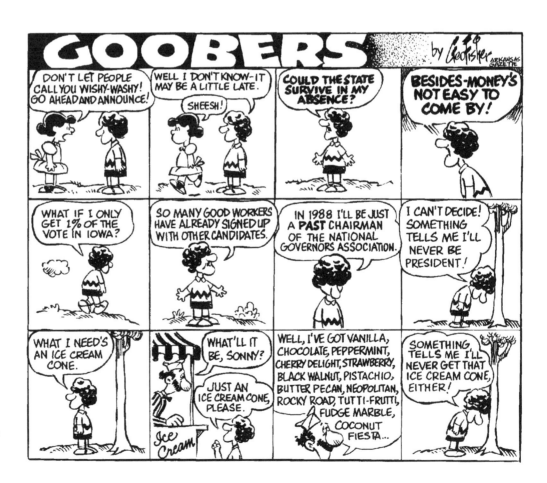

July 2, 1987

July 15, 1987

After summoning the national press to Little Rock for his presidential announcement, Clinton decided not to run.

December 3, 1987

Clinton supported the finance chairman of his campaign for highway director, which seemed to violate the spirit of the Constitution's guarantee of political independence for the highway agency.

January 26, 1988

Clinton called a special session of the legislature to enact legislation to enforce ethical standards on legislators and lobbyists.

February 9, 1988

August 2, 1988

The governor's long-awaited evening in the national spotlight as the nominating speaker at the Democratic National Convention was a bust.

March 12, 1989

Clinton offered an ambitious program of education and tax reform, but the legislature emasculated it.

The Third (Preposterously) Extraordinary Session of 1989

October 27, 1989

The governor and the legislature tried for a third time to correct their errors.

May 20, 1990

Gubernatorial candidate Tom McRae's campaign went downhill after a confrontation with First Lady Hillary Clinton in the Arkansas Capitol rotunda. It was reminiscent of former Governor Frank White's appearance before the Public Service Commission during the 1986 campaign.

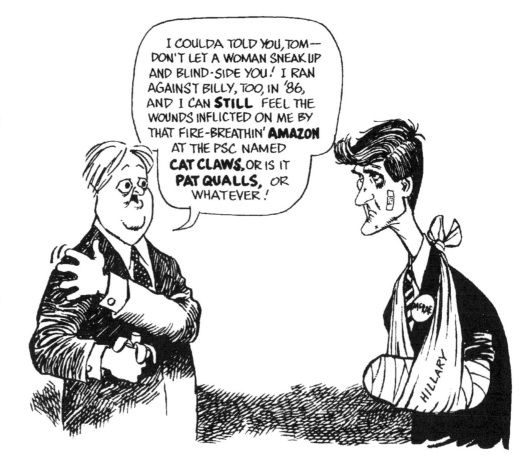

November 8, 1990

Sheffield Nelson
lost to Clinton,
and it wasn't
even close.

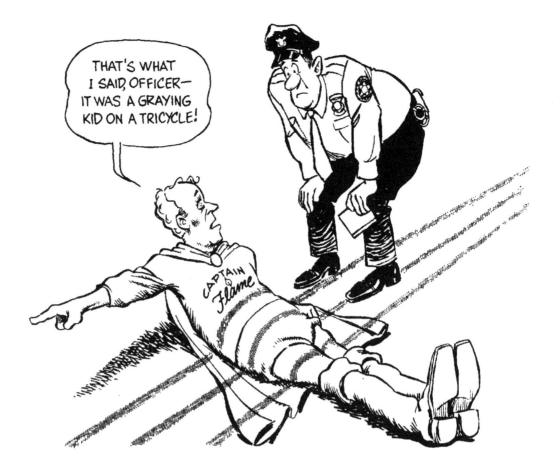

April 17, 1991

Clinton protested,
weakly, that he
hadn't made the
decision to run for
president.

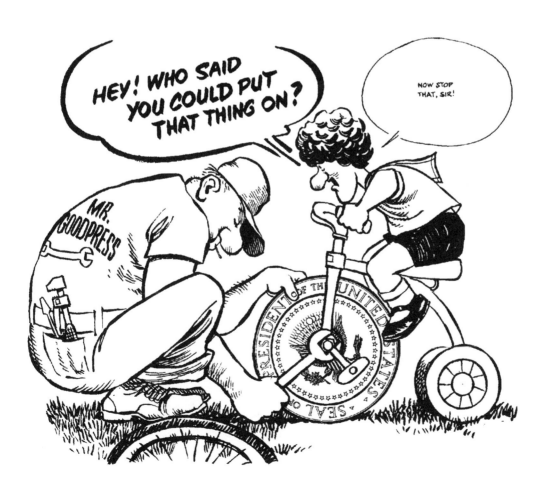

163

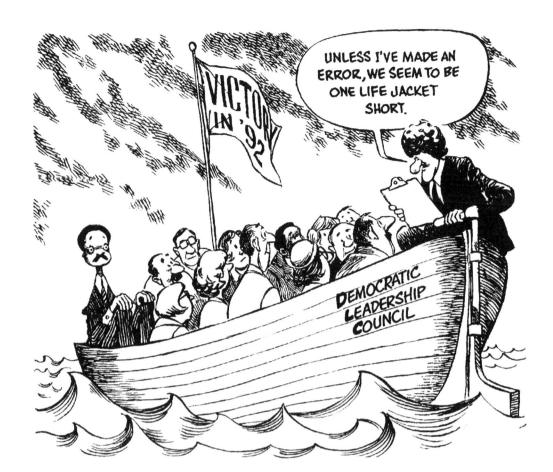

May 6, 1991

Jesse Jackson was the odd man out when Clinton's Democratic Leadership Council assembled.

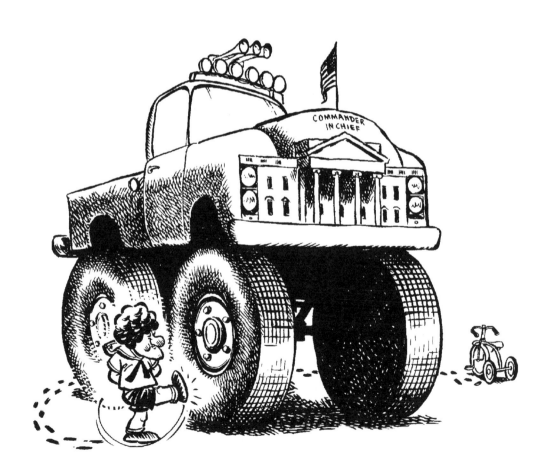

August 21, 1991

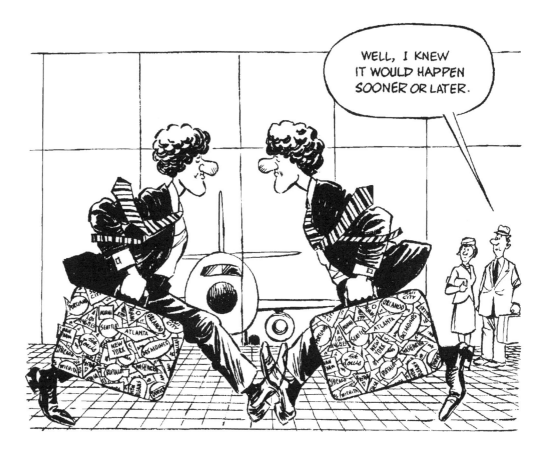

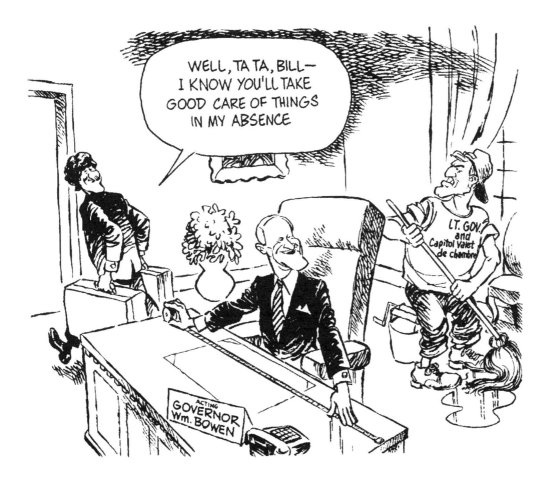

September 25, 1991

Worried that Lieutenant Governor Jim Guy Tucker would exercise too much power in his absence, Clinton named banker Bill Bowen as his executive secretary before taking off to campaign for president.

Good Riddance

Arkansas had barely rid itself of its old statute forbidding the teaching of evolution (the U.S. Supreme Court had to do the deed because the Arkansas Supreme Court actually upheld the law, 6-1) when the religious fundamentalists saw an opening with the election of Frank White as governor. In the closing days of the 1981 legislative session, Senator Jim Holsted of North Little Rock offered a bill that required schools to teach the biblical account of creation in six days (overexertion required God to rest the seventh day) whenever evolution came up in a classroom. It was called "balanced treatment." Told of the bill, White said he'd be obliged to sign it if the boys passed it. They did, and he signed it into law—without reading it, he acknowledged. The federal judiciary, in the person of District Judge William Overton, saved the state's children, if not its pride, by declaring the law unconstitutional.

March 19, 1981

Fundamentalist legislators extracted a
promise from Governor White to sign the
bill if they could pass it.

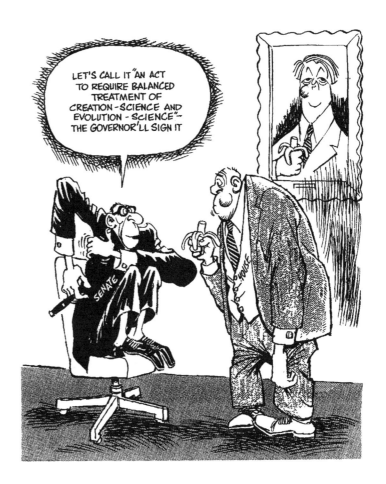

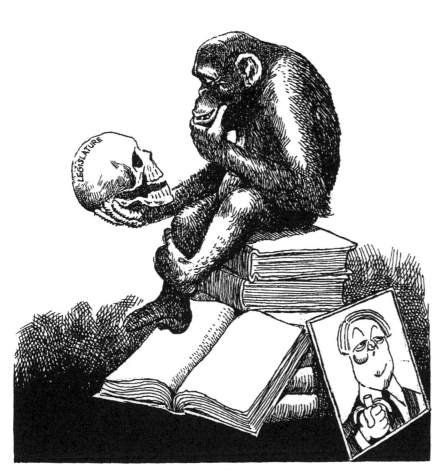

March 24, 1981

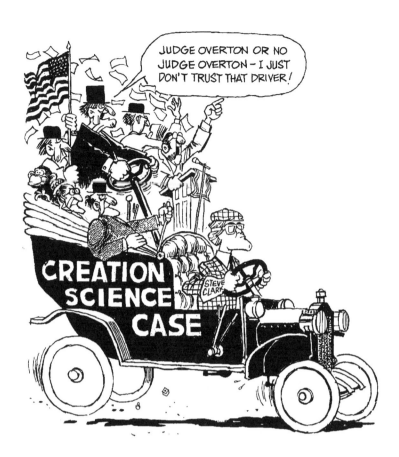

September 2, 1981

Fundamentalist groups didn't trust Attorney General Steve Clark to defend the creation-science bill vigorously in federal court and intervened in the suit.

December 11, 1981

Clark put on the state's defense.

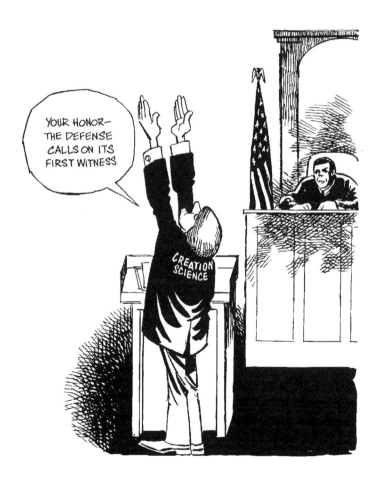

December 18, 1981

Reverend Jerry Falwell of the Moral Majority doubted that Clark was a true believer.

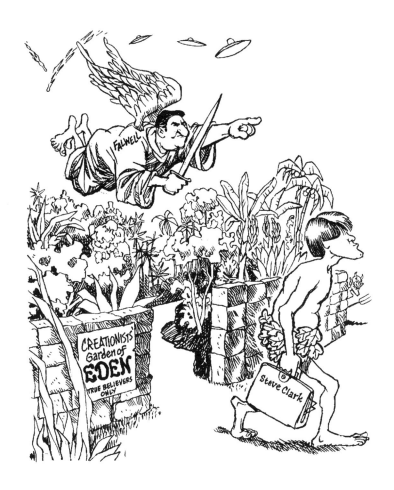

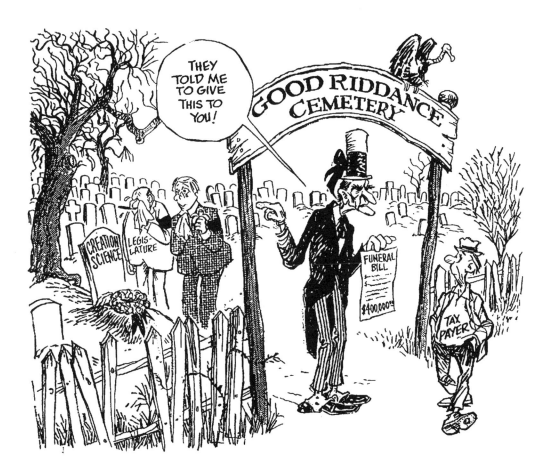

March 22, 1983

The federal court said the state, meaning the tax-payers, had to pay the legal bills for the plaintiffs who had successfully attacked the law.

The Banana Republican

 Having no program of his own when he became governor in 1981, Frank White nevertheless made history by one celebrated act. He signed—without reading, he would admit—a bill requiring public school teachers to teach the biblical account of the creation of the universe and man in six days whenever they taught the theory of evolution. White embarrassed the state, which had to endure yet another monkey trial, and it seemed appropriate that he always carry the simian fruit of preference, the banana. White served a single two-year term and was buried in a landslide in 1982 and again when he tried to make a comeback in 1986. His three races with Bill Clinton were among the meanest in modern times.

A storm broke when White wrote a letter to the Arkansas Governor's School for talented high-school students which said he expected his philosophy, not "garbage," to be taught there.

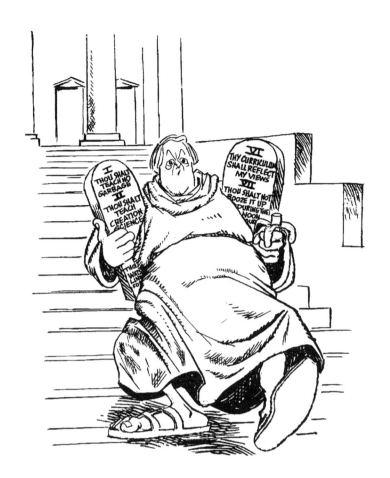

July 23, 1981

During the 1980 campaign, White had made an issue of Cuban refugees coming to Arkansas and taking the jobs of Arkansawyers.

CHIPPENDALE

QUEEN ANNE

HEPPLEWHITE

FRANK WHITE

September 16, 1981

White seemed to have an obsession with executing someone while he was governor.

December 13, 1981

Old-time Republicans were mortified when Orval Faubus showed up in the White administration as director of Veterans' Affairs.

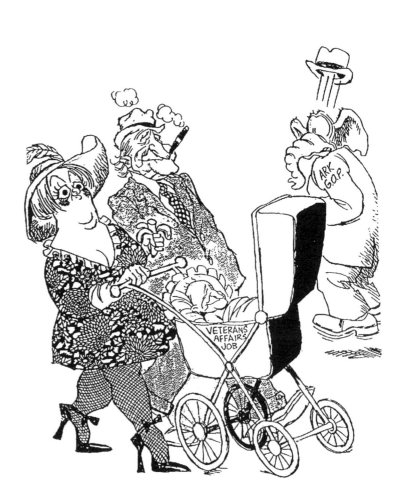

172

July 2, 1982

Clinton kept pressing for a debate in his rematch with White.

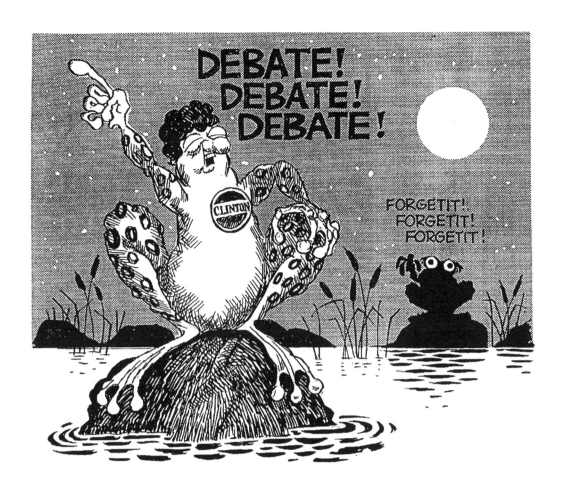

October 31, 1986

The final match between White and Clinton was the dirtiest ever, with White seeking to link Clinton with Dan Lasater, the head of a bond brokerage who went to prison on a drug charge.

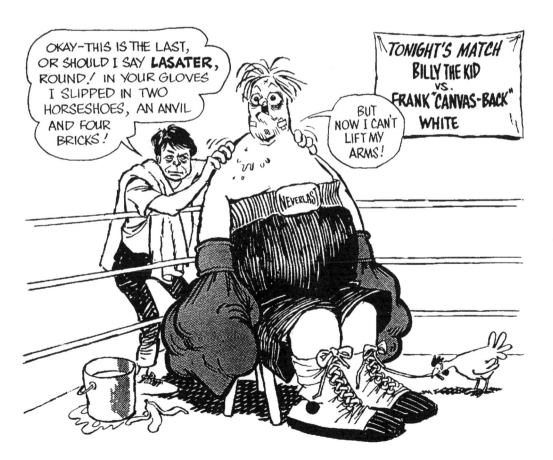

Where the Sun Don't Shine

 How do you caricature a caricature? The cartoonist's tool is hyperbole, but Tommy Robinson took care of it himself. You could only illustrate, not exaggerate, him. As a cop, police chief, state administrator, sheriff, and congressman, Robinson always strove toward higher absurdity. When Sheriff Robinson made an obscene gesture to a young motorist, no one was amazed. When Congressman Robinson, at a public forum, told a highly respected woman who had a petition against nuclear missiles in her community to "stick it where the sun don't shine," no one was shocked. And when the books were finally opened on Arkansas in the House of Representatives bank in 1992 and they showed that no one had come close to Tommy Robinson in writing hot checks on his account at the bank—nearly one thousand in less than three years—no one was surprised.

May 22, 1982

Sheriff Tommy Robinson and his deputies raided a private "toga party" at the old Sam Peck Hotel and arrested people for lewd conduct.

IT'S TWO O'CLOCK IN THE MORNING...

DO YOU KNOW WHERE YOUR SHERIFF IS?

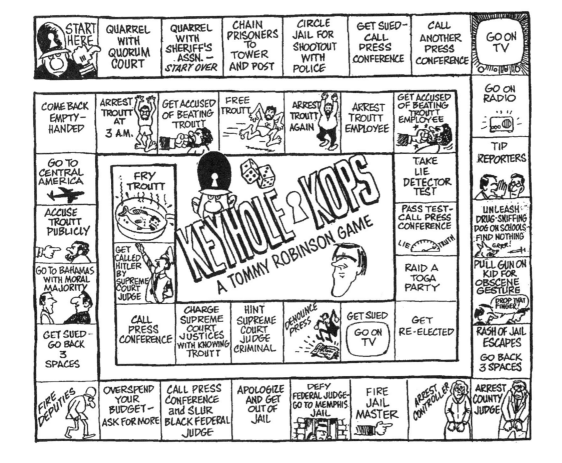

June 22, 1982

Robinson made the front page nearly every day, usually for something bizarre.

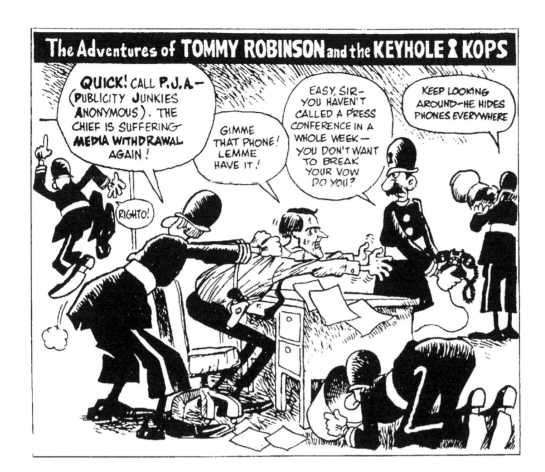

June 29, 1982

Robinson said he was going to quit talking to the press.

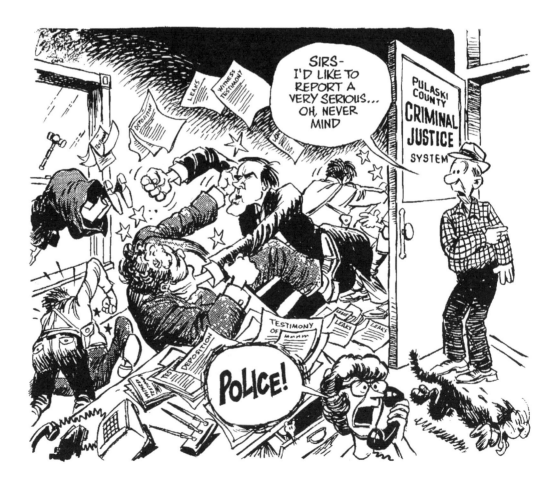

September 7, 1982

January 6, 1983

Prosecutor Wilbur C. "Dub" Bentley was trying to prosecute the murderers of Alice McArthur, but Robinson, on a witch hunt of his own, threatened to jail Bentley.

Where the Sun Don't Shine

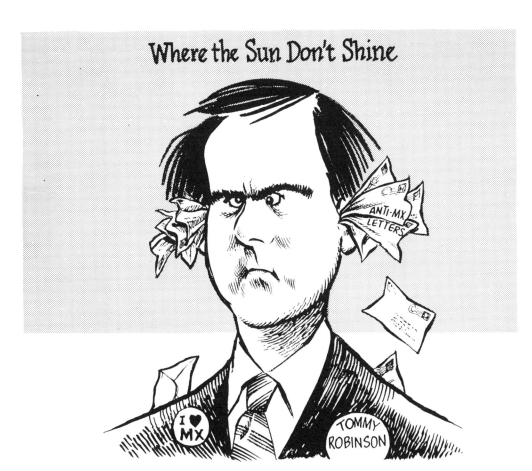

April 28, 1988

At a public meeting, Congressman Robinson told an elderly woman who wanted to give him some petitions protesting the locating of a new kind of nuclear missile at sites around Little Rock to "stick them where the sun don't shine."

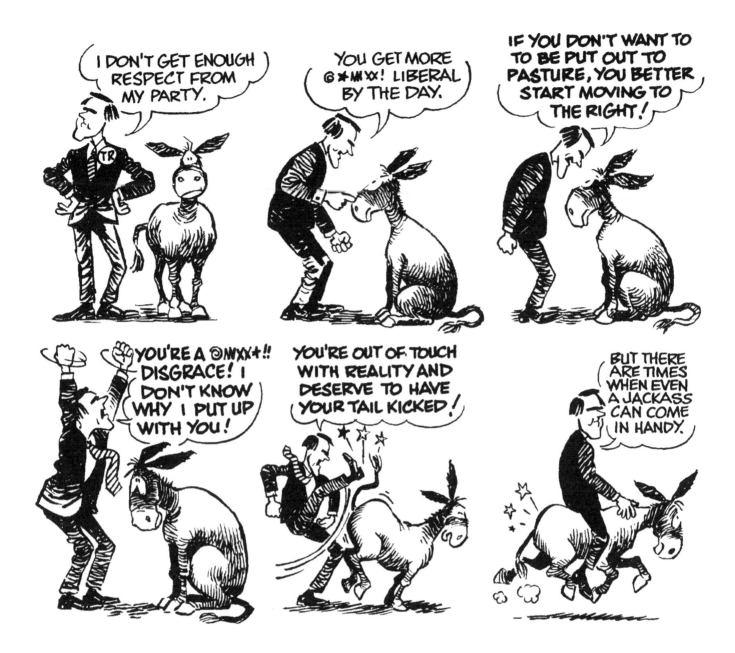

February 10, 1989

Robinson said the Democratic party had strayed too far to the left, but he said he would not switch to the Republican party, which was wooing him.

March 1, 1989

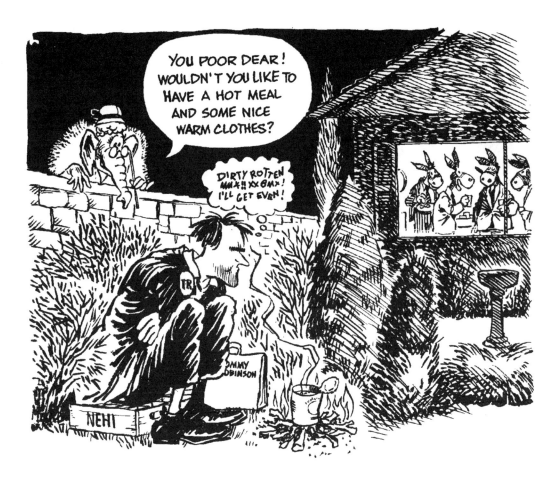

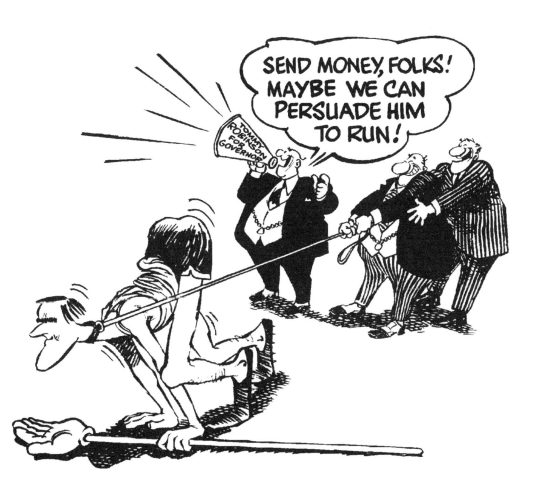

April 27, 1989

Business backers of Tommy Robinson began raising money to encourage him to run for governor.

179

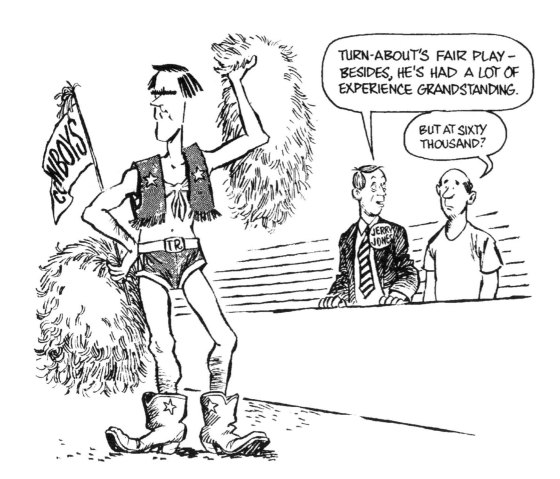

May 9, 1989

Jerry Jones, Robinson's old pal and benefactor, bought the Dallas Cowboys football franchise and began having trouble with the Cowboys cheerleaders.

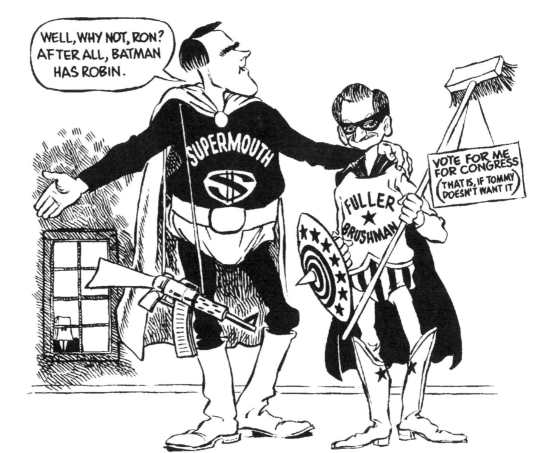

September 12, 1989

State Representative Ron Fuller of Little Rock said that he'd be willing to be congressman from the Second District if the great man didn't want the job any longer.

October 10, 1989

Old pals Sheffield Nelson and Tommy Robinson switched parties and ran for governor. What followed was not a model of civilized discourse.

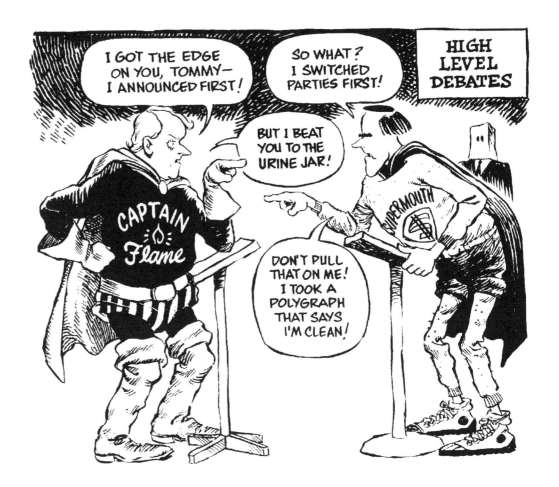

November 9, 1989

It was beginning to be hard to keep up with the political and financial alliances of old gas cronies. It seemed at times that Jackson T. Stephens was calling the shots from behind the scenes.

181

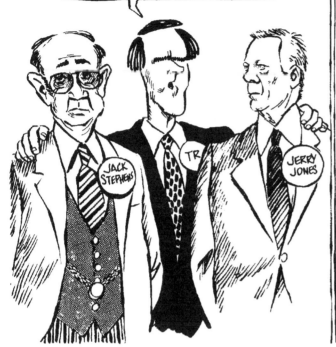

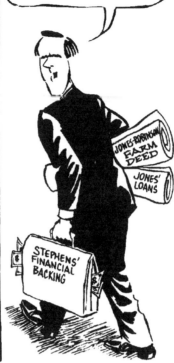

November 15, 1989

There were suggestions that Robinson promoted the interests of his financial backers in Washington.

December 12, 1989

Robinson began to criticize Sheffield Nelson's gas deals with Robinson's childhood buddy and principal benefactor, Jerry Jones. Jones supported Nelson and called his massive notes to Robinson.

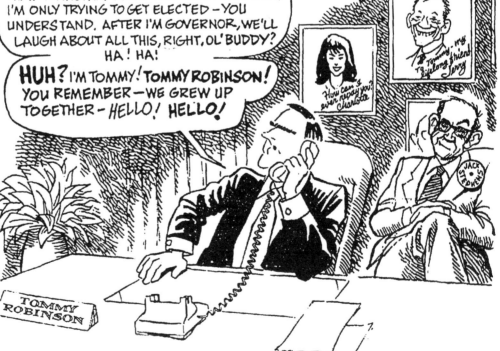

182

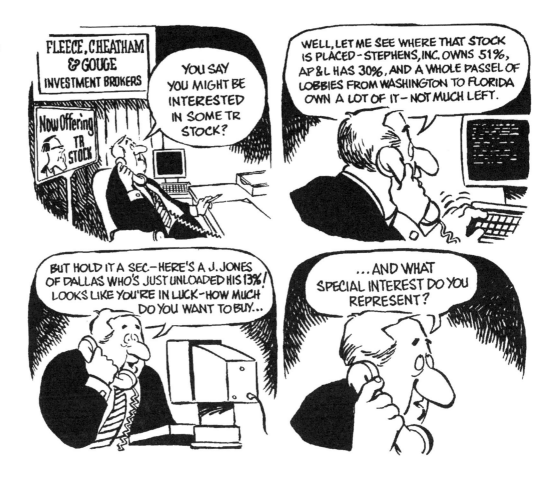

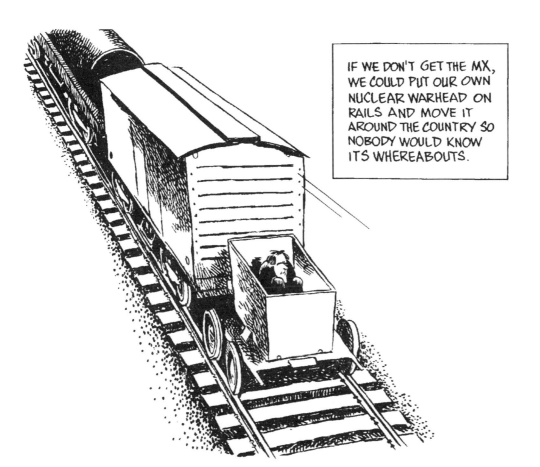

December 28, 1989

Robinson urged
the Defense
Department to
put MX missiles
in Arkansas.

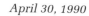

April 30, 1990

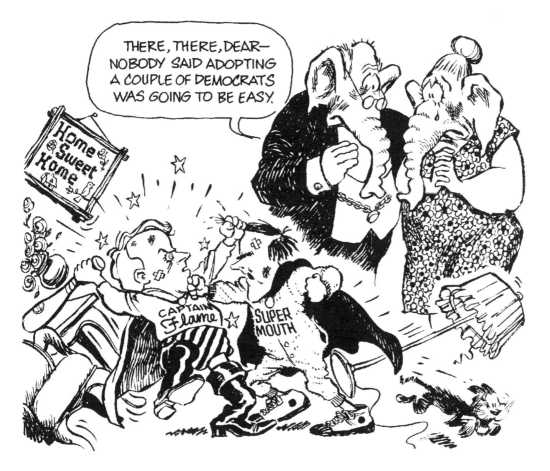

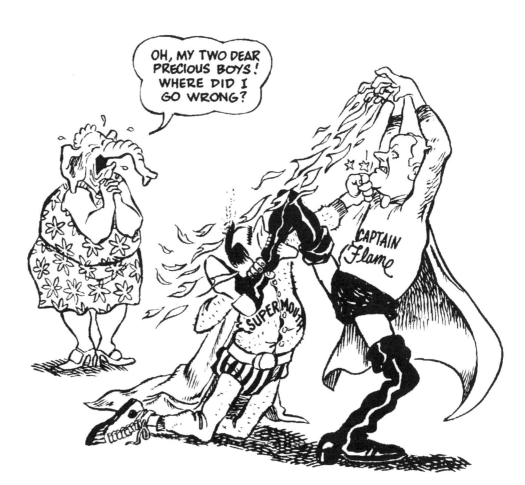

September 11, 1990

Robinson called
a "unity plan"
under which
two defeated
Republican can-
didates would
be cochairmen
of the party the
"disunity plan"
and said he
wouldn't sup-
port them.

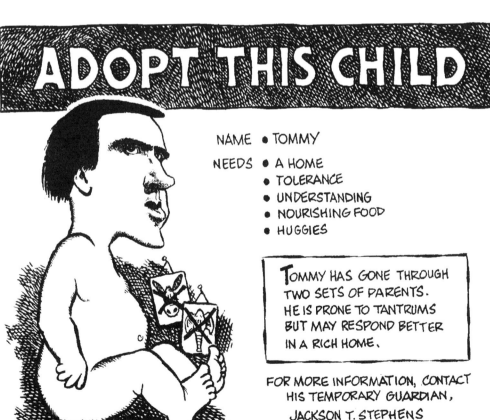

ADOPT THIS CHILD

NAME ● TOMMY

NEEDS ● A HOME
● TOLERANCE
● UNDERSTANDING
● NOURISHING FOOD
● HUGGIES

Tommy HAS GONE THROUGH
TWO SETS OF PARENTS.
HE IS PRONE TO TANTRUMS
BUT MAY RESPOND BETTER
IN A RICH HOME.

FOR MORE INFORMATION, CONTACT
HIS TEMPORARY GUARDIAN,
JACKSON T. STEPHENS

February 14, 1991

Defeated,
Robinson went
home to farm.

Communism— Requiescat in Pace

It turned out that Marx had made a small miscalculation. It was communism, not democratic capitalism, that had internal contradictions and carried the seeds of its own destruction. The termites had already eaten away the foundation of communism—we just wouldn't believe the evidence—but everyone was shocked by the rapid pace of the destruction of the vast communist empire. It was sped along by the force of one man—Mikhail Gorbachev. Maybe there is truth after all to the popular American axiom, "One person can make a difference."

May 16, 1985

WORLD HISTORY LESSON by GeoFisher

SINCE THE BEGINNING OF TIME, NATIONS, IN THEIR FEAR AND FOLLY, HAVE BUILT MYRIADS OF OBSTACLES TO KEEP OUT THEIR HATED ENEMIES WHO HAVE ALWAYS FOUND WAYS TO PENETRATE THEM.

The Walls of Troy

The Great Wall of China

The Maginot Line

The Siegfried Line

Sandbag Walls in Beirut

Star Wars

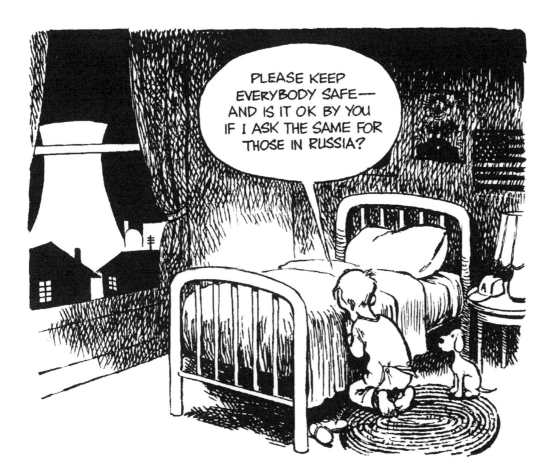

PLEASE KEEP EVERYBODY SAFE— AND IS IT OK BY YOU IF I ASK THE SAME FOR THOSE IN RUSSIA?

May 1, 1986

The catastrophe at the Chernobyl power plant reminded us of the dangers of nuclear power.

187

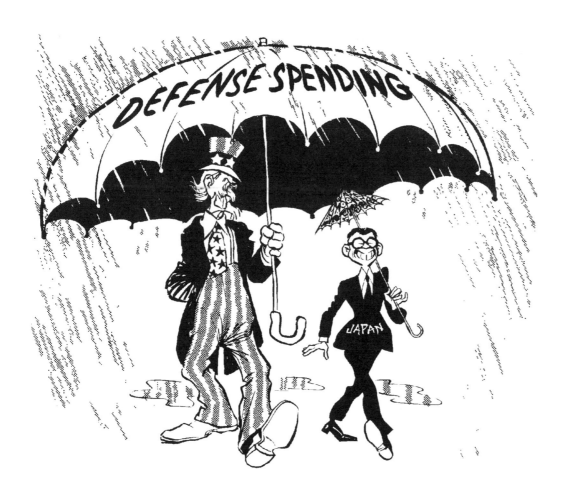

October 2, 1987

Barred by its constitution from spending much on defense, Japan could bask under the American umbrella and concentrate on becoming the world's greatest commercial power.

June 6, 1989

The army's slaughter of democracy protesters in Tiananmen Square ended the illusion of enlightenment in China.

June 13, 1989

Preoccupied with
internal troubles,
the Soviet Union
abandoned the
promotion of
communism in
the western
hemisphere.

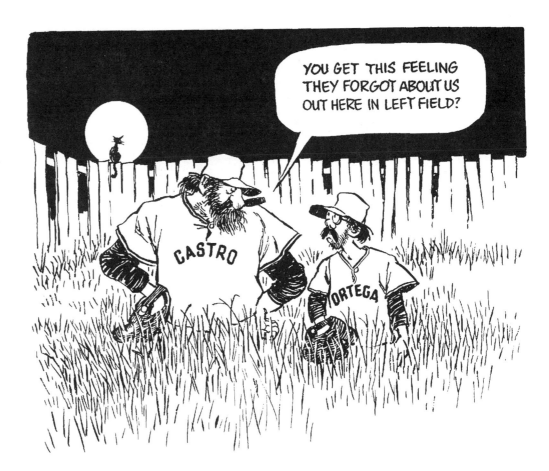

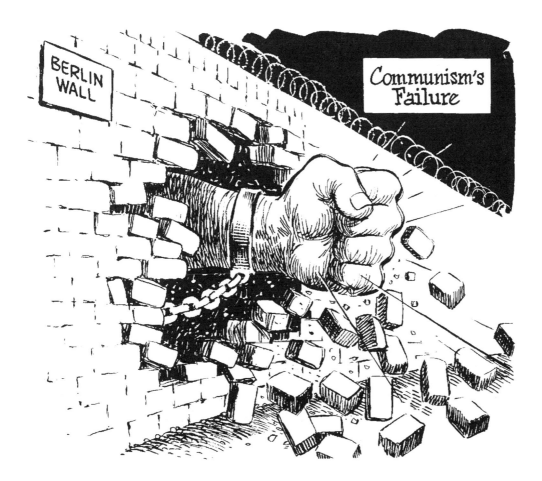

November 14, 1989

January 11, 1990

There seemed to be an inconsistency in the Bush administration's treatment of a couple of tyrants. He sought to bestow most-favored-nation status on the more brutal.

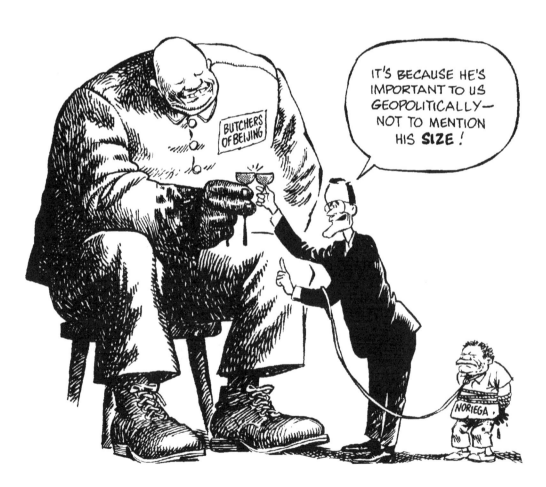

February 6, 1990

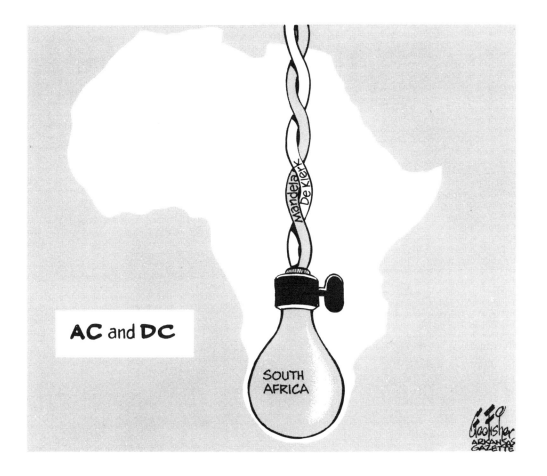

AC and **DC**

SOUTH AFRICA

Mandela / De Klerk

February 25, 1990

It seemed impossible: the collaboration of the white government of South Africa and black freedom fighter Nelson Mandela.

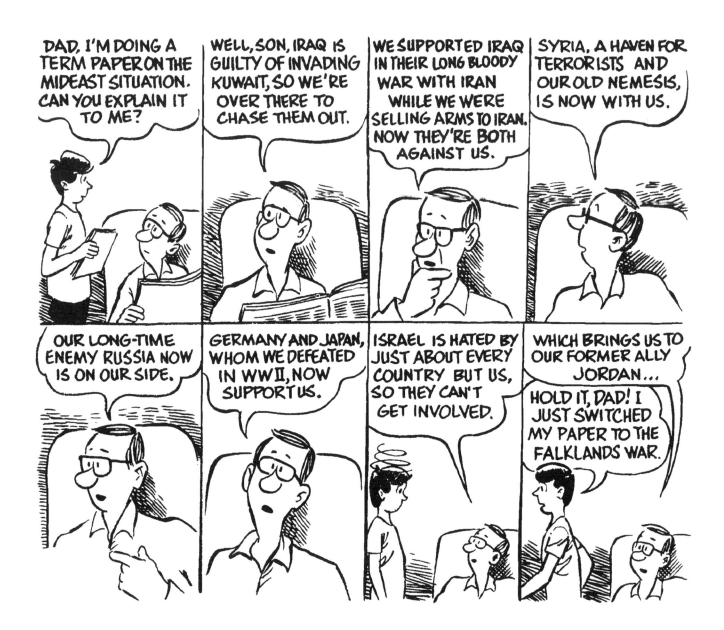

November 16, 1990

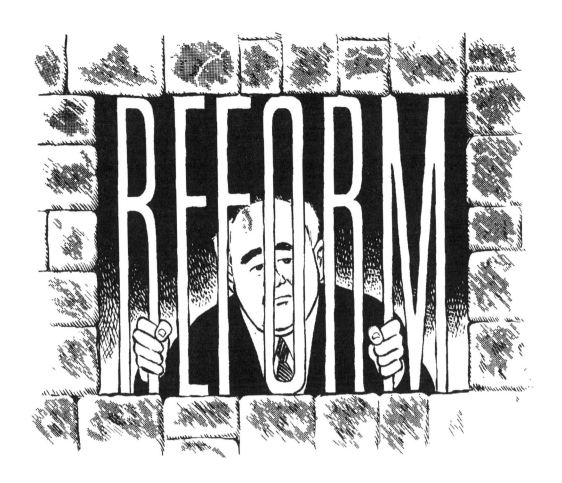

January 24, 1991

Mikhail Gorbachev could not control the impulses of freedom and democracy that he had set in motion.

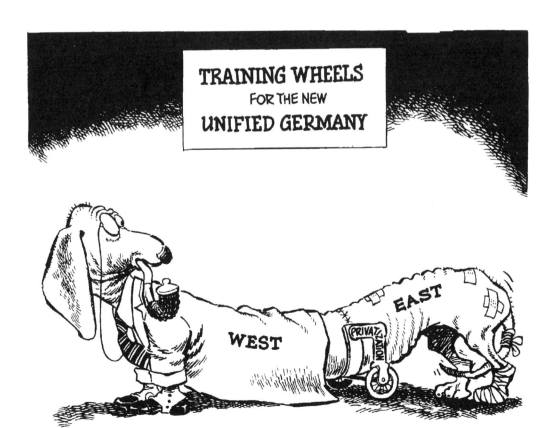

TRAINING WHEELS
FOR THE NEW
UNIFIED GERMANY

March 29, 1991

The transition to a unified Germany wasn't easy.

193

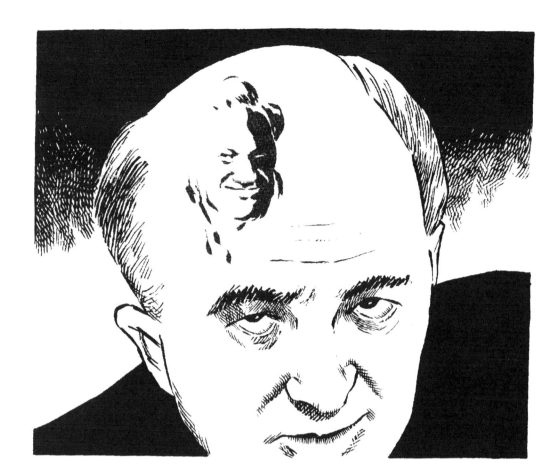

June 28, 1991

Gorbachev began to be eclipsed by his old protege, Boris Yeltsin.

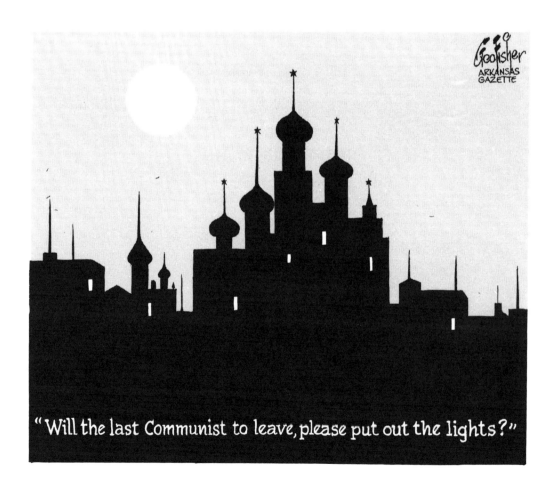

July 7, 1991

"Will the last Communist to leave, please put out the lights?"

July 28, 1991

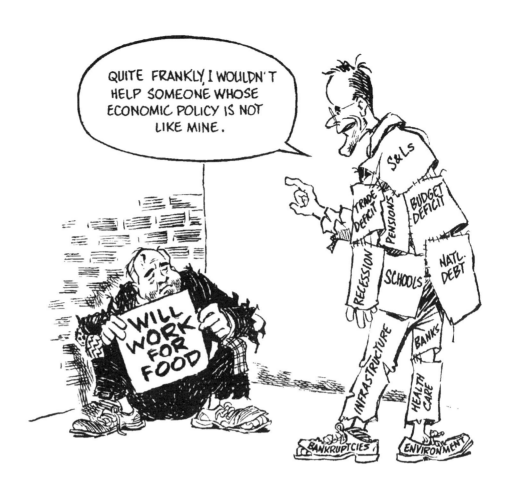

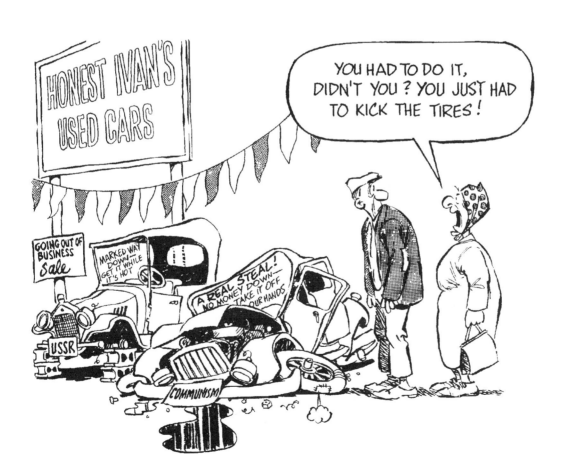

September 3, 1991

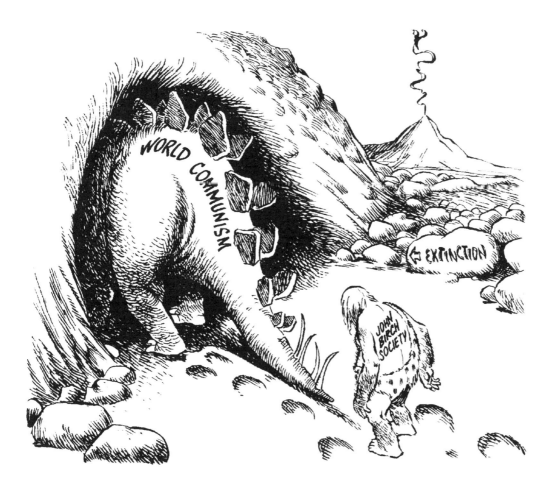

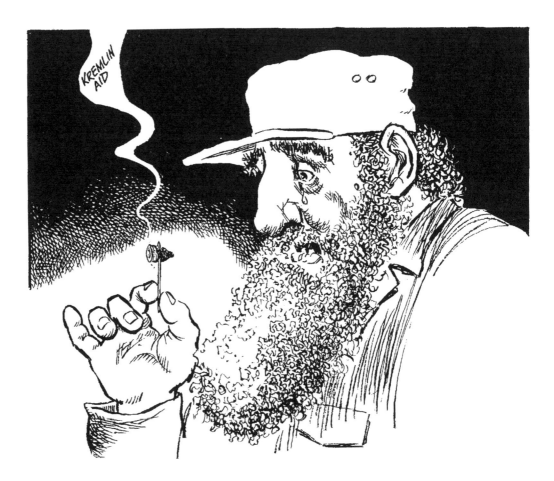

Church of the Nine Commandments

 Television made the American people, with their deep religious impulses, more vulnerable to the ersatz piety of money-grubbing preachers. But as their financial empires expanded in the 1980s, the slick TV preachers overreached. They grasped for political power and encroached on each other's turf. Sex and money scandals brought some of them down, and so sullied by the scandals was the whole TV soul-saving business that even pious Jerry Falwell's financial and religious empire crumbled.

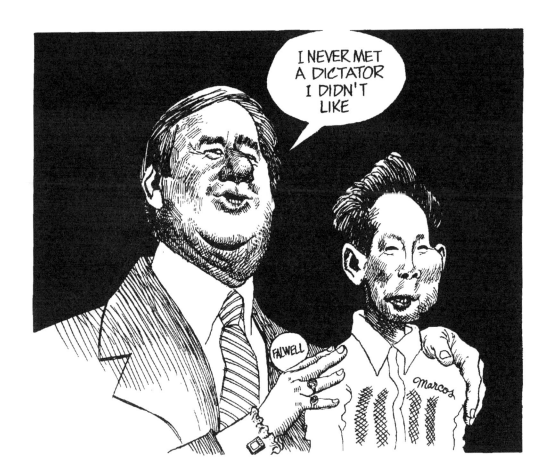

November 15, 1985

Falwell expressed
his admiration
for the Philippine
dictator Ferdinand
Marcos.

January 30, 1987

His gospel empire
pinched for
money, Oral
Roberts said God
would call him
home if his
money-raising
goal wasn't
reached. God
changed his mind.

September 27, 1987

Reverend Jerry
Falwell led the
condemnations
of Jim and
Tammy Bakker.

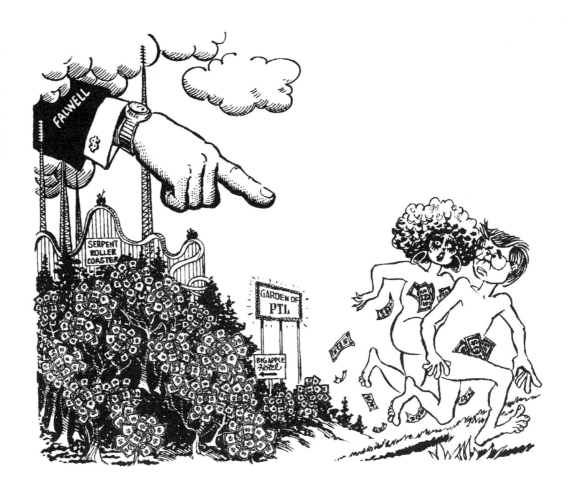

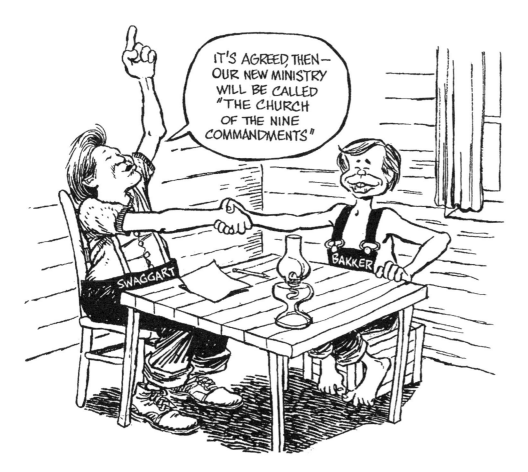

February 23, 1988

Reverend Jimmy
Swaggart, like
Bakker, was caught
patronizing loose
women.

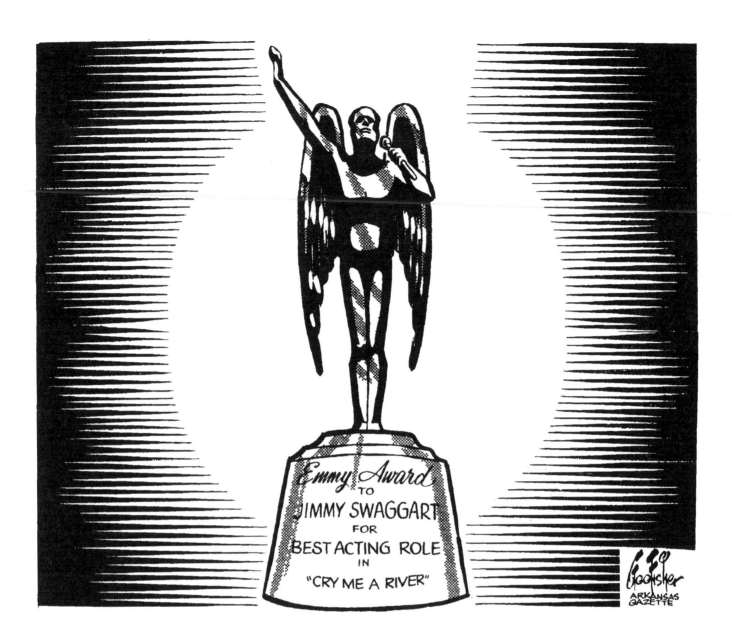

March 2, 1988

Swaggart returned to the pulpit, wept and said he had
sinned and been forgiven. Later, he got caught again.

The Vision Thing

George Bush may have had the most impressive resumé in the history of the American presidency, and he had a dogged Nixonian lust for the job. The problem was that he never seemed to have much idea of what to do with the job when he got it. He promised to be the education president, the environmental president, and the health-care president, but he never got beyond the proclamation of those goals.

March 25, 1987

Vice President Bush's name kept popping up in the Iran-contra mess, but the evidence of his role was never definitive.

August 16, 1988

August 18, 1988

September 29, 1988

Bush made a shocking choice for a running mate, a lightly regarded senator from Indiana known chiefly for his golfing prowess.

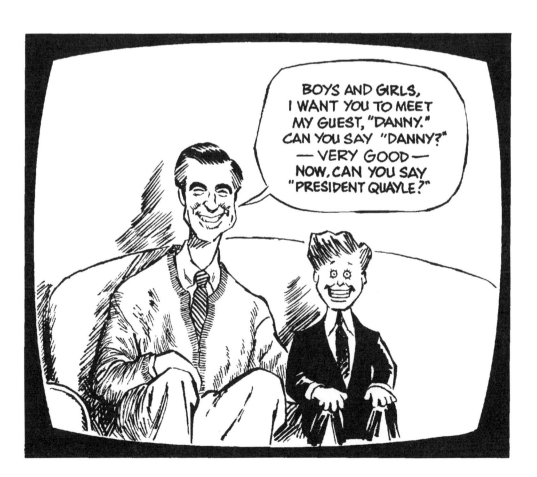

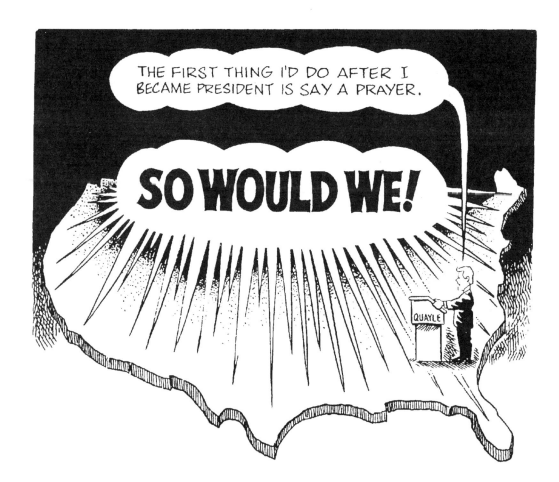

October 13, 1988

In a debate, Quayle was asked what his first act would be after he became president.

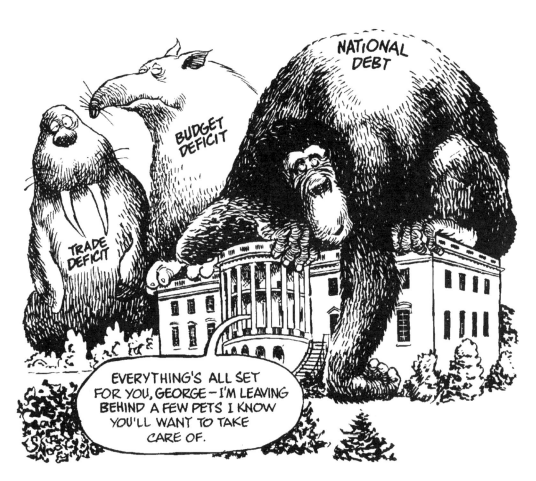

November 6, 1988

March 14, 1989

In the first weeks of his term, Bush saw the Senate reject his nominee for secretary of defense, John Tower.

May 5, 1989

With budget "summits," splits within the congressional ranks of both parties, and divisions within the White House itself, it was clear that the budget was going to be a mess.

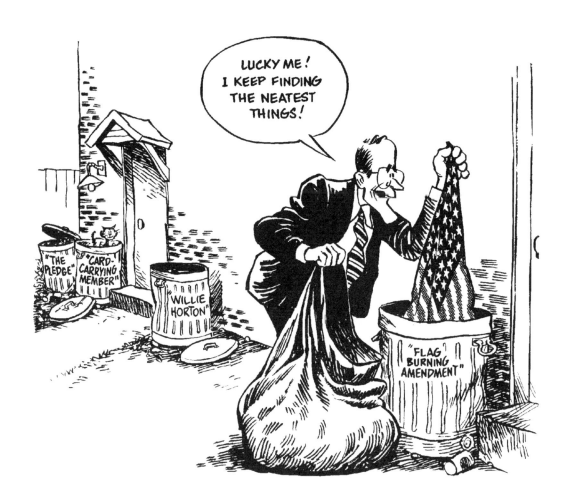

July 2, 1989

Bush found a handy issue to demagogue when the U.S. Supreme Court said citizens had the right to burn the American flag in protest.

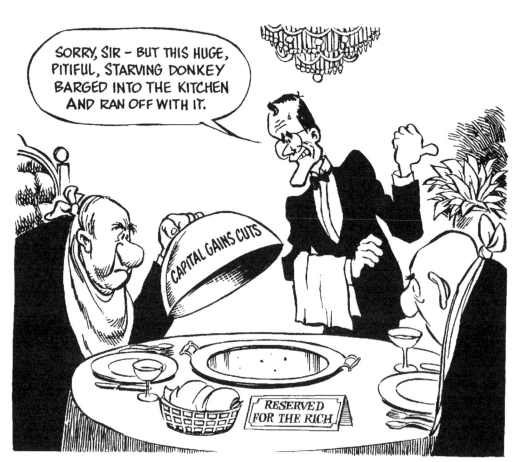

November 10, 1989

During the campaign Bush promised a tax cut on the profits of investors who sold off their assets, but Democrats in Congress wouldn't buy it.

April 15, 1990

President Bush came out with his big transportation initiative. It called for less initiative by the federal government and assumed that higher taxes would be imposed by the states.

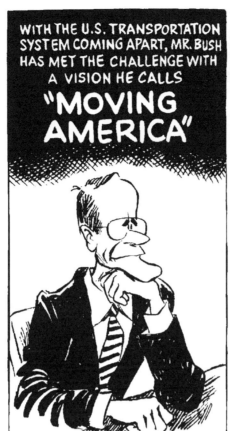

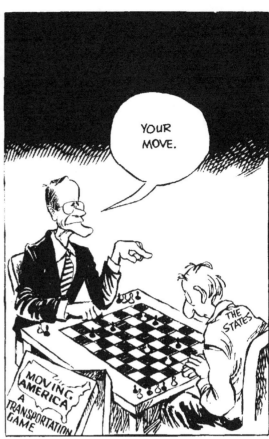

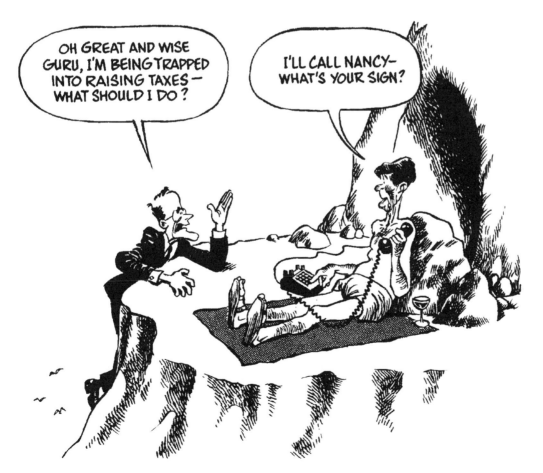

May 15, 1990

With the deficit mounting, Bush found himself under pressure, even in his own party, to raise taxes. Like Reagan, he had promised not to raise taxes and, like Reagan, he violated the pledge.

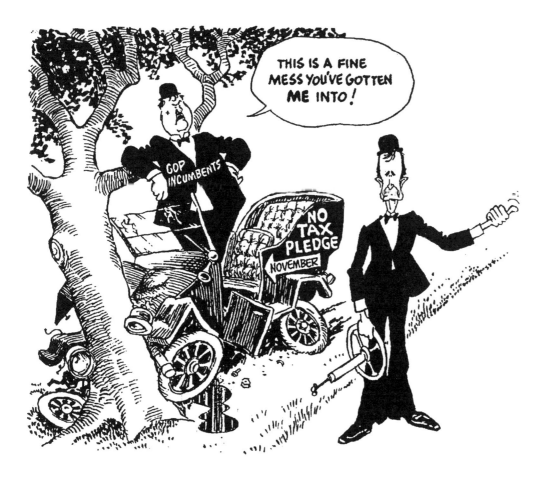

July 25, 1990

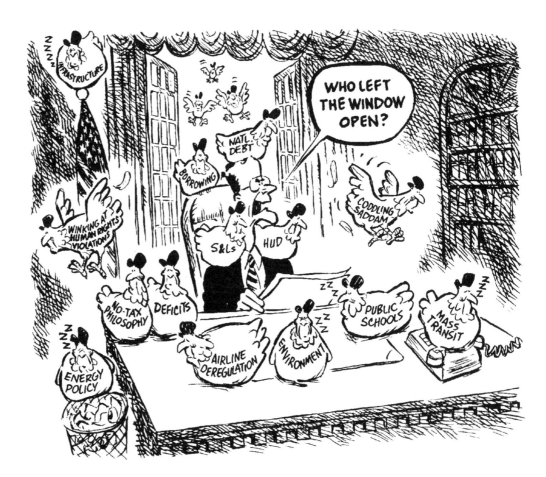

October 11, 1990

October 12, 1990

Bush kept changing signals on the budget and taxes. Conservatives in his own party were getting sore. They had banked on his campaign promise, "Read my lips: No new taxes."

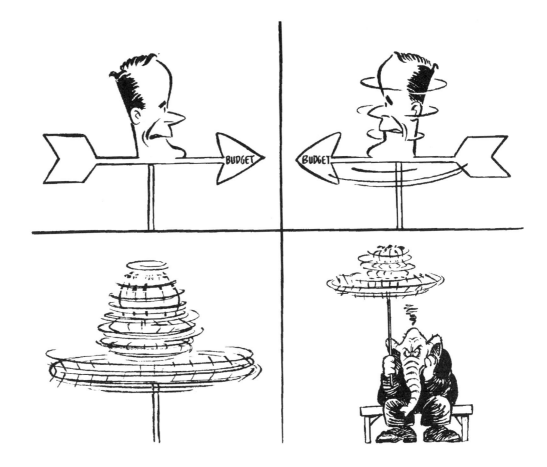

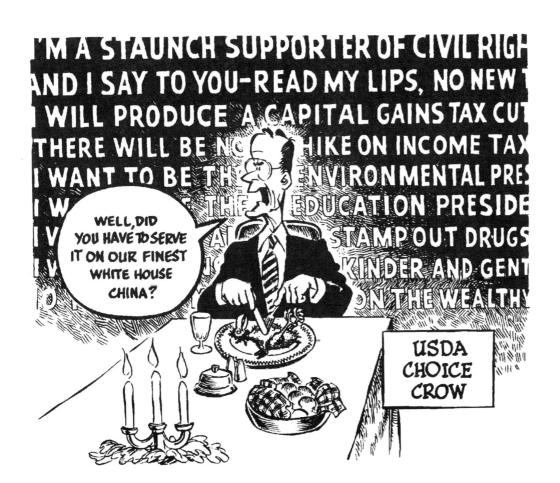

October 23, 1990

Finally, Bush endorsed and signed a tax increase.

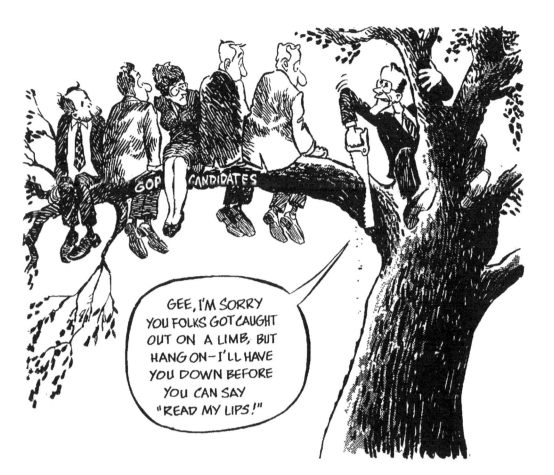

October 28, 1990

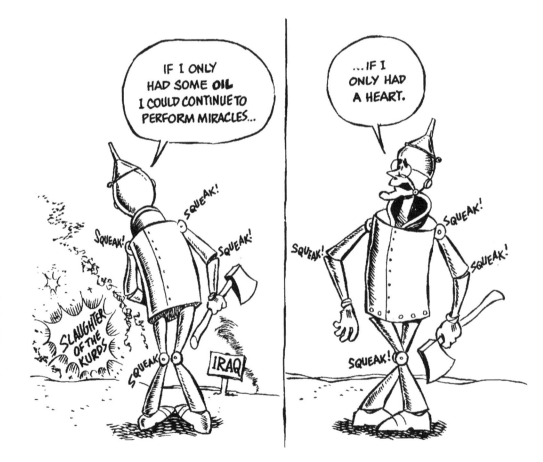

April 11, 1991

Bush urged the
Kurds and other
Iraqis to revolt but
then watched
Saddam Hussein
brutally suppress
the rebellion.

April 28, 1991

White House Chief of Staff John Sununu took elaborate personal junkets on the taxpayers' tab.

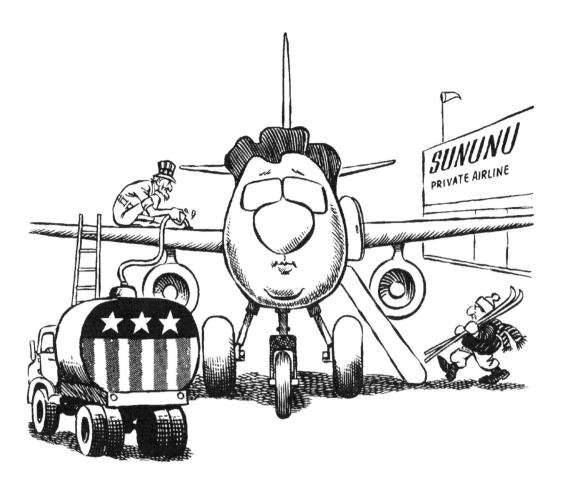

May 10, 1991

It made no difference what a civil rights bill contained or whether a Republican or a Democrat sponsored it, Bush uttered a single judgment about it.

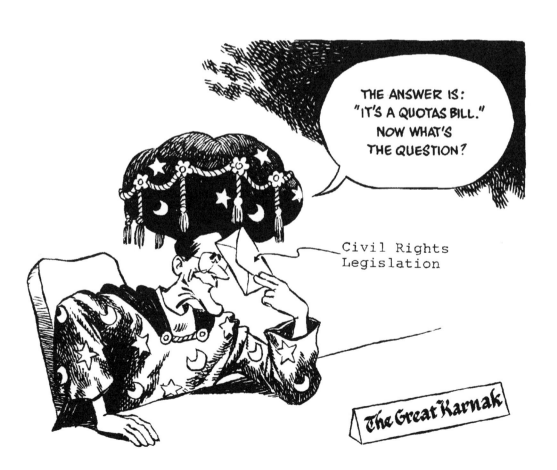

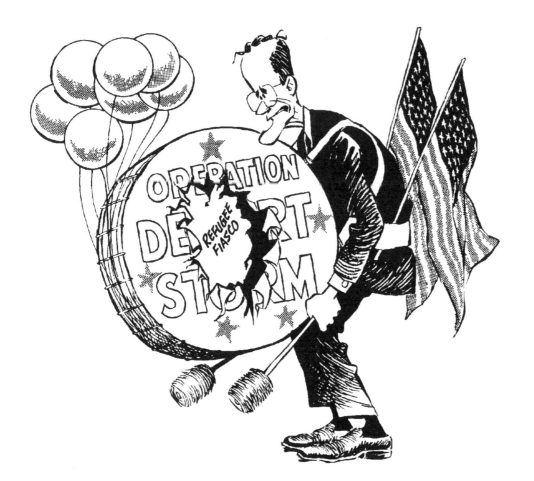

May 17, 1991

The plight of Iraqis fleeing the genocide of Saddam Hussein muted the celebrations of Bush's great victory.

May 19, 1991

After the massacre of freedom demonstrators at Tiananmen Square, Bush decided that China deserved favored trading status with the United States.

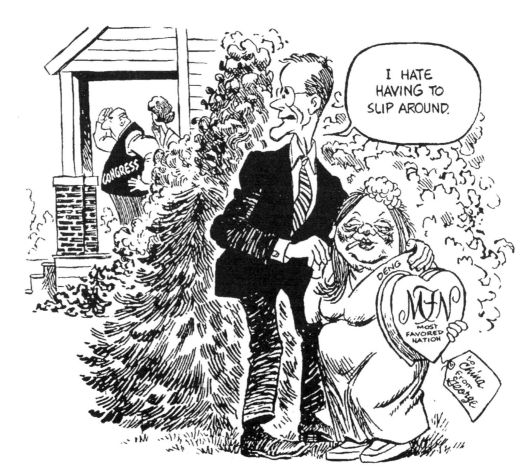

August 2, 1991

World Agenda | Domestic Agenda

While the president was reveling in cheers for the commander in chief, the country was falling apart. He seemed to have no idea what to do about it.

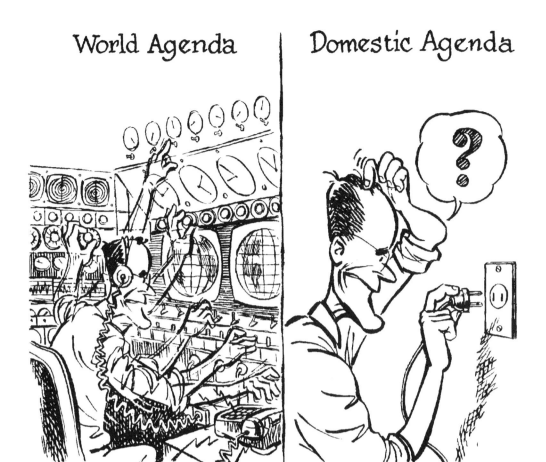

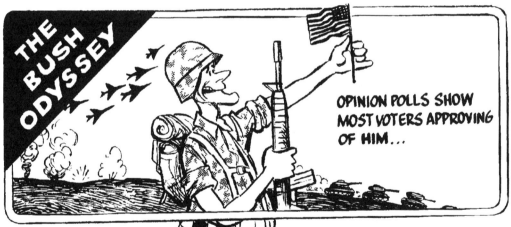

THE BUSH ODYSSEY

OPINION POLLS SHOW MOST VOTERS APPROVING OF HIM...

...BUT NOT OF THE DIRECTION HE IS TAKING US.

DOMESTIC ISSUES

September 11, 1991

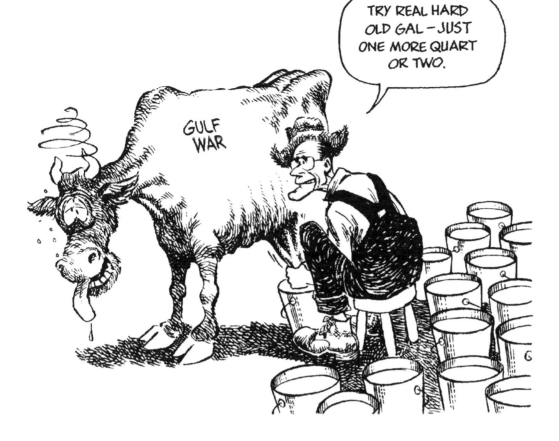

October 10, 1991

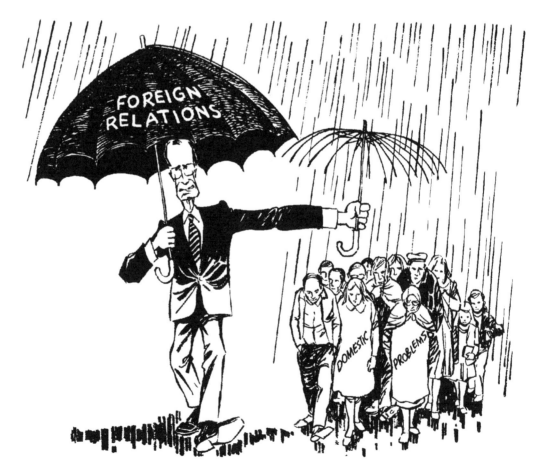

October 18, 1991

214

The Rich Get Richer, the Poor Get Poorer

 George Bush called it "voodoo economics" before he became the witch doctor's apprentice. Ronald Reagan said it would be no trick at all to slash the taxes of the well-to-do, multiply the most destructive military arsenal on the planet, balance the budget, and make the country safe and prosperous. He fell about $2.5 trillion short of balancing the budget. The borrowing financed a ten-year party, but only about 1 percent of the American people got invitations.

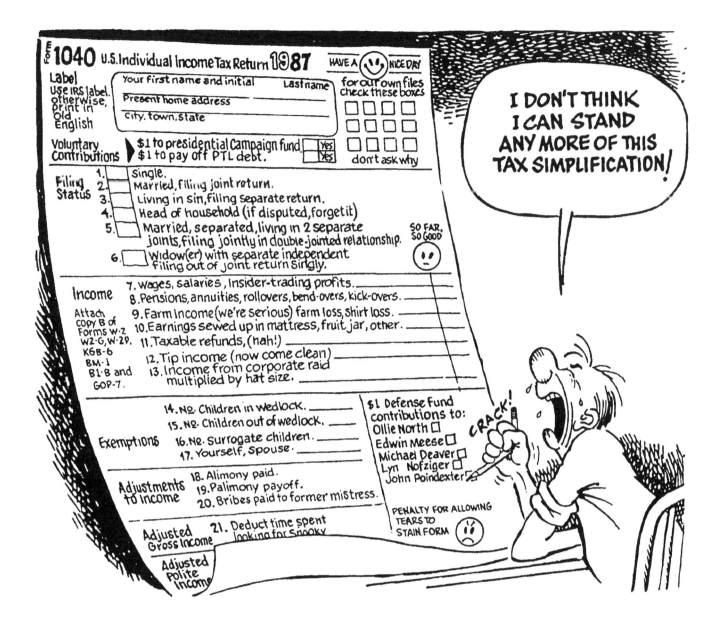

January 27, 1988

The tax-reform act of 1986 was supposed to simplify tax filing.

S&Ls' new drive-through window

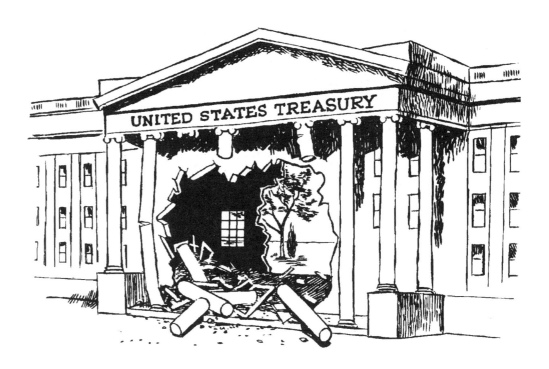

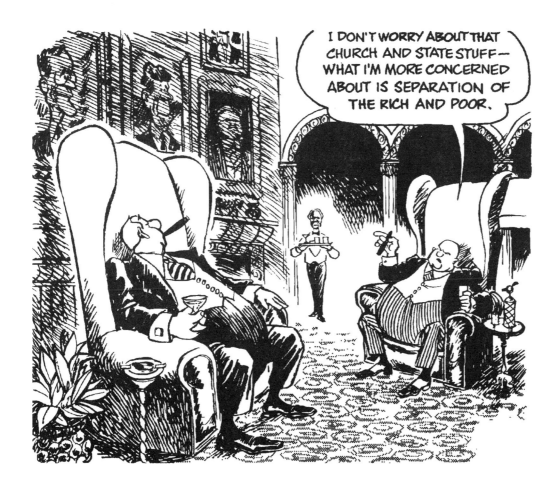

May 7, 1989

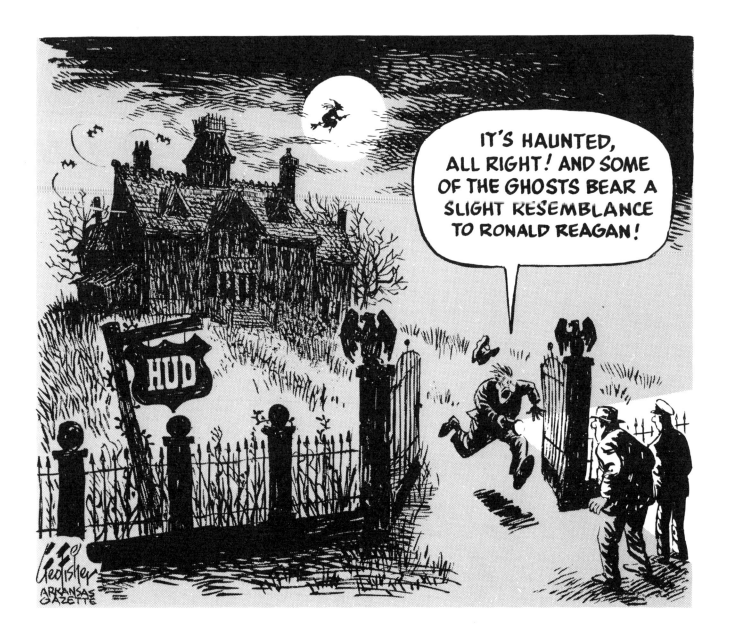

June 22, 1989

The Department of Housing and Urban Development
was running a slush fund for Republicans.

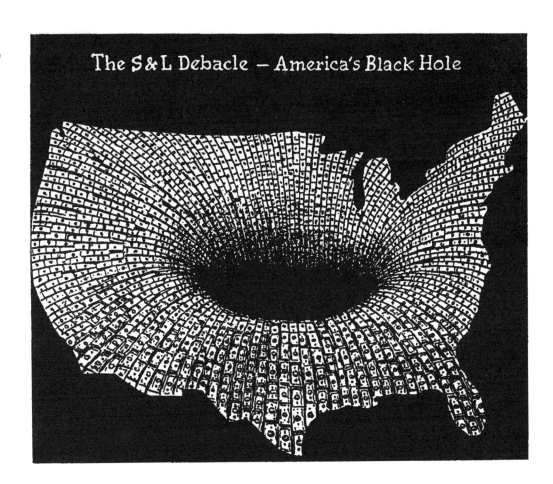

April 5, 1990

The S & L Debacle — America's Black Hole

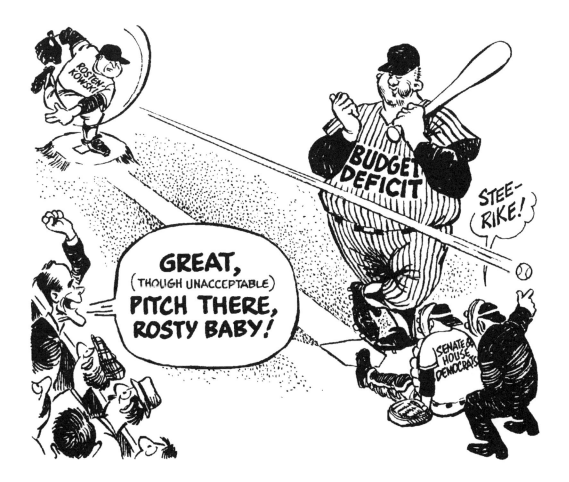

April 26, 1990

Bush praised a budget-reduction plan of Ways and Means Chairman Dan Rostenkowski's but said he'd probably veto it.

219

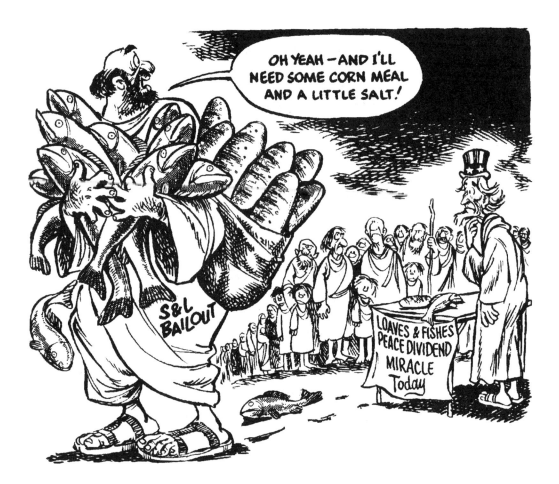

April 29, 1990

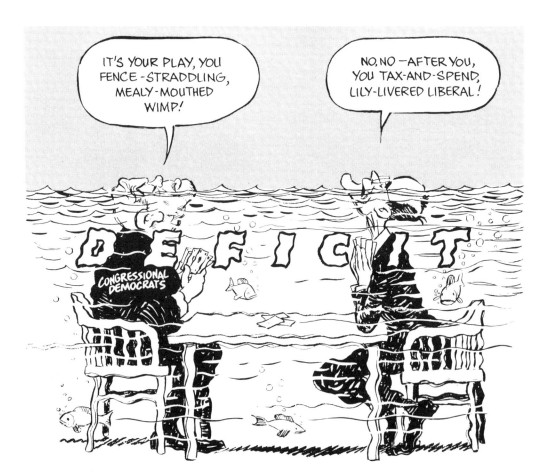

May 17, 1990

May 25, 1990

The country became absorbed with flag-burning after the U.S. Supreme Court ruled that it was a protected form of free speech.

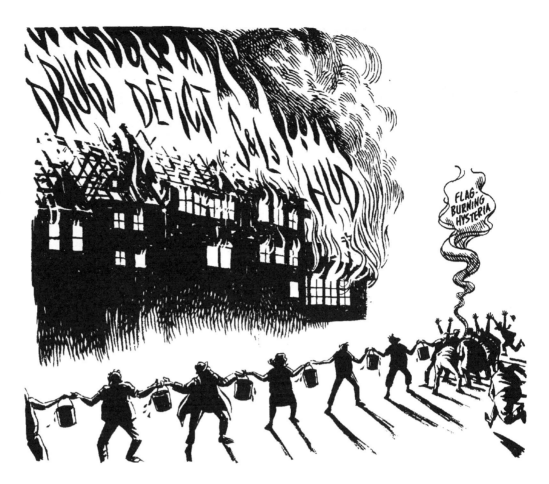

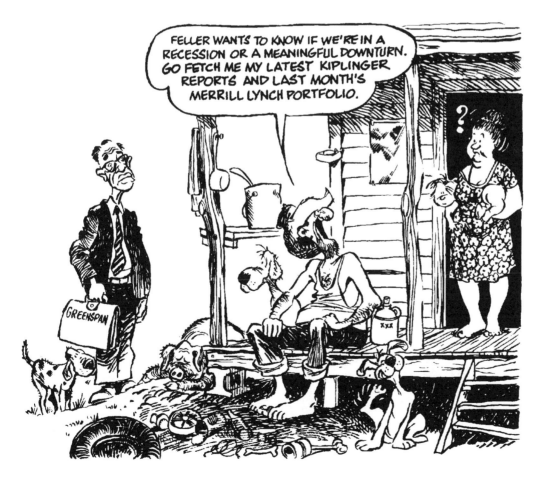

December 14, 1990

Alan Greenspan, the chairman of the Federal Reserve, couldn't decide if the United States was really in a recession.

Speaking of Faults...

January 13, 1991

Then the United States worried about earthquakes.

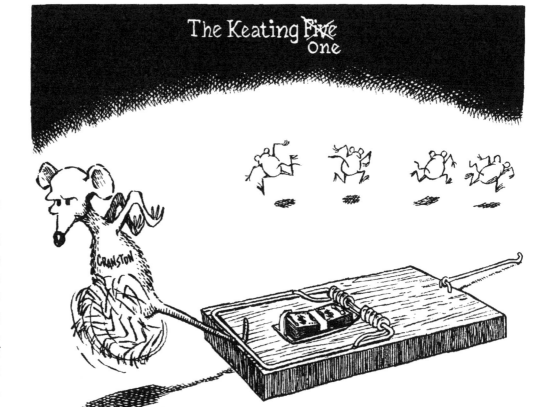

The Keating ~~Five~~ One

March 10, 1991

The Senate decided that only one of the five senators who had helped Savings and Loan king Charles Keating, Alan Cranston of California, had done much wrong.

Fisher's Valhalla

 Napoleon's Old Guard vegetated and contemplated the return of the great man to power. So, too, do the old band of segregationists and machine politicians who surrounded or served Orval Faubus and his ideas for a generation. At their rustic retreat, the Old Guard Rest Home, they reminisce and detect in the passing scene encouraging signs that the public is prepared for their return. Occasionally, their surrogates in real life act out their cartoon fantasies—Faubus himself three times. The other inmates (the roll changes after each election) are Jim Johnson, former supreme court justice; Marlin Hawkins, former sheriff; Marion Crank, former state representative; William F. "Casey" Laman, former North Little Rock mayor; Dale Alford, former congressman; Tommy Robinson, former congressman; Knox Nelson, former state senator; Milt Earnhart, former state senator; Glenn F. Walther, former state representative; and Boyce Alford, former state representative.

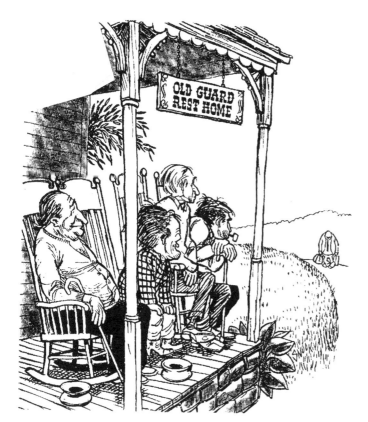

June 1, 1976

Representative Paul Van Dalsem's second stint in the House of Representatives ended in defeat in the Democratic primary.

"That looks like it might be . . . yes, it is . . .
It's Ole Paul!"

May 22, 1980

Jim Johnson, alarmed that Judge Richard Adkisson had won the nomination for chief justice of the Arkansas Supreme Court, announced that pals were circulating petitions to put him on the general-election ballot as an independent.

August 6, 1981

Governor Frank White rewarded Faubus for his support in the race against Clinton by naming him director of Veterans' Affairs.

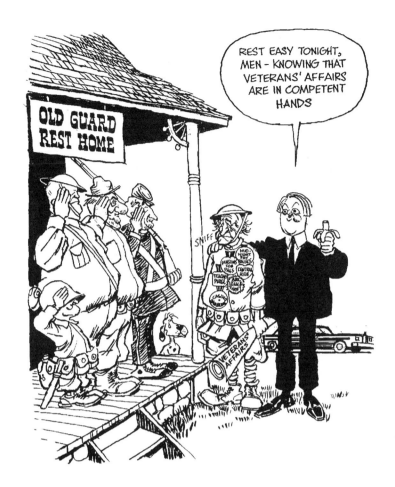

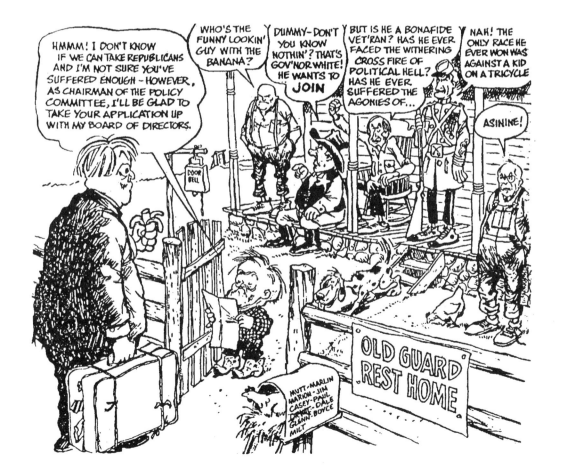

November 7, 1982

White was defeated in the general election.

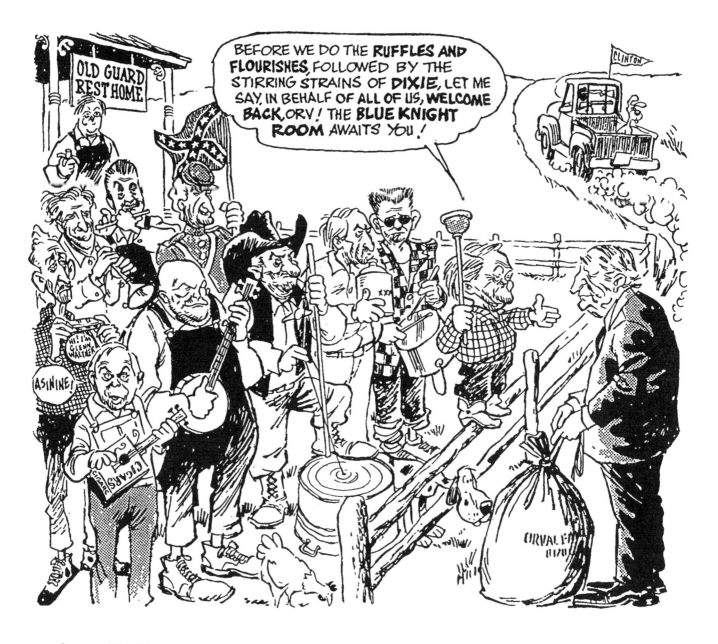

January 27, 1983

Clinton resisted appeals to keep Faubus in his administration.

August 24, 1983

White got to talking about consolidating schools and raising taxes.

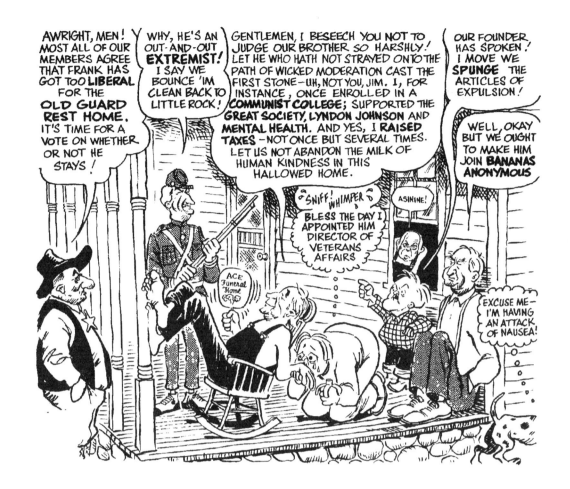

March 15, 1984

Jesse Jackson brought his presidential campaign to Arkansas and got the improbable support of Faubus, restaurateur Robert "Say" McIntosh, and clothier Jimmy Karam, a prominent segregationist in 1957.

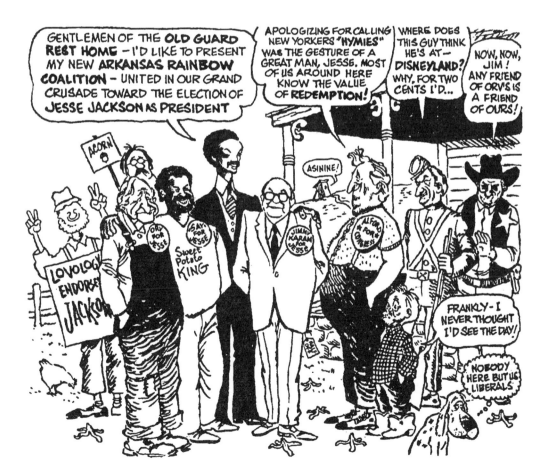

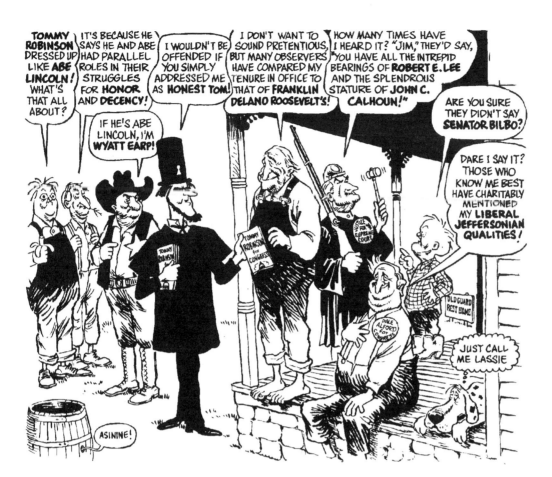

May 1, 1984

Running for
Congress in the
Second District,
Sheriff Tommy
Robinson com-
pared himself to
Abraham Lincoln.

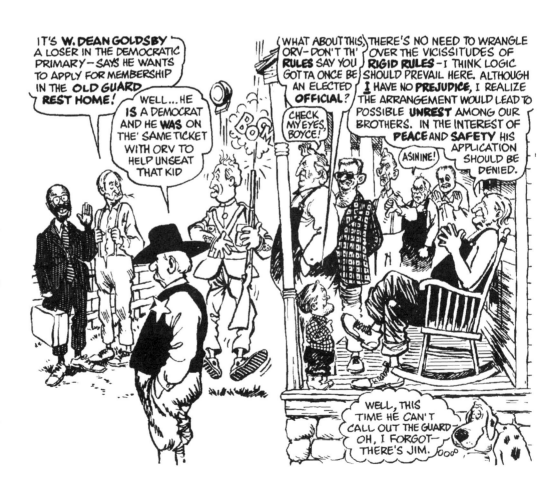

June 4, 1986

Dean Goldsby,
former head of
the Economic
Opportunity
Agency of Pulaski
County, ran
against Clinton
in the Democratic
primary and lost
badly.

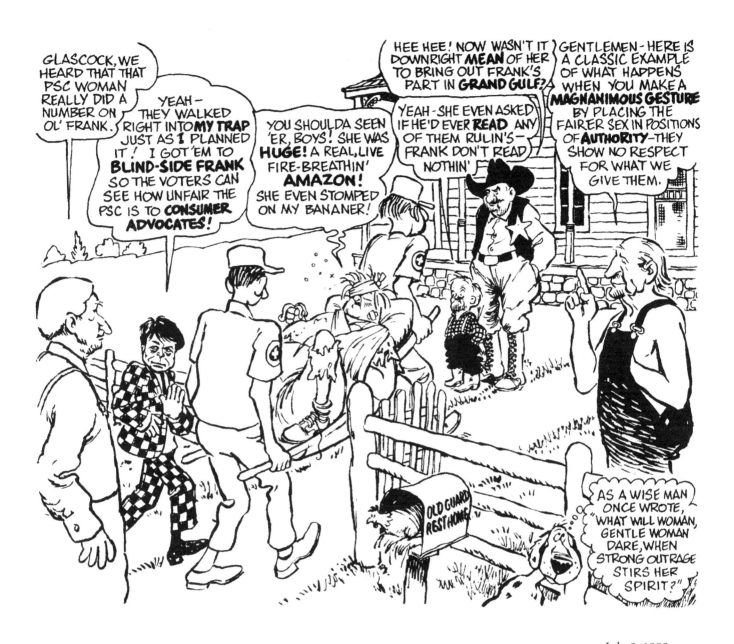

July 6, 1986

White, staging a comeback against Clinton, tried to make political hay by testifying at a rate hearing before the state Public Service Commission, where he received a brutal tongue-lashing by Patricia Qualls, a normally quiet member of the commission.

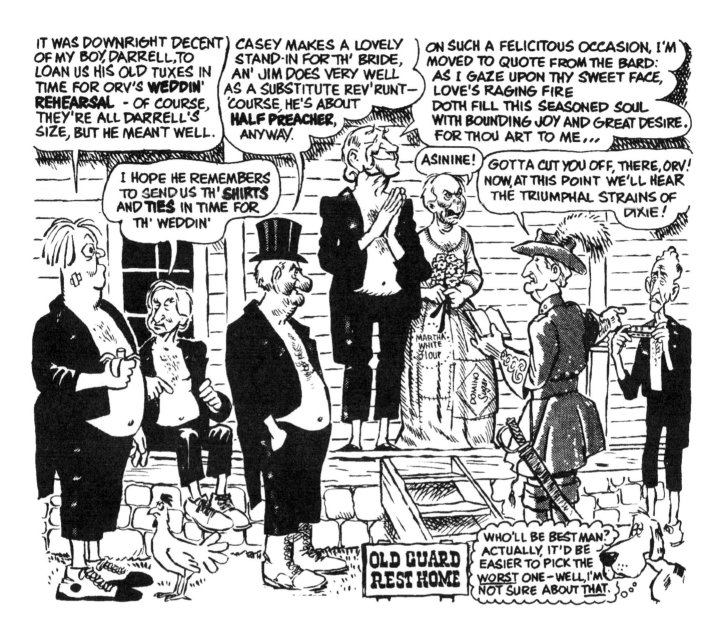

November 21, 1986

Faubus prepared to marry for a third time.

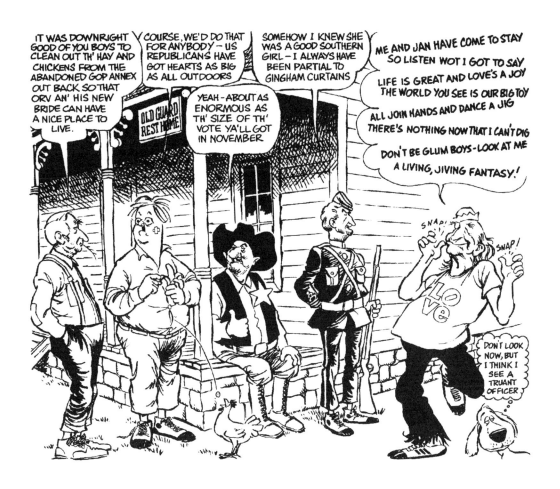

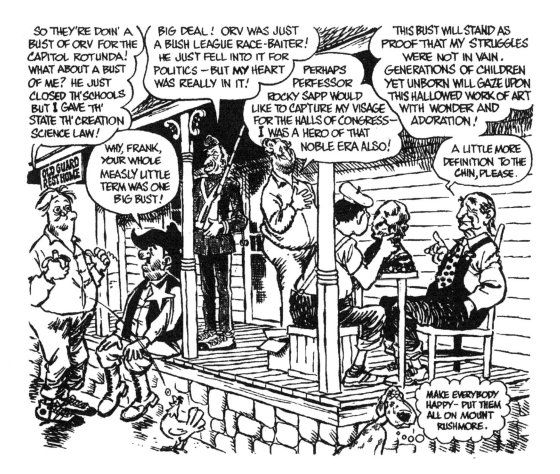

February 11, 1988

Friends commissioned a bust of Faubus for the Capitol.

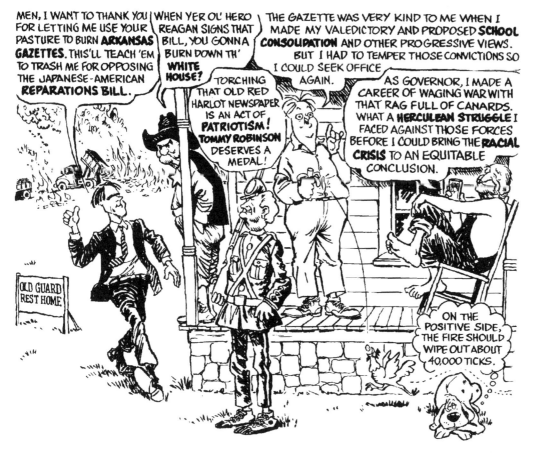

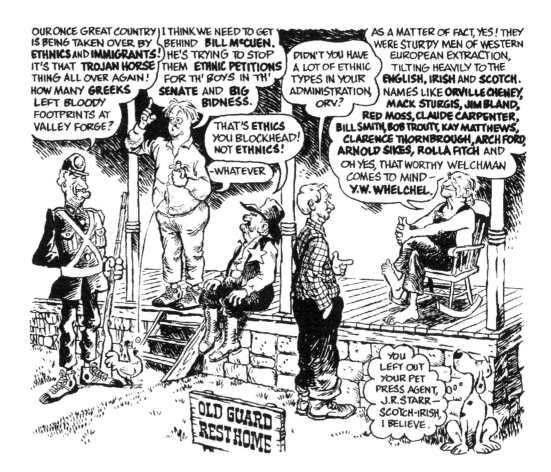

Michael Dukakis,
a Greek, won the
Democratic
nomination for
president.

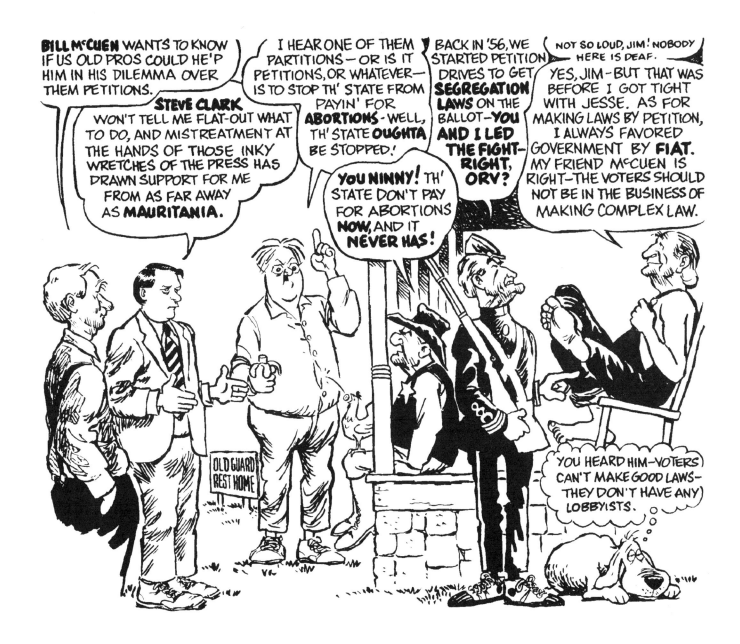

August 31, 1988

Secretary of State W. J. "Bill" McCuen found convenient interpretations of the Constitution to support his curious handling of petitions for constitutional amendments.

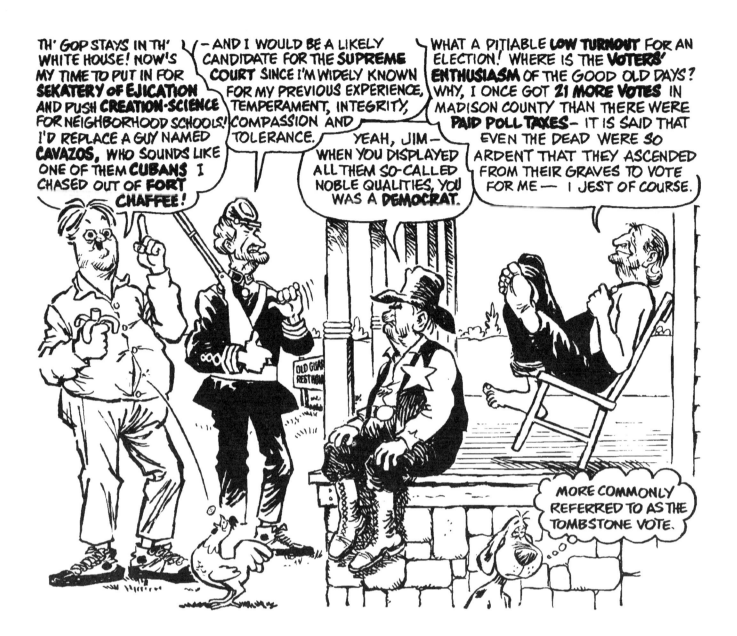

November 10, 1988

Republican George Bush won the White House.

September 1, 1989

Supported behind the scenes by financial tycoon Jackson T. Stephens, Tommy Robinson prepared to run for governor.

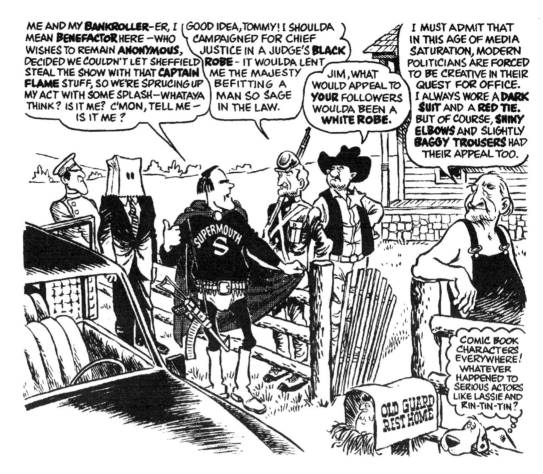

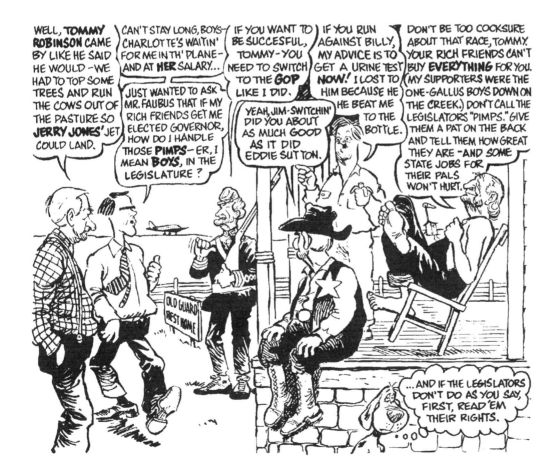

May 28, 1989

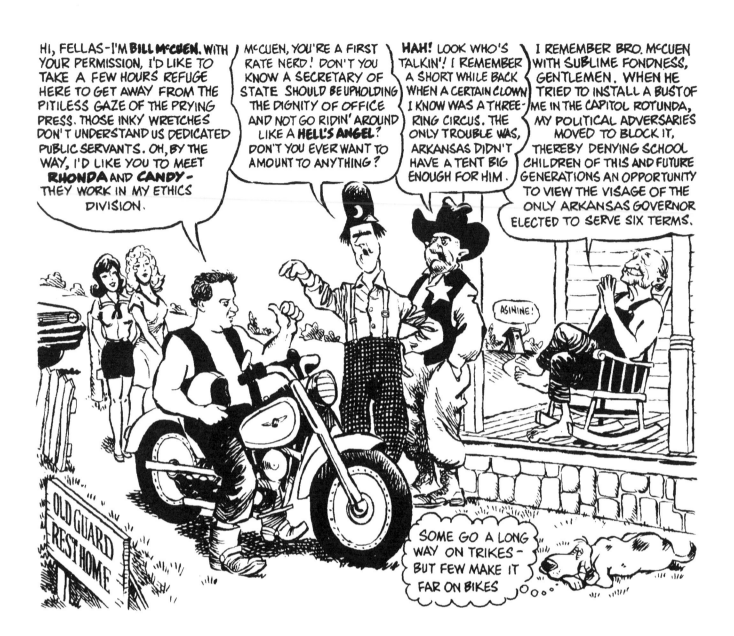

May 26, 1990

Secretary of State Bill McCuen visits the Old Guard Rest Home.

May 31, 1990

The primaries produced prominent losers: Robinson and Old Guard senators Knox Nelson of Pine Bluff and Paul Benham of Marianna.

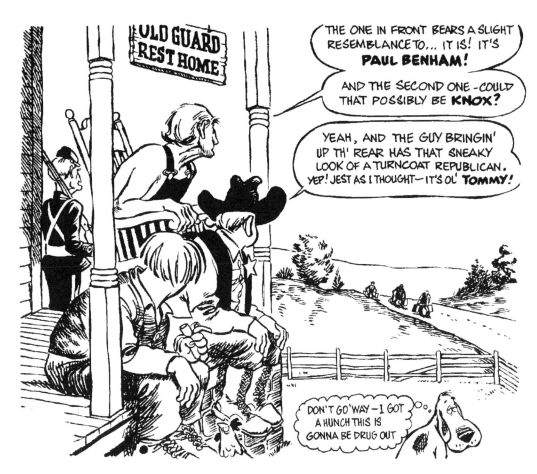

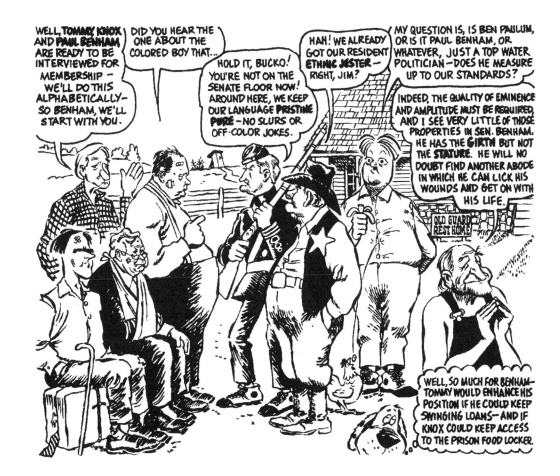

June 5, 1990

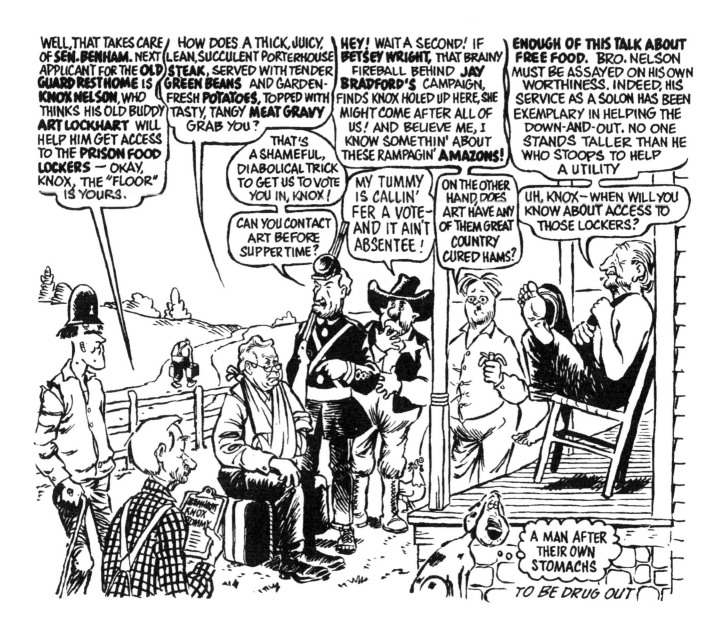

June 10, 1990

238

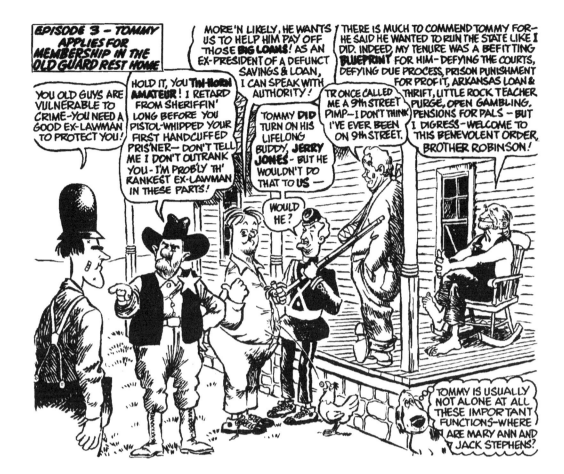

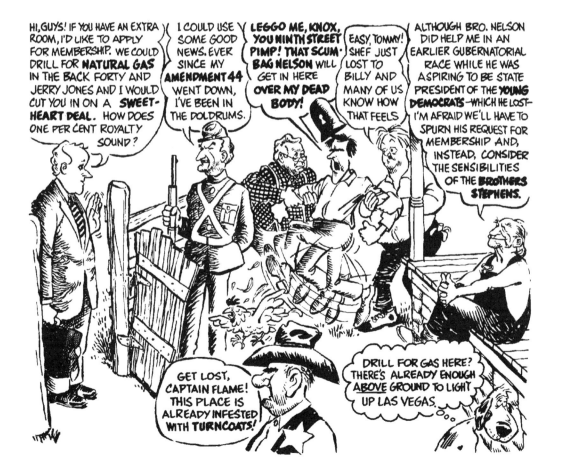

November 15, 1990

Sheffield Nelson, who had defeated Robinson, was himself buried in a November landslide.

Fisher's Favorites

Here are a few cartoons on a wide range of subjects that don't fit into any of the previous categories.

September 21, 1975

The Ozark Folk Center at Mountain View, built with federal and state money, was supposed to preserve the state's precious folk culture, but a bitter falling-out among the musicians left most of them boycotting the music hall.

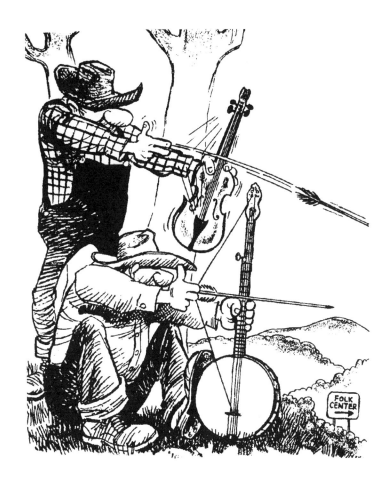

September 2, 1977

Marijuana became the Ozarks' big cash crop.

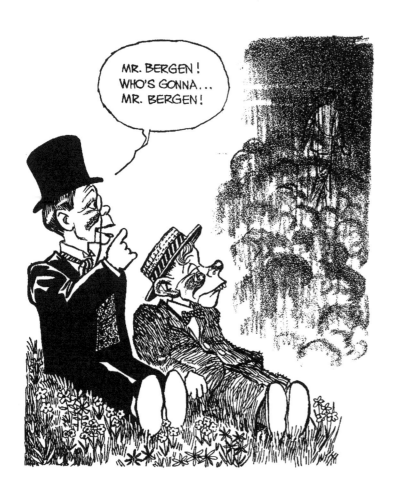

October 3, 1978

Edgar Bergen died.

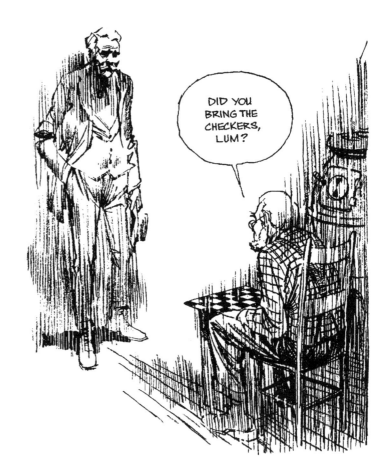

February 24, 1980

Chet Lauck ("Lum"), who died at seventy-eight, was the last survivor of "Lum and Abner," the popular postwar radio team.

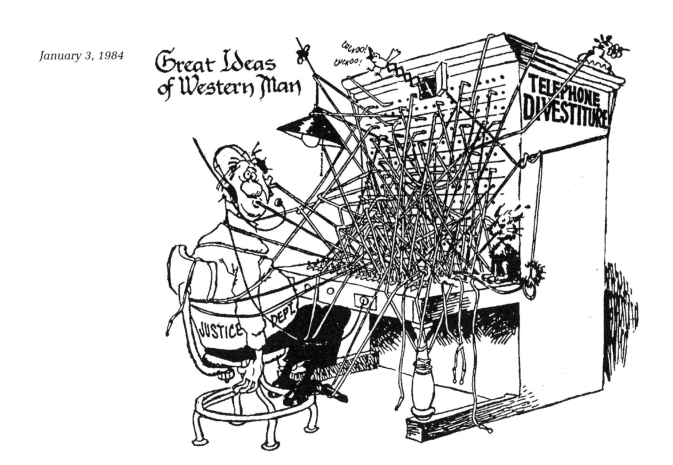

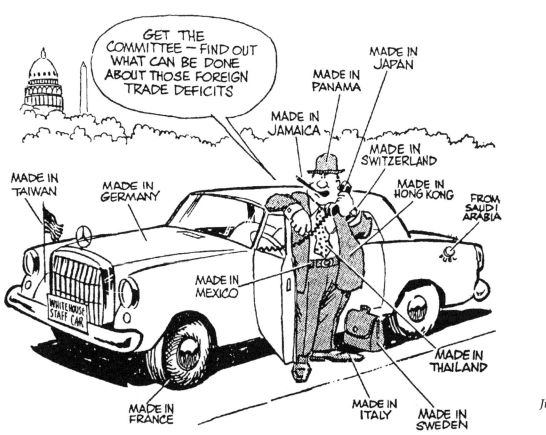

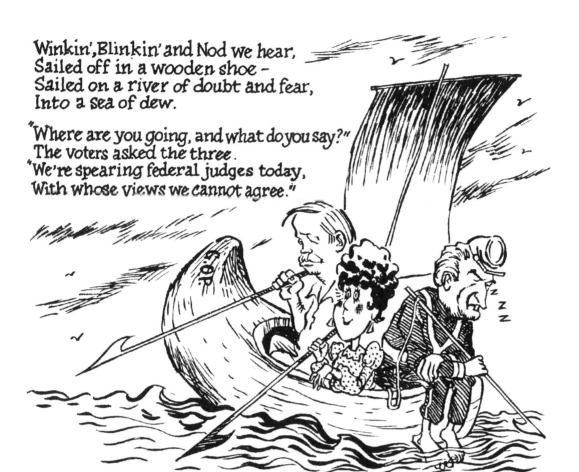

Winkin', Blinkin' and Nod we hear,
Sailed off in a wooden shoe –
Sailed on a river of doubt and fear,
Into a sea of dew.

"Where are you going, and what do you say?"
The voters asked the three.
"We're spearing federal judges today,
With whose views we cannot agree."

August 28, 1984

The Republican candidates (Ed Bethune for the U.S. Senate, Judy Petty for Congress, and "Justico Jim" Johnson for chief justice) campaigned on a common theme. A federal judge had ordered the consolidation of school districts in Pulaski County.

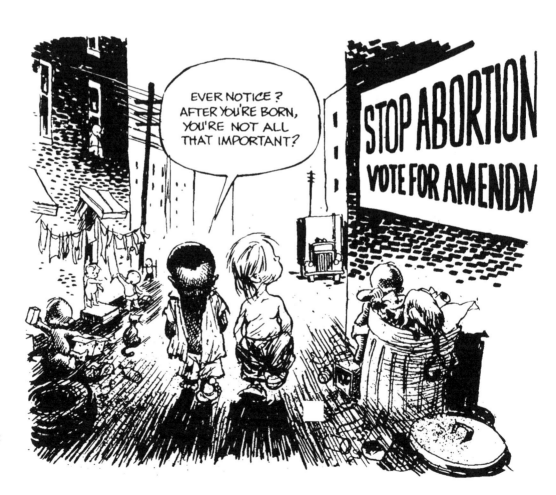

October 18, 1984

244

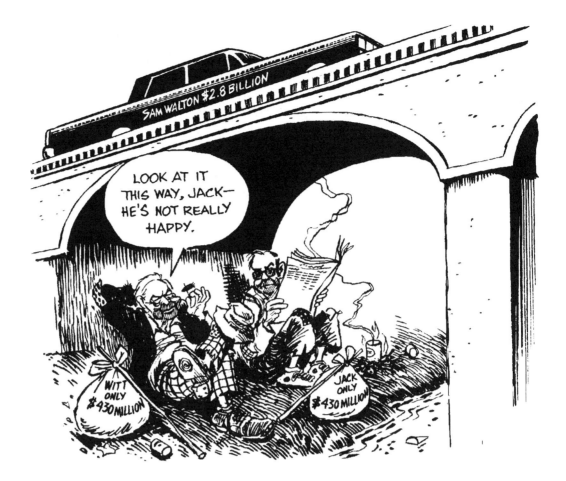

October 16, 1985

In a listing of the nation's wealthiest people, Sam Walton eclipsed the Stephens brothers, "Witt" and Jack.

January 30, 1986

As the nation watched, the *Challenger* spacecraft exploded in the sky over the Atlantic, killing all its passengers.

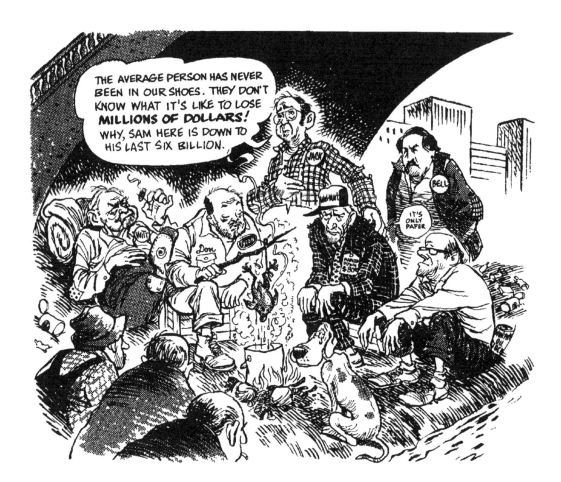

October 30, 1987

The papers gravely reported the momentary effect of the October stock-market crash on the legendary fortunes of a few Arkansas industrialists.

Playing Chicken

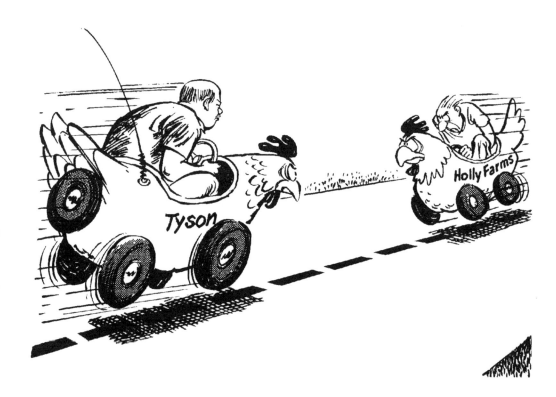

May 2, 1989

Tyson Foods and Holly Farms engaged in a gigantic buyout war.

246

June 29, 1989

Tyson won.

July 18, 1989

There is biennial talk of reforming the state's nightmarish car-licensing system.

247

July 28, 1989

Industrial interests set out to turn the Crater of Diamonds State Park into a commercial mine.

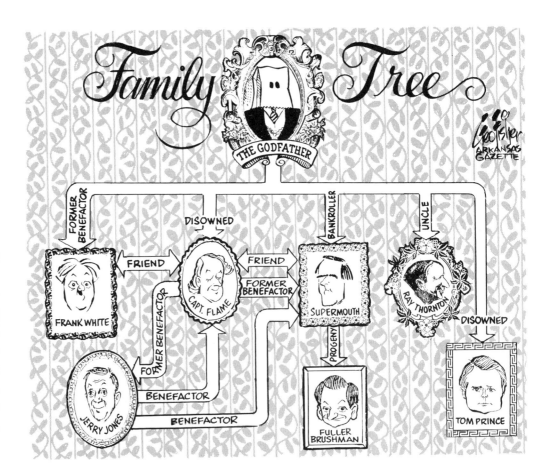

September 17, 1989

Republican politics was getting Byzantine. All the players had a connection with Jack Stephens, who kept his own counsel.

July 20, 1990

The Arkansas Supreme Court invalidated a state law empowering the chancery courts to take stern action against wife beaters.

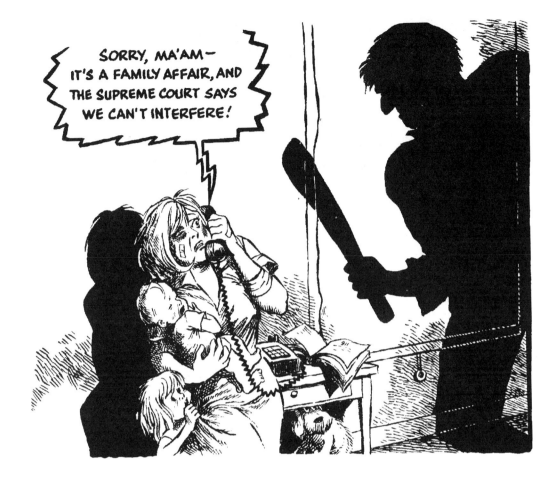

November 9, 1990

Arkansawyers were absorbed in the next-door fight for the governorship of Texas. With one *faux pas* after another, Republican big-mouth Clayton Williams whittled away his mammoth lead and lost to Ann Richards.

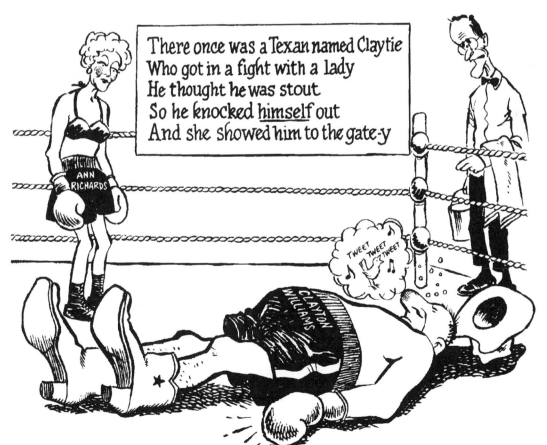

Deliverance

December 18, 1990

The U.S. Supreme Court ruled that a state could prevent the removal of food or treatment from permanently unconscious patients who had not made it clear beforehand that they wanted to die rather than live in a vegetative state, but the state of Missouri finally granted the parents' wishes and withdrew a feeding tube from Nancy Cruzan, who had been comatose for seven years. She died soon afterward.

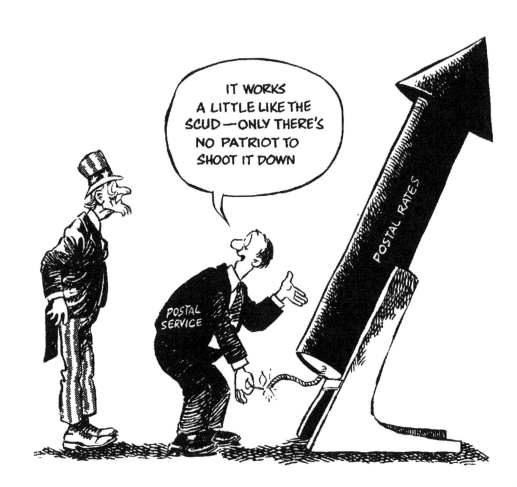

January 31, 1991

Arkansas Gazette.

A few days short of its 172nd birthday, the *Arkansas Gazette* closed its doors, having been bought by the *Arkansas Democrat*. For reasons not explained, the *Gazette* was not permitted to publish a farewell edition, so this cartoon was drawn live on KARK-TV.

The Salon de Refusé

Occasionally, the artist offended the editorial sensibilities of his patrons at the *Arkansas Gazette.* (What works did the Medici scorn? We'll never know.) Printed here for the first time, unexpurgated, are cartoons rejected by the *Gazette,* for reasons that needn't be explained. Several were drawn, in fact, with no intention of publication.

The Governor surrounded himself with strong women—in this case, Hillary Clinton, his wife; Joan Roberts, his press secretary; and Betsey Wright, his executive secretary.

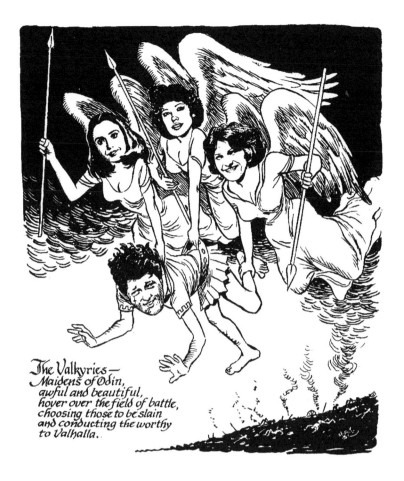

The Valkyries—
Maidens of Odin,
awful and beautiful,
hover over the field of battle,
choosing those to be slain
and conducting the worthy
to Valhalla.

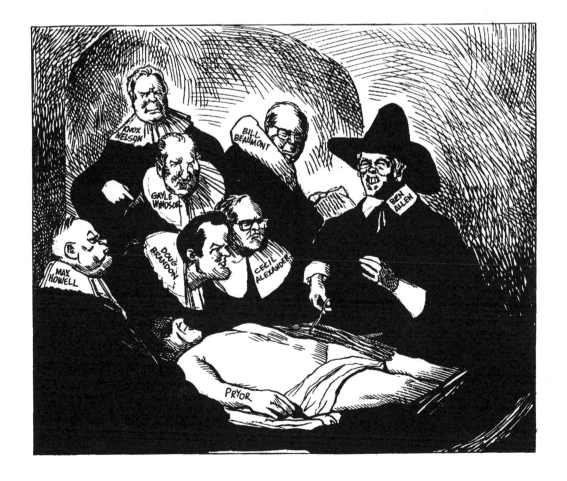

The legislature carved up Gov. David Pryor's grand scheme to reorder state taxes and spending, the famous Arkansas (or Coon Dog) Plan.

First Lady Barbara Pryor got her hair frizzed,
setting off a statewide controversy.

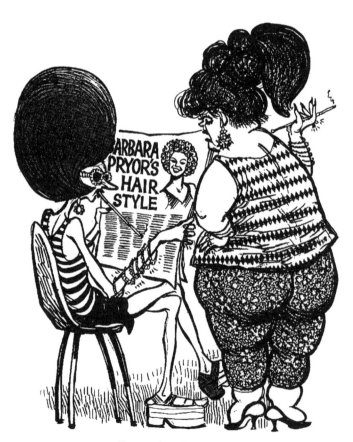

"Personally, I Think It's Disgusting."

Congress was beset by sex scandals.

I'm Not Yet Ready To Accept Evolution

Orval Faubus, former governor,
preferred the biblical account
of creation.

Madonna and Child

Jimmy Carter's support from Coretta Scott King, widow of the slain civil rights leader, was pivotal to his election.

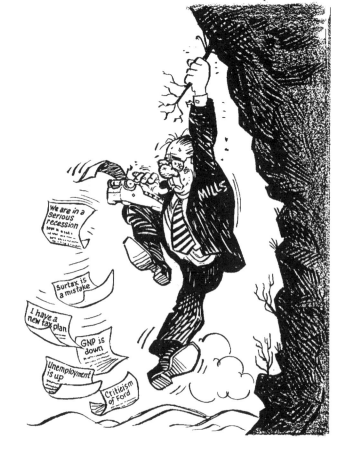

U.S. Representative Wilbur D. Mills was having his political troubles in 1976. He chose not to run again.

On the comeback in 1970, Faubus said he would have a youth-filled reform administration.

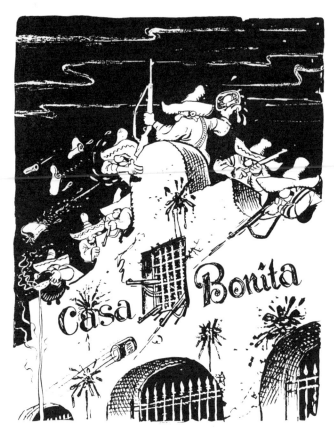

In the seventies, some Little Rock high-school students started a rumor that the restaurant Casa Bonita served dog food in its Mexican dishes. The rumor hurt the restaurant's business until the public learned it was a hoax.

Remember the Casa Bonita!

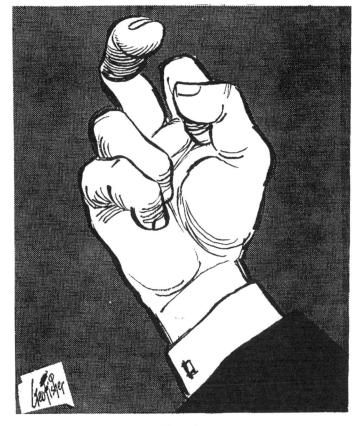

Vice President Nelson Rockefeller made an obscene gesture to hecklers as he was about to make a speech. *The Gazette* ran the news photo on page one, but wouldn't run the cartoon.

Half Nelson

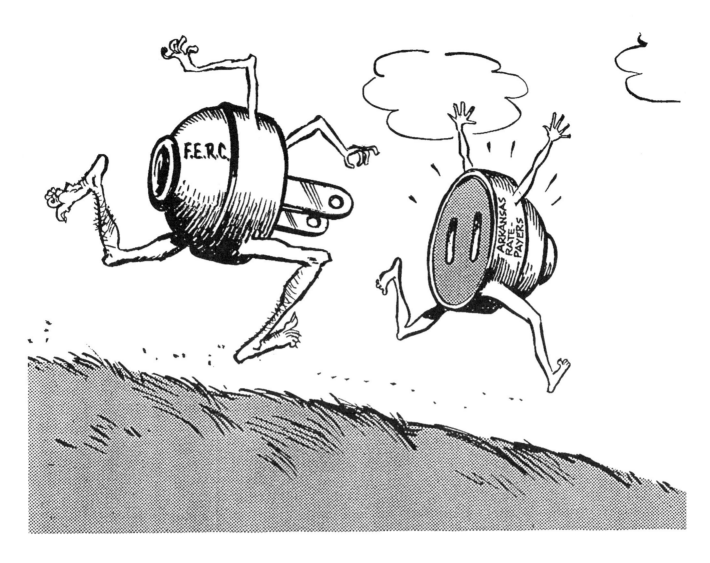

Reagan's Federal Energy Regulatory Commission ruled that Arkansas ratepayers must pay a disproportionate share of Grand Gulf.